MODERN ART AND SCIENTIFIC THOUGHT

Modern Art and Scientific Thought

John Adkins Richardson

UNIVERSITY OF ILLINOIS PRESS

URBANA CHICAGO LONDON

for Charlene, Christopher, and Robin
WITH DEEP APPRECIATION TO
John and Constance Ades

Acknowledgments

APART FROM the luminaries cited in the Introduction, I am indebted to John Barker, William Bennewitz, David Clark, Lyman Holden, Laurence McAneny, Eric Sturley, and Frederick Zurheide for help with certain points in science; to Harry Hilberry and Andrew Kochman for moral and administrative support of my varied interests; to Edwin Ziegfeld and Arthur R. Young for recognizing the value of an idea long, long, ago; to Daniel and Eleanor Havens, Michael and Valerie Smith, and Arthur and Evelyn Buddemeyer for assistance and also for necessary distraction; and, finally, to the many art students who have had to tolerate and sometimes correct my digressions into science and philosophy.

Contents

Illustrations

The reproductions are of oil paintings unless otherwise indicated.

Introduction

THIS BOOK had its start in my feeling that a kind of complacency had settled over all statements having to do with the relationship between visual art and scientific thought in modern times. There are indications that a long period of tension between the two areas is closing with what passes for a dialogue but is really just a litany. From one quarter we hear that science is intellectual and mechanical, art intuitively expressive. Often this invocation is accompanied by a chorus, either affirming the superior integrity of the artist or shaming him for his contempt of Reason. But then, rejoicing, an answer swells from another side. In all things are we one, it sings. Scientific strictness is at its very base rooted in an aesthetic sensibility; the crystaline purities of mathematics are judged according to notions of clarity, consistency, and harmony. And the arts, too, have a methodology and rigor; their mysteries also require a special intelligence and apprenticeship. This paean to unity is most often sung by artists desirous of foundation grants to do "research" and by scientists defending their own humanity. In either case the parallels between art and science are prudently left obscured by the supervening notion of something called "creativity."

The above is not intended to accuse the speakers of cynicism. I too often find myself saying these same things in all sincerity. Neither does it deny that there is real substance in what is said. The trouble is that these invocations and supplications have actually become ceremonial. They no longer tell us anything at all. That is not, however, for the lack of a literature.[1]

[1] None of this has anything important to do with C. P. Snow's now popular phrase, "The Two Cultures," from an essay that is far more famous than it was understood. His

Art as it pertains to science would appear to be the subject of an extensive bibliography in aesthetics and art criticism. But things are not quite what they seem. Most works on the list deal with art exclusively and touch on science as a contingency. For instance, any number of writers have tried to demonstrate the dependency of the sublime upon proportion. Their arguments, though based on coördinate geometry, have little to do with mathematics. That is, the existence of a ratio such that the smaller element is to the larger as the larger is to the whole is, in and of itself, of no importance to geometry. The significant thing about Euclid's famous Golden Mean is that is ubiquitous in art as well as nature and is harmonious and appealing to human sight. Books about it and its relatives have to do with the sensations described by the formulae, not with the formulae themselves. Similarly, a book like Rudolf Arnheim's *Art and Visual Perception* is about the application of Gestalt psychology to the study of art; about the Gestalt theory itself it has little or nothing to say.

The arts have also been treated in terms of the history of technology, as Geidion did with impressive results in *Space, Time and Architecture* and *Mechanization Takes Command*. The emphasis there is upon the relationship of the fine arts to the *applications* of scientific thought. That is true also of books devoted to disclosure of the ways in which technology has afforded us new perceptions of the universe and, consequently, influenced the appearance of our art.[2] It is still more obviously true of the texts which discuss art as the object of scientific inquiry in terms of conservation, restoration, and professional studio technique. Seen from their position all modern painting is derivative of science because, since the nineteenth century, all of the materials have been commercially produced by industry. During the past decade there was an increasing tendency to approach art in light of this because so many synthetic products developed for use within industry have found their ways into serious art.[3]

concern was peculiarly British—though this seems not to be apparent to American readers —and had to do with the purported values of a traditional classical education, particularly for leaders of government. Scientific culture is contrasted by him not with the arts in general but with the curiously literary culture of England's "Establishment." (That use of the term, incidentally was coined by Henry Fairlie in a 1955 London *Spectator* article where he suggested that spies Guy Burgess and Donald Maclean had needed no "cover" for their activities simply because they belonged to "the Establishment.")

[2] See, for example: Gyorgy Kepes, *The New Landscape* (Chicago, 1956); Ray Faulkner and Edwin Ziegfeld, *Art Today* (New York, 1969), and K. G. Pontus Hultén, *The Machine* (New York, 1968).

[3] See Allen S. Weller, *The Joys and Sorrows of Recent American Art* (Urbana, 1968), pp. 66–72.

All of these publications are of unquestionable value. But they do not, except sometimes by happenstance, deal with science in the way they often do with art, in terms of the history of ideas. And that kind of treatment is what is really needed if we wish to examine the role of the artist as a mental worker in the same context with the role of the scientist.

There are a very few authors who actually do deal with historic relationships between art and science as intellectual spheres rather than with some special contingency. Several of these pretend to infer from the synchronisms of history hermetic connections between the reasoned-out and the instinctive. A very famous one, Oswald Spengler, maintained that, during the seventeenth century, analytic geometry, the music of the thoroughbass, and Baroque painting had all developed out of the "same inspired ordering of an infinite world."[4] That may have been true, of course, but in Spengler it is all quite vaporous. He was so committed to an embracing law of historical development to which all men were bound that he constantly tested reality against his theories rather than the other way about. Marxist scholarship tends in this direction also,[5] as indeed does every interpretation of history that takes its lead from Hegel. These "historicisms," which assume for history an overall structure or movement of some kind, place hazards in the way of truth by insisting that each event be accommodated into the system at all costs.

Less pretentious studies of art and science have usually been either too narrow in scope to be of interest to any but specialists or have been so "philosophical" as to have become part of the existing litany.[6] Too, since the mediocre outnumber the gifted in art criticism as elsewhere, many of these speculations have been so misinformed as to be worse than useless. One purpose of the present volume is to correct a few of the more egregious of those writings. The other is to bring into clearer focus whatever modern painting has had in common with concurrent tendencies in the physical and behavioral sciences.

[4] Oswald Spengler, "Meaning of Numbers," trans. Charles Francis Atkinson, *The World of Mathematics*, Vol. 4 (New York, 1956), p. 2320.

[5] One should note, in fairness, that neither Marx nor Engels was so dogmatic about economic determinism. But Engels pointed out in a letter that Marx and he "were compelled to emphasize its central character in opposition to our opponents who denied it, and there wasn't always time, place and occasion to do justice to the other factors in the reciprocal interactions of the historical process."

[6] One of the most diverting exceptions to this is a little book by William M. Ivins, *Art & Geometry, A Study in Space Intuitions*, (Cambridge, 1946), which uses Greek and Western conceptions of space to argue, more-or-less, that the vaunted Greek sense of unity

When the author restricted his work to the modern period he was, naturally, indulging a personal interest. But there are also objective reasons for confining ourselves to a period bracketed by the middle of the nineteenth century and the Second World War. In the first place, what scientists themselves think of as properly scientific is a product of those years. Secondly, what dominates present discussions of art and science is the modern fact of specialization in regions of thought removed from the ordinary experience of men. And, thirdly, any direct historic parallels between painting and scientific thought (as distinct from technology) seem to me to fall pretty much between the centers of the centuries. For even designers who master FORTRAN, PL#1, or other computer languages have merely an adventitious relationship to science. All that they have done is substituted magnetic tape for pencils in order to obtain instantaneously the number of alternative layouts that once took days of concentrated trial and error.

The main reasons for neglecting sculpture entirely are that painting exerted the predominate influence on modern art from the 1850's through the 1950's and that our mode of visual presentation in a book is two-dimensional.

Presumably there will not be much question as to the desirability of writing about art together with science; the real question is as to the feasibility of doing so. Even if it were granted that there are general principles common to all intellectual work, the fact remains that any interrelationship between painting and physics or mathematics is obscure compared to their more obvious and apparent differences. Is it possible to correlate things so different without distorting them beyond all recognition? Yes, if one strives for common sense, not unity.

The principle of comparison that submits itself for use here is quite unpretentious. It is the same device used by a lecturer when he illustrates an idea in his own field with an analogous notion from another. These occur to the lecturer because of their very reasonableness, because they clarify things for his listeners. When someone draws an analogy between the views of Marx and Freud, saying that both emphasized that we see the world from a distorted angle, he does not perforce maintain that a condition more profound than that similarity exists. If an economist he

is an invention of German archeology. The contention is doubtful, but the comparisons of art and geometric principles from antiquity through the Baroque are fascinating.

might at the same time point out that Marx resembles nineteenth-century Positivists in his assumption of the dialectic as a descriptive system rather than as Hegel's *dialectic creatrice*. If a psychologist he would perhaps note that Freud's view of man as a creature driven by primordial urges is a systematic statement of ideas already embodied in Romantic literature. But in no case does the speaker presume more than the specific resemblance. He may, of course, account for such similarities on the basis of their social context but he is not required to do so. Indeed, the social conditions may themselves be looked upon by him not as causes of the similarities but as concommitant similarities.

When someone makes such comparisons he is expressing his discovery of "families of relations" among the things bearing upon the object of his inquiry. Like the relations of a family in real life these may not always be easy. Some may even be illicit. But overall, again as with real families, a pattern of resemblances will prevail. This pattern is not the ephemeral product of some mystic destiny; it is nothing more than kinship manifest.

The existence of such kinships has been strongly emphasized in the researches of a particular school of historical study which emerged towards the end of the nineteenth century in the work of the Viennese art historians Max Dvorak and Alois Riegl and the writing of French literary critic Hippolyte Taine. Generally, these men held that the arts should be studied in terms of the greater culture and that their character might be determined by events wholly removed from the overt awareness of individual artists. The importance of this conception in the study of art history and criticism was considered, along with all sorts of connected matters, by the connoisseur and polyhistor Meyer Schapiro in a brief essay on "Style" which has come to be the measure of all later commentary.[7]

Schapiro and his students have been remarkably imaginative and resourceful in exploring various aspects of culture that influence artistic expression, even bringing to bear upon their criticism such resources as Schilder's research into the subjective images people have of their own bodies.[8] The author has, in some of the following chapters, leaned par-

[7] See Meyer Schapiro, "Style," in *Anthropology Today*, ed. Sol Tax (Chicago, 1952), pp. 287–312.

[8] See Paul Schilder, *The Image and Appearance of the Human Body* (New York, 1951). Schilder deals not only with the obvious facets of the subject, but with things of greater interest. He talks of psychological auras, body phantoms, the heavy mass of the body, the interrelation of body-images, and many other aspects of the phenomenology of the body about which most of us have never even thought.

ticularly hard on leads suggested by Professor Schapiro in publications and lectures which are of such brilliance as to make alternative statements appear either wrong or mere facsimiles. Hardly less important are insights gleaned from philosophers James McClellan and Charles Frankel and from mathematicians Myron Rosskopf and Richard von Mises. Indeed, it is not too much to say that whatever in this book is brilliant has probably been derived from these and other men while what seems banal, uninformed, or preposterous belongs to me alone.

A considerable attempt has been made to keep the tone of the work general rather than technical. This has led, in some places, to the abandonment of original sources for secondary ones. It must be obvious that the author, a painter and engraver, is himself in no position to comment at length on Einstein's General Theory of Relativity or on such specialized topics as Brouwer's "Intuitionism," a school of modern logic. Few readers would be in a position to understand the meaning of documents originally addressed to audiences of physicists and mathematicians. This circumstance explains the frequency with which works a professional may consider "popular" appear in footnote citations. The selection of such references, though, was made circumspectly and, whenever it seemed possible, interpretive works by the originators themselves were used.

The presentation is of a relatively straightforward kind. In most cases the chapters deal with separate movements in painting, comparing these with specific scientific developments or science-connected philosophies. Normally, I have first analyzed a painting style with some reference to its social context and then have compared the style with a specific theory or a scientific posture to which it seems related. The reader, however, should bear in mind that a number of these topics have been selected precisely because they represent segments from a range of events that are contiguous even when they are not phases of a continuous development. Frequently a subject introduced in one chapter awaits amplification in another. Thus, Cézanne is treated separately from the Impressionists with whom he exhibited; Freud's concept of the unconscious is discussed in connection with "projection" in Chapter Four but its role in dreams not mentioned until Chapter Six. The Bauhaus is touched upon in different respects in Chapters Six and Seven.

To the extent that it seemed reasonable I have stressed scientific theory and philosophy of science rather than applied science and technology.

Within the behavioral sciences, however, that line has been neither easy to draw nor particularly helpful to understanding. And, while it is obvious that connections between technology and artistry cannot be considered equivalent to those between science and art, the emergence of the machine as a theme cannot be ignored altogether when dealing with modernity. It may seem curious, therefore, that while Dada is discussed, any reference to Futurism—the Italian movement devoted to realizing the beauty of pistons, power and motion—has been omitted entirely. This is not an oversight. Dada had a special pertinance to later developments that is far clearer than is the importance of Futurism to its immediate future.

It may also be helpful to know that for purposes of organization I have employed an extremely durable interpretation of modern art. This conception sees everywhere an antecedent contest between classical precision and romantic power. There are paired opposites all along the way: Ingres and Delacroix, Seurat and van Gogh, Mondrian and Kandinsky, Sheeler and Marin. Besides the tendency towards pure formalism there flows a strong current tending to absolute subjectivity. If one conceives of these tendencies as streams analogous to actual rivers one must think of them as meandering alongside one another in a common voyage from Impressionism to the present. Sometimes they are parallel, sometimes they link and pool, sometimes they are so far apart as to seem entirely unrelated. Such an interpretation has both the advantage and disadvantage that any mapping-out of reality will have; it makes for great clarity and provides us with an overview at the expense of explicit detail. We follow the bends of the rivers but never see the bullrushes and only rarely heed subsidiary features. Still, we pretend to have no more than a map.

It is a somewhat two-dimensional map with respect to the whole of art and science. Had biology been given serious attention it is quite possible that still more provocative relationships between painting and scientific theory might have emerged. But to have dealt adequately with everything of relevance would have been a superhuman task. All that the present author could hope to do was indicate a direction for other men to follow. Certainly, this study has faults of the kind with which all human productions are in some degree afflicted. Knowing it is corrigible, I submit it to the reader in the hope that it will assist both our understandings.

MODERN ART AND SCIENTIFIC THOUGHT

French Impressionism and the Empirical Ideal

RATIONAL MEN must be suspicious of historians who insist upon the necessary correspondence of all the elements of an age. The assumption that a *Zeitgeist* can accommodate all the facts of life is clearly unsupportable if only because it is impossible for a historiography to take every fact into account. On the other hand, we can speak safely of the unity of an age in terms of a consensus of ends, purposes, or ideals. And more often than not the coincidences of purpose that override, but do not abolish, distinctions among fields of interest tell us far more about the time than the disharmonies which provoke conflict. Precisely such a coincidence of purpose is revealed in the parallels between nineteenth-century scientific views and attitudes common to Impressionist painters, literary Naturalists, and Positivists in philosophy. Coincidence does not preclude the play of differences, and, indeed, differences abound. But the similarities are more interesting, particularly when unexpected. More importantly, they are of greater pertinence in showing up the continuousness of a tradition of "modernity" that cuts across the several fields.

It seemed at first that the artists connected with this tradition would experience no success at all. Their Second Impressionist Exhibition was announced to the world by a storm of journalistic dissension that broke over Paris in the spring of 1876. The following review, representative of the public attitude generally, appeared in *Le Figaro* on April 3 of that year:

> These self-styled artists give themselves the title of noncomprisers, impressionists; they take up canvas, paint and brush, throw on a few tones haphazardly and sign the whole thing. . . . It is a frightening

spectacle of human vanity gone astray to the point of madness. Try to make M. Pissarro understand that sky is not the color of fresh butter, that in no country do we see the things he paints and that no intelligence can accept such aberrations! Try indeed to make M. Degas see reason; tell him that in art there are certain qualities called drawing, color, execution, control, and he will treat you as a reactionary. Or try to explain to M. Renoir that woman's torso is not a mass of flesh in the process of decomposition with green and violet spots which denote the state of complete putrefaction of a corpse![1]

Yet, despite the hostility of the crowds, Impressionism was the painting that would ultimately break the ironbound prestige of the Salon and change the face of art for all the coming century. Paradoxically, this was due less to the force of radical elements in the style than it was due to the conservative aspects of it.

Impressionism was a much less revolutionary art than is generally supposed. Painting had been moving towards such expression, "at once sensual and fastidious, bent on strictly personal experience" since the 1600's. "Impressionism formed merely the last step in a process of increasing obscurity that had been going on for centuries. Since the baroque, pictorial representations had confronted the beholder with an increasingly difficult problem; they had become more and more opaque and their relation to reality more and more complex."[2]

The irony is that these earlier steps towards obscurity had not prepared a climate of any clemency. On the contrary, the predecessors of Impressionism—the Romantics and Realists—actually increased the likelihood that anything following them would be met by a public reaction of extreme violence. To the respectable art lover of the nineteenth century certain names seemed to mark stages in the progressive deterioration of artistic competence and good taste. Delacroix was bombastic, Corot clumsy, Courbet ignoble. If Gericault's *Raft of the Medusa* marked the beginning of the decline of the French school, Manet's *Olympia* (Fig. 1) stood for its utter degeneration. And, since Impressionism was little more than an exaggerated version of what the Realists had been practicing, its appearance was accompanied by alarums of disaster.

Although the appearance of Realism as a phase in the development of modern art is well known, its role is not widely understood. Nor is this

[1] Quoted in John Rewald, *The History of Impressionism* (New York, 1946), pp. 295–99.
[2] Arnold Hauser, *The Social History of Art* (New York, 1951), pp. 875–76.

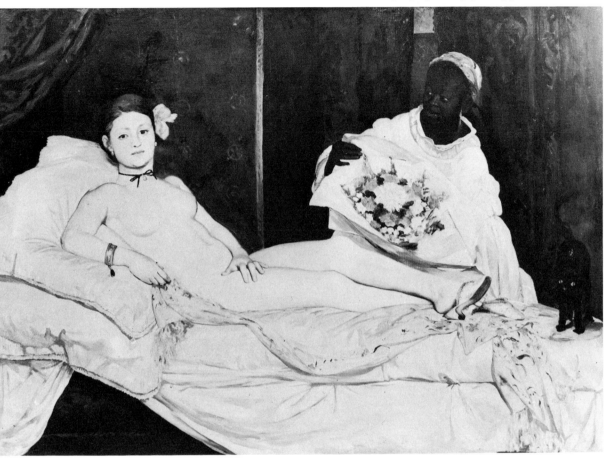

lack of understanding at all surprising. It grows from what seems a real incongruity; modernity in art is associated with abstraction, and it was the Realists who argued most fiercely in favor of patterning art after mundane reality. But the truth is that Realism was neither so matter-of-fact nor so unalloyed as it seemed. Its affectation of a coarse materialism was hostile to the status quo and, because of that, became so exaggerated as to conceal the finesse of its true means.

Despite the self-conscious radicalism of its practitioners, the movement was dominated by a strangely passive aesthetic called "pure painting." That aesthetic meant "dedication to the visual as a complete world grasped directly as a structure of tones without the intervention of ideas or feelings about the represented objects."[3] Courbet harkened to the idea

[3] Meyer Schapiro, *Cézanne* (New York, 1952), p. 24.

when he once maintained that he did not know what he was painting.

One must recognize that such objectivity is not possible to attain. Even photography's images are shaped by subjective notions of order and significance. Thus, in discussions of Courbet, it has become fashionable to stress the mannered character of his Realism. From a strictly formal point of view such criticism is correct. But in the study of art history one is concerned with trends as well as achievements; the intentions of a movement sometimes prove to have been more important than its actual works.

The motive driving Courbet and his followers was their hatred of every form of social fraud. They opposed academic painting because they saw in its pretensions and its artifices an expression of the moral hypocrisies of the bourgeoisie. Of course, their own honesty made them into hooligans. That comes of opposing always every form of deception wherever recognized. It is not without reason that the common feature of avant-garde etiquette is wholesale subversion of conventional deportment; the absolute measure of one's tolerance for a social system is the degree of respectability one attains within it. In Courbet's time the achievement of respectability entailed more concessions to gentility than it does today. Consequently, we find Realists doing such "perverse" things as portraying men with their hands in their pockets and other similar postures that were considered too ignoble for any medium except Daguerre's.

Pure painting is connected with all of this in a quite explicit way, for it is an augury of much that is to be done in the name of modernity, both in art and in literature, and even in philosophy and science.

Let us take as an example the masterpiece by Courbet's follower Edouard Manet, the *Olympia*. First exhibited in 1865, it was received with the kind of shock that had greeted Flaubert's *Madame Bovary* nine years before. The picture is based on a sixteenth-century prototype, Titian's *Venus of Urbino*, (Fig. 2) but while the poses are similar the ladies are quite different. Olympia is not Titian's loving creature, she is a hard and cold professional. The candid image of a courtesan, this might be—though it is not—a portrait of Marie Duplessis, the model for Dumas's *La Dame au camélias*. Despite her ostensible situation, Manet did not portray Olympia as a human being so much as a visual phenomenon. He approached his model as a special instance of the object world. Her face became for him a mere array of lights and darks. Furthermore, no greater attention was lavished on the head than on the bedclothes. It is as if a bed were as important as the lady within it, differing only in its absorption of

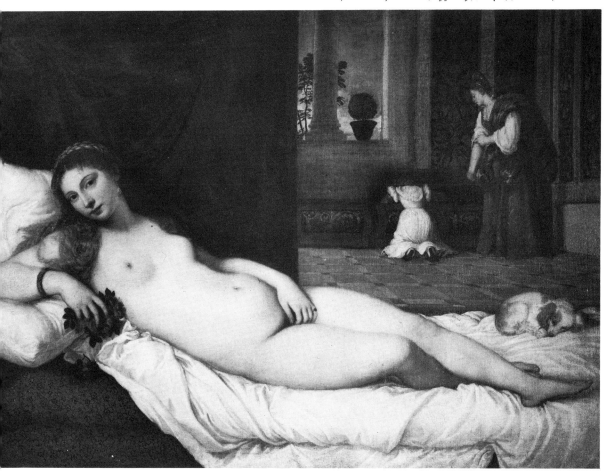

light—as if there were no preordained hierarchy of values. Such a view-point, which habitually concedes all to a coatsleeve that it gives to a face, requires a not inconsiderable degree of detachment. It is contingent on seeing the world in terms of varying intensities of light, without regard for substance. And precisely this attitude was what the phrase "pure painting" signified.

Manet's view of things may seem peculiar, or even odd, but it was in no sense revolutionary. His painting was in direct line of a distinguished tradition extending back through Franz Hals and Fragonard to Velasquez. All of these men saw nature as a fury of light to be transcribed in a flurry of brushstrokes; Manet's was merely the most extreme and self-conscious extension of that heritage.[4]

[4] Cf. José Ortega y Gasset, "On Point of View in the Arts," *The Dehumanization of Art, and Other Writing on Art and Culture* (Garden City, N.Y., 1956), pp. 99–120. In this

To appreciate the significance of such vision for the 1860's one must see it in contrast to the standard of the day. During the seventh decade of the nineteenth century men in hundreds of studios were busily transforming living women into pristine goddesses, populating Italianate landscapes with the by-then-weary olympic pantheon. What Manet was doing in his *Olympia* was opposing high-minded fancies with the realities of a palpable world. As antidote to the pretentious literary content of pseudoclassical art he presented viewers with a revelation of the obvious.

The Revelation of the Obvious is one of the commonest characteristics of avant-garde art. It practically constitutes a principle of modernity. When writers like D. H. Lawrence and James Joyce introduced into serious literature the brief Anglo-Saxon words common to everyday speech they disclosed no secrets; they revealed the quite obvious gulf between literary convention and reality. When, in the late 1960's, the popular theater and the cinema began showing men and women wholly naked, a comedian, Groucho Marx, explained the significance of nudity found in a Broadway musical. He said that he had saved the price of admission by staying at home and disrobing before a mirror. After all, what is more commonplace than the human body? Similarly, when Manet modernized Titian's *Venus of Urbino*, turning her into a demimonde courtesan, he said nothing obscure. The capitalist equivalent of Venus was the whore. Aphrodite's life-force had become a kind of merchandise, her ease was matched by promiscuity's detachment.

The ideal of pure painting was itself connected with this desire to attain objectivity. When a painter takes as his task the recreation of prosaic reality unadorned by higher purposes, he is saying that disclosure of the apparent is the point of art. But the technique also tended to reinforce a taste for overtness in *every* aspect of Manet's art. One consequence of his orientation was that it made the work of painting into an exercise in managing subtle contrasts. All of Manet's virtuosity is centered on neutralities, on the play of lights and darks and shades between. His figures, the landscapes behind them, the world in which they stand, are all made of the same infinitely nuanced substance, light, the transitory flickering substance of the phenomenal world. Such paintings are not representa-

famous essay the author makes of this single tradition a general law that "explains" the history of all painting since Tintoretto. He holds, more or less, that the inspiration for artistic images has moved from the object to its visual medium, light, from there to the artist's retina, and finally to the interior of the mind itself.

tions of the known world, with spatial and tactile components, so much as they are descriptions of the artist's retina. Since the human eye merely picks up reflections of varying intensities and has no ready-made spatial geometry built into it—perspective being a mathematical approximation of the way we see with one eye closed[5]—a further consequence of the style was its tendency towards flatness. Manet compensated for the poverty of volume with his facility in handling the tonalities of three centuries of oil painting.

The creation of the *Olympia* established Manet as the unwitting founder of modern art[6] by turning classical weaknesses into formal strengths. In this work volumes were not ignored, they were deliberately suppressed. The flat, tangible surface of the canvas was emphasized by having the nude, her bed, and the maid's clothing all comprised within one gigantic pale silhouette that has some of the impact of a poster. As Venturi has said:

> There is no transition from light to dark, no chiaroscuro. Because chiaroscuro attenuates the brilliance and the purity of colors, its absence means that the color becomes rich even when it is not intense. Every element depends on this general effect, which is achieved by presenting zones of colors so consistent and powerful that their plasticity is accentuated in spite of the lightness of their relief.[7]

Too, Manet's technique of copying visible nuances in terms of little brushstrokes reduced the heterogeneity of reality down into the homogeneous texture of paint. Pictures *are* flat and not three-dimensional; an oil painting is composed of pigment and canvas, not flesh, silk, and satin. And when an artist stresses such facts he is Revealing the Obvious in somewhat the same way that he does when he shows us that his model is just a woman and not a living statue. But in doing that he has done far more besides; he has insisted on the *autonomy of the picture* as a thing independent of the external world. To have done that, of course, was to have acted as the herald of the future.

By the time of the Second Impressionist Exhibition at Durand-Ruel's in 1876 young painters considered Manet the spearhead of a movement.

[5] See William M. Ivins, Jr., *Art and Geometry, A Study in Space Intuitions*, p. 41 and Rudolf Arnheim, *Art and Visual Perception* (Berkeley, 1954), pp. 88–116.

[6] Cf. Lionello Venturi, *Four Steps Toward Modern Art* (New York, 1955), p. 52.

[7] Venturi, p. 53.

But also, by then, the criteria for fidelity in the depiction of the world of
light had become much more exacting, the paintings much more fluid, and
the representations of objects much more adumbrate. By then, the work
of the Impressionists could be seen as either photographic (insofar as it
attempted to render concrete the fleeting medium of vision) or unreal
(insofar as its methods tended to avoid the establishment of spatial refer-
ents and to discount the evident content of classicist and romantic art).
To the vast majority of the public it was fantastic, or worse, meaningless.
It was not, of course, meaningless.

The nature and disposition of Impressionism depended, finally, upon
the personalities of its creators, and those personalities depended in turn,
upon their milieu, for no man stands outside his times no matter how ada-
mantly he stands against them. It would be informative to analyze the
movement in terms of the personalities of Manet, Degas, Monet, Renoir,
Pissarro, Sisley, and the others because even though they share Impres-
sionism they are so differentiated by social stratifications that one is struck
by their individuality. To satisfy brevity, however, the movement must
be analyzed here in terms of its stylistic attributes, despite all of the dan-
gers of caricature and misrepresentation inherent in such a procedure. But
the reader should know the risk.

Actually, Impressionism is not a style at all—at least not in the thor-
oughgoing sense that more recent and programmatic schools of painting
are. It is far easier to see the cardinal elements among Suprematists, Sur-
realists, or Abstract Expressionists than to see what is common to the
works exhibited together in 1876. Sometimes Impressionism seems to be
only an arbitrary segment in a continuous range; it is more flecked than
Corot and less bounded than van Gogh. But it is special, nonetheless.
What all of the Impressionist shared at some time, in some fashion, was
not so much a style as an outlook, a radically empirical *Weltanschauung*
which incorporated into art the informal, unregulated vision of the
moment.

The whole point of view of Impressionism, which took pure paint-
ing as one ideal, implied a passive acceptance of data. The artists some-
times talked as though they were highly sensitive recorders and little else;
they registered color impressions and transferred them to canvas. Thus,
Claude Monet, the most representative of the Impressionists, once said in
an interview, "Try to forget what objects you have before you. . . .
Merely think, here is a little square of blue, here an oblong of pink, here a

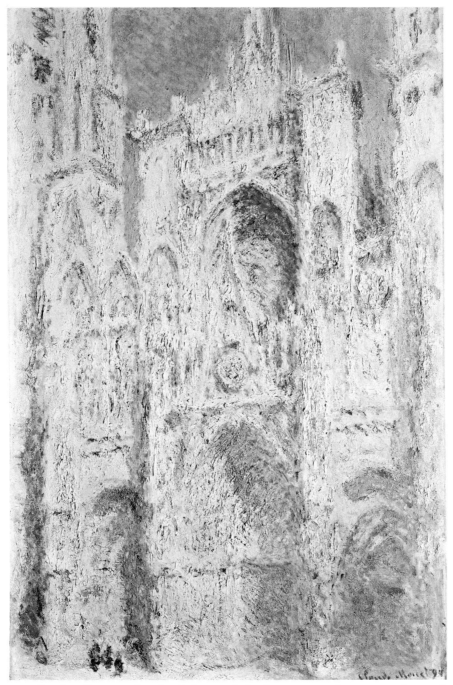

streak of yellow, and paint it just as it looks to you, the exact color and shape, until it gives your naive impression of the scene. . . ."[8]

Monet's picture of *Rouen Cathedral* (Fig. 3) provides a proof of the passivity associated with the Impressionist method he described. In this

[8] Quoted by Lilla Cabot Perry in "An Interview with Monet," *The American Magazine of Art*, 18, no. 5 (March, 1927): 120.

painting, the lavender shadows of the cathedral's great portal are shot with oranges, reds, and blues. Are these curious "induced" colors put there to heighten the sense of fantasy or religiosity? By no means. They are instances of the optical phenomenon called "simultaneous contrast," the tendency to see in a color the fugitive complements of an adjacent hue.[9] This is an effect everyone has experienced when concentrating his gaze on bright shadows during a sunlit day. (Laymen tend, however, to be more *aware* of a related phenomenon called "successive contrast" in which one's eye retains a color impression in the form of its complement. For example, when we have stared for some time at a green dot and then turn to look at a white one the latter will at first seem red. Some contemporary "Op" artists have made use of this effect to create paintings that are entirely fugitive.) But when a traditional painter had looked long and hard at a green vase and began to see red or violet spots afloat on it he abstracted them and left them out of the final work; he knew that they were not "real." The Impressionist, feeling that the optical sensation of the moment *is* the structure of visible reality, searched out such contrasts to make the atmosphere live and the whole surface of the painting function chromatically.

That was not the same thing as breaking light and its reflections down "into a dazzle of spectrum colors."[10] Although the Impressionists worked with vivid little strokes of pure color their pictures were not brightly colored. At first the paintings had been rather tonal, grays enlivened and made scintillant with piquant little touches of vermilion, yellow, green, or blue. Until the end they exhibited something of this character except that later, as in Monet, the grays were the result of a close interweaving of colors instead of mixing them on the palette. Local colors of objects became lost in a gauze of light modulations, in the myriad tiny marks that composed the pictures. Areas were never violet, instead, they were "violescent." Finally, the paintings became shimmering phantoms of encrusted pigment.

It would be difficult to exaggerate the apparent perversity of the Impressionist method. For, while it represented no more than a logical extension of Velasquez, it entailed the overt acceptance of effects that had been explicitly proscribed by every authority on either art or optics. The

[9] See Herman von Helmholtz, *Treatise on Physiological Optics*, ed. James Southall (New York, 1925), Vol. 3, pp. 269–71.

[10] Sam Hunter, *Modern French Painting* (New York, 1956), p. 60.

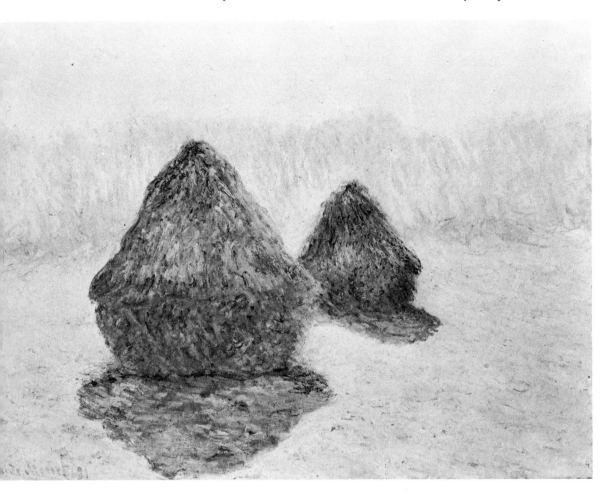

contemporary physiologist Herman von Helmholtz noted that "not every illumination is suitable for representing a landscape."[11] His studies imply that painters should not light objects from behind since that would cause the thing depicted to appear flat, surrounded by a nimbus of light, and continuous with its own shade. Moreover, the artist's vision would be impaired by *mouches volantes* and fugitive sensations dancing within the silhouette of the form. In his haystack pictures (Fig. 4) Monet did exactly what he was supposed not to, and with precisely the results Helmholtz predicted. That was what he *wanted* to have happen. Monet did not discover such phenomena; they were well known. Impressionism simply made them part of an aesthetic currency. In doing so, it asserted the primacy of sensation over knowledge, a thing that no serious art had ever done

[11] Helmholtz, p. 292.

before. And what made this assertion all the more disconcerting to traditionalists was the extreme specialization of Impressionist vision. Helmholtz himself had commented on the difficulty some people have in seeing fugitive effects:

> Even the after-images of bright objects are not perceived by most persons at first except under particularly favourable external conditions. It takes much more practice to see the fainter kinds of after-images. A common experience, illustrative of this sort of thing, is for a person who has some ocular trouble that impairs his vision to become suddenly aware of the so-called *mouches volantes* in his visual field, although the causes of this phenomenon have been there in the vitreous humor all his life. Yet now he will be firmly persuaded that the corpuscles have developed as the result of his ocular ailment, although the truth simply is that, owing to his ailment, the patient has been paying more attention to visual phenomena.[12]

The unpracticed public saw in Impressionism only quivering blobs of color and a tapestry of heavy brushwork that reduced all shapes to mergent areas, making transitory all that ought be permanent. The Impressionists, examining one another's works, perceived them as refreshingly accurate recordings of visual reality. The cliché about the beholder's eye was never more true than in this context.

Still, the Impressionist painter was not a human camera which, set up and given certain conditions of light and atmosphere, produced a work of art. In *Rouen Cathedral* one sees what Monet saw at one-hundred and twenty or one-hundred and thirty feet, but one sees what Monet *did* at arm's length—two quite different things. Speaking of the picture George Moore, the English writer, remarked, "Monet's handicraft has grown like a weed; it now overtops and chokes the idea; it seems to exist by itself . . . independent of support. . . . The quality of paint in Monet is that of stone and mortar." Each stroke was, first, a notation of a single nuance and thereby became the unit of visual operation, the thing that ultimately constituted the pictorial image, the element beyond which the picture could not be reduced. Thus, the artist's touch became itself a source of delight and enjoyment. Renoir, when asked at what distance an Impressionist picture should be viewed—the assumption being that the strokes should merge—answered that one should hold such a picture at arm's length and

[12] Helmholtz, p. 6.

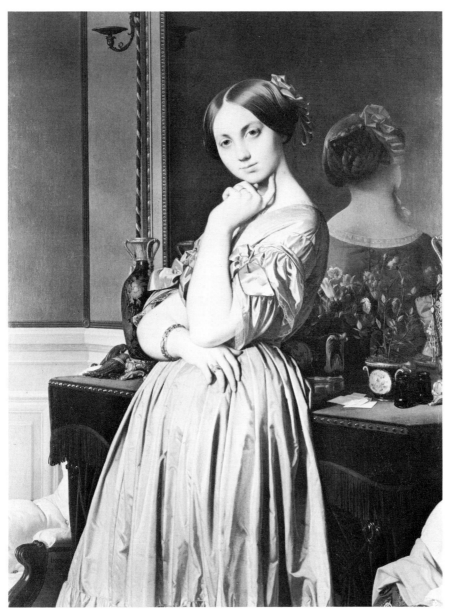

read it like a book.[13] The personal decisions of the artists were manifest in painting that exposed its anatomy so candidly. Such frankness entailed an attitude entirely different from that of Ingres (Fig. 5), who wished the final creation to seem a magical occurrence produced by a master necromancer. Monet and Renoir wanted it known that they were prestidigitators.

Similarly, willingness on the parts of these painters to accept and

[13] George Moore, *Modern Painting* (London: Walter Scott, 1900) p. 248. Renoir is quoted in Ambroise Vollard, *Renoir, an Intimate Record*, trans. H. L. Van Doren and R. T. Weaver (New York, 1934), p. 25.

make evident the two dimensionality of the canvas surface resulted from their habit of viewing the world as a phenomenal screen behind which the volumes of objects existed coincidentally, as if in some Kantian meta-physic. But then, visual data *is* empty of space. The person who chooses can determine this for himself by simply testing Helmholtz's proposition that in a world seen upside down colors tend to be seen divorced from their capital functions:

> In the usual mode of observation all we try to do is to judge cor-rectly the objects as such. We know that at a certain distance green surfaces appear a little different in hue. We get into the habit of overlooking this difference, and learn to identify the altered green of distant meadows with the corresponding colour of nearer ob-jects. . . . But the instant we take an unusual position and look at the landscape with the head under one arm, let us say, or between the legs, it all appears like a flat picture. . . . At the same time the colours lose their associations also with near or far objects, and confront us now purely in their own peculiar differences. . . . This whole differ-ence seems to me to be due to the fact that the colours have ceased to be distinctive signs of objects for us, and are considered merely as being different sensations.[14]

Of course, the Impressionists neither took such curious positions nor suf-fered from a common defect of vision. To paint nature in their way was a deliberate act of will. The objective of the act, when realized in paint, was deliberately to blur the distinctions of far and near so as to enchant the viewer with a display of tiny modulations and surface richnesses.

Late in his life, after 1900, Monet painted a miraculous series of paint-ings which, in its choice of theme and its manner of rendering, charac-terizes the Impressionist preference for surface effect. In these pictures of ponds and pools (Fig. 6) he concentrated on a small, select portion of space, eliminating entirely the horizon and looking down on things. His objects of interest—the reflections and the water lilies—were themselves floating things, things that existed on a surface to begin with. This limited universe reflected clouds and burst with sunlight. Such a theme offered a truly phenomenalistic realm to explore and re-create in pigment. The idea of the reflection recurs again and again in the works of the men connected with Impressionism; even so atypical a member of the group as Edgar Degas was fascinated by the mirrors in the *foyers de danse*. Reflecting

[14] Helmholtz, pp. 8–9.

6. Claude Monet, *Waterlilies*, c. 1920. 6′ 6½″ x 19′ 7½″. Courtesy of The Museum of Modern Art, New York. Mrs. Simon Guggenheim Fund.

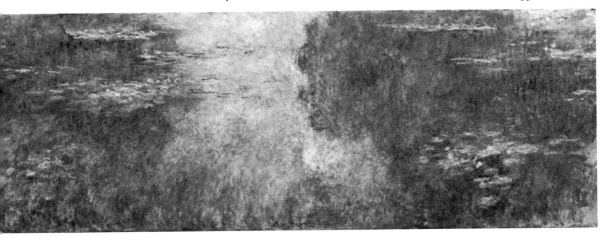

planes exemplify the preference among these painters for the embellished but unbroken surface.

Along with the Impressionist preference for the sensational, momentarily given world of vision over the fixed, intellectual world of matter there went hand in hand a desire for variability and fragmentation. Every work was a visual spectacle, a reproduction of some space singled out by a solitary, moving observer. Each painting is like an elaborate, random snapshot, full of partial forms and arbitrary segmentations.

Yet, the pictures had to "hold together," had to have order. It could not be an order derived from traditional schemes which would impose a rigid paradigm upon the impressions and hinder spontaneity. Perspective, for example, is a technique of ordering space formally and is determined by laws external to the individual. It requires certain kinds of positions, proportions, and a particular range of hue warmth and coolness. Perspective substitutes for intuition and sensation the mathematics of central projection. For that reason, Impressionist perspective is always empirical and theoretically "wrong," even in the work of a man like Degas who was actively interested in perspective drawing; the orthoganals have no common vanishing point and proportions are not in strict accord with the principles of central projection. For the same reason, compositional armatures such as the "great triangle" of the Renaissance had small prestige or place among the majority of Impressionists. Their style depended upon a sense of liberation from such preconceived, restrictive patterns; its very strength resided in what was called its "horror of composition."

In painting which pretended to be a reconstitution of multiple im-

17

7. Different modes of orderliness achieved with identical elements.

A.

pressions and which used the stroke as the unit of visual operation, any order that could have been achieved with consistency had to be dependent on things constant to small elements. And the kind of orderliness most commonly associated with minutiae is statistical. Out of an immediate need, then, rather than from any theoretical requirement, Impressionists began to employ what I would call a "probability principle of pictorial order."

The function of such a principle in the fine arts, and its difference from the schematic principles of ordering, is most clearly observed if put graphically. In Figure 7 the same amount of space has been articulated in two distinct ways. Given white area *y* and *x* number of gray and black rectangles, one can obtain order *A*, which is absolutely predictable and

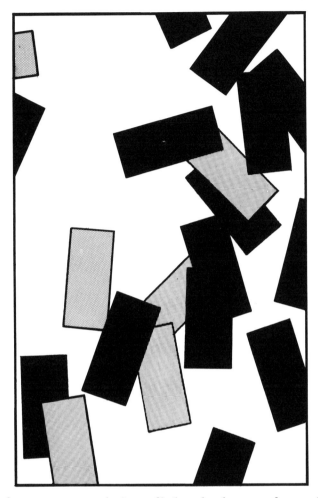

B.

certain before any rectangle is applied and whose perfect order can be disturbed by the introduction or elimination of a single form. On the other hand, given the same area and same number of gray and black rectangles, one can achieve order *B*, which is intuitively random. Of *B* it can be said only that there was a certain probability of achieving order within the given conditions. The forte of the Impressionists was their ability to select random sequences of the latter kind, sequences whose probability of satisfying spectators was high. The selection of such sequences avoided the haphazard dictates of undiluted impulse that would have otherwise followed from the phenomenal precepts of pure painting. The pictures were deliberately contrived coincidences of the separate accidents of the moving brush.

In this connection, it is enlightening to study Pissarro's view of Paris from a window (Fig. 8). The human population is reduced to brushstrokes, scattered, like an urban crowd, as undifferentiated as the homogeneous mass of a modern city. Each stroke has its own freedom of mobility, its own power of possibly being elsewhere. The brushstrokes seem to approximate the conditions of the urban dweller's freedom as an individual in an undifferentiated whole.

The metaphorical comparison of strokes with members of a crowd indicates that Impressionism is not, for all its interest in fabrication, the result of introducing arbitrary themes into the art of painting. There seems to be an association of style and theme in all paintings, inevitably, under any circumstance. Surely they are married in Impressionism. Can anyone imagine an Impressionist madonna of any significance? Is it possible to conceive of the style containing elements of desperation and profound urgency? Hardly. The movement entailed a taste for objects of pleasure and a passive attitude towards things. It was purely spectatorial, and whatever it consciously held could be directly conveyed and was unproblematical. Impressionism amounted to the creation of an ideal realm of happiness and enjoyment by spectators uncommitted to the world of action. Impressionists painted flowers, cafe scenes, lush still lifes, landscapes, and scenes of crowds in which everyone was in a state of random motion but as an individual was in a scheme of general association and harmony. Their paintings reflect the values of a people devoted to the discovery of enjoyable moments and instances of casual aesthetic content.

For instance, between the Impressionists and their immediate predecessors, Millet and the Barbizon school, there was an astonishing difference in attitude towards the rural landscape. For the Barbizon the countryside was a field of pastoral activity, containing working mills, livestock, and noble peasants. For a painter like Monet it was a scenic spectacle. His image of a sunset had no room for cattle homeward bound with udders full. It had nothing to do with the rural concept of the end of day; instead, the sunset afforded an overt opportunity for contemplation of shifting colors; it was an interstice between a vacation outing and the activity of the night. What went on in the landscape and in the theater or cafe were regarded as more-or-less equivalent. The attitude underlying Impressionism was one which conceived of the entire world as a vast artist's studio and the artist as its certified interpreter.

The Impressionists' newfound freedom was identical in type with

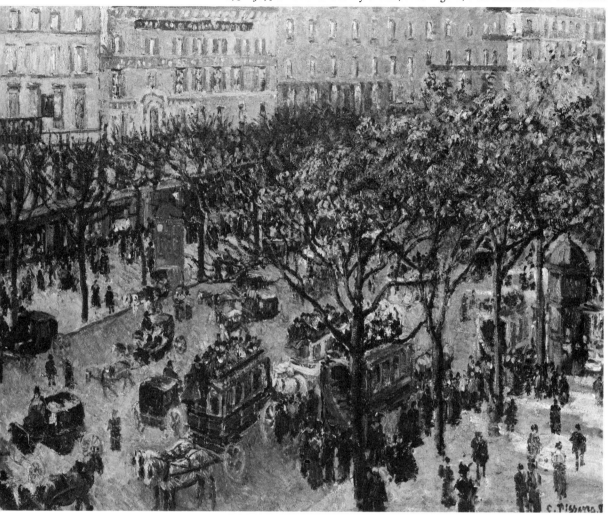

the specialized liberty of the intimate evinced by the cultivated bour-
geoisie in his domestic environment where the selection of a wine was
relished above all as a free choice uncompromised by the *maitre d'hôtel*,
in which, on a less trifling plane, the whole of literature was left available
for personal delectation and no impersonal prescript imposed upon one's
tastes. In an extraordinary essay written many years ago Meyer Schapiro
devoted incidental attention to the subject. In speaking of a "moral as-
pect" of early Impressionism, he said:

> In its unconventionalized, unregulated vision, in its discovery of a
> constantly changing outdoor world of which the shapes depended

on the momentary position of the casual or mobile spectator, there was an implicit criticism of symbolic and domestic formalities, or at least a norm opposed to these. . . . In enjoying realistic pictures of his surroundings as a spectacle of traffic and changing atmospheres, the cultivated rentier was experiencing in its phenomenal aspect that mobility of the environment, the market and of the industry to which he owed his income and his freedom. And in the new Impressionist techniques which break things up into finely discriminated vision, he found in a degree hitherto unknown in art, conditions of sensibility closely related to those of the urban promenade and the refined consumer of luxury goods.[15]

While fastidiously opposing the norms of the philistine middle classes from which they came[16] the Impressionists became, willy nilly, the champions of that very bourgeois culture which aspired to sensibility and refinement. That is borne out by the fact that before 1900 the Impressionist attitude had become the very model of middle-class sensibility and every member of the school still living after 1886 died a relatively successful painter in the public view. Because of its thoroughgoing commitments to the aesthetic and technical sides of art and because of its preoccupation with freedom and mobility, Impressionism is a style that is in the spirit of its times.

Its social appositeness is what has made seem so unlikely every attempt to link Impressionism to the scientific thought of its day. Not that there have been no attempts. On the contrary. Inspired by Monet's practice of painting as many as thirty "impressions" of the same scene, any number of critics have interpreted Impressionism as a doctrinaire application of the optical psychologies of Helmholtz, Rood, or Chevreul.[17] During the earlier part of our century, especially, it was fashionable to disregard the thematic features of the style and think of it as an exclusively mimetic art which sacrificed subject-matter to scientific observation. Even Monet's close friend Georges Clemenceau described him as a laboratory technician: "He stands before a light, he takes that light, breaks it into its component parts, puts it together again. From the point of view of

[15] Meyer Schapiro, "The Nature of Abstract Art," *Marxist Quarterly*, 1, no. 1 (Jan.–Mar., 1937): 83.

[16] Cf. William Gaunt, *The Aesthetic Adventure* (London, 1945), pp. 63–64.

[17] For example, see P. Francastel, *L'Impressionnisme—Les origines de la peinture moderne, de Monet à Gauguin* (Paris, 1937).

science nothing is more interesting."[18] And, so far as subject matter goes:

> Once I said to him, "Monet, the rest of us fools, seeing a field or a sky, think 'This is a field and that's a sky'; but for you that's not so . . . for wherever your glance happens to fall you must wonder not 'What is that?' nor even 'What colour is that?' but 'Of what are those spots composed?' I should think your wits would be turned by that sort of thing." He answered, "You can't have any idea to what extent what you've just been saying is true. One day I was at the deathbed of a woman I had dearly loved, whom I still love dearly. I looked at her temples and said to myself, 'There is a kind of violet there—what is there in it of blue? of red? of yellow?' "[19]

In his 1929 monograph, *Claude Monet, Les Nymphés*, Clemenceau made the claim that Impressionism was, in principle at least, dependent upon electromagnetic theory!

Arguments of the last type, holding that the Impressionist technique was developed in response to discoveries in physics and chemistry have been made by many writers. And it must be admitted that some of them are perfectly commonsensical. There can be little doubt, for example, that the invention of new chemical pigments furnished painters with a new and powerful range of hues. Zinc white, chrome green, and cobalt blue came into existence about 1800, and between 1826 and 1861 artificial ultramarine blue, cadmium yellow, mauve, cobalt yellow, and magenta appeared.[20] Moreover, in 1841 artists' colors began to be sold in tin tubes and became, thereby, easily transportable into the field.[21] Without all these, Monet's series of plein air haystacks would be impossible to imagine.

As for the relationship between Impressionism and scientific theories, it is quite easy to prove that the artists of the movement did buy and read scientific papers and that some scientists—Chevreul and Helmholtz, for example—were interested in contributing to art. On the other hand, Impressionism was immune to many of the insights held out to readers of those studies. Thus, while the painters incorporated into their art fugitive or "ghost" sensations, they ignored all sorts of more prominent ocular phenomena, such as the blind spot.

[18] Quoted in Jean Martet, *Georges Clemenceau*, trans. Milton Waldman (London, 1930), p. 203.
[19] Quoted in Martet, pp. 203–4.
[20] Cf. John Ives Sewall, *A History of Western Art* (New York, 1961), p. 859.
[21] See Maurice Grosser, *The Painter's Eye* (New York, 1951), p. 72.

Curiously, at least one scientific invention of the nineteenth century has often been made to appear the antagonist of modern art when it was, in fact, an inspiration to it. Photography, which married the principles of the ancient *camera obscura* to modern chemistry, directly influenced Manet and Degas. The former actually devised his famous etching of Baudelaire from a photograph by Nadar. Baudelaire had called modernity "the transitory, the fugitive, the contingent half of art."[22] To represent it was a leading concern of the age, and what, after all, could be more up-to-date than a picture taken by a camera? Moreover, it is entirely possible that the granular tonalities of the early plates suggested to painters new ways of looking at the play of light within a picture. Finally, it has been pointed out repeatedly that certain mannerisms appearing in Impressionist compositions, particularly those of Degas, are characteristic of photography. Brutal interruptions of figures by the canvas edge, objects and parts of objects and people looming in foreground positions, and abrupt foreshortening "might have arisen from purely pictorial considerations. But photography acted as a catalyst. It brought justification to the painter's bold innovations. . . ."[23]

The fact remains that, while new pigments, optical theories, and the invention of photography may have been necessary to the character of Impressionism, they are all quite ancillary to its cultural significance. Given all those colors and every study of optics and a camera with plates, Bronzini still would not have created an Impressionism. Neither could Galileo, presented with the dynamo, have come up with Maxwell's theory of electromagnetic induction. Historically, at least, the school of painting and the electromagnetic theory are coincident. In fact they are related.

It would be as much a mistake to disregard the relationship between Impressionism and scientific thought as it is to suppose that the former is but a department of the latter. The relationship that does obtain—though indirect—is useful to consider if only because it points up so well the true dynamics of interchange among the arts and sciences. When avant-garde art and new ideas in science do show a genuine connection it is almost never more intimate than a sort of cousinship. Still, in the study of culture, as in genealogy, family resemblances play an important role.

When the Realists and Impressionists took as their task the recreation

[22] Charles Baudelaire, *Curiosités esthétiques, Œuvres*, (Paris, 1868), p. 884.
[23] Pierre Schneider, "The Many-Sided M. Nadar," *Art News Annual* (New York, 1956), p. 71.

of prosaic reality unadorned by higher purposes, they were saying that disclosure of the apparent is the point of art. In literature, Balzac, Flaubert, and Zola attempted something quite similar. To that extent they are first cousins to the painters. And Auguste Comte had acted in the role of paterfamilias when he so defined the limits of knowledge as to exclude speculative philosophy. But, of course, Comte was presaged by Kant.

Immanuel Kant's *Critique of Pure Reason*, published in 1781, foreshadows the whole of nineteenth-century thought; even those unaware of its existence seemed destined to become its partisans on history's behalf. For it presented philosophy with an inescapable dichotomy—the distinction between *phenomena* and *noumena*. Kant's one unquestionable achievement was to have shown, for once and all, that the external world can be known to us only as sensation and that sensation itself is resident in the structure of the perceiver. Otherwise, he asked, "How should our faculty for knowing be awakened into action if the objects affecting our senses did not partly of themselves produce images. . . ?"[24] In experiencing roughness or smoothness we know only what our bodies themselves feel; in sweetness nothing but what our taste buds convey about the chemical constituencies of various substances. "Sensation" refers, therefore, not to the nature of objects external to us but, rather, to internal responses provoked by our contact with those objects. In this regard, objective knowledge of the external world is impossible. Helmholtz, the physiologist, merely rephrased the philosopher when he wrote:

> There is no sense in asking whether vermilion as we see it, is really red, or whether this is simply an illusion of the senses. The sensation of red is the normal reaction of normally formed eyes to light reflected from vermilion. A person who is red-blind will see vermilion as black or a dark grey-yellow. This too is the correct reaction for an eye formed in the special way his is. All he has to know is that his eye is simply formed differently from that of other persons. In itself the one sensation is not more correct and not more false than the other, although those who call this substance red are in the large majority.[25]

Kant would have called the sensation "phenomenal" and would have

[24] Immanuel Kant, *Critique of Pure Reason* (in *The Philosophy of Kant*, ed. Carl J. Friedrich, New York, 1949), p. 24.
[25] Helmholtz, pp. 21–22.

termed the true, nonsensational nature of vermilion noumena or *Das Ding an Sich* (the-thing-in-itself) which lay beyond human experience.

While knowledge of phenomena is empirical and necessarily a posteriori, Kant hastened to point out that other kinds of knowledge are a priori, that is, "knowledge absolutely independent of all experience."[26] "All ties that are red are also colored," is verifiable a priori simply because the subject embodies the predicate. The same sentence, written in Swedish or Chinese, would be incomprehensible to me, but to anyone who can read it the thought expressed is indisputable. It is what logicians call an "analytic" statement; it can be confirmed or disproved on the basis of its contents alone. A statement such as "All ties that are red are also made of cotton," is quite different since it depends for verification upon an appeal to experience.

Every philosopher before him—especially Leibniz, who was an expert in the matter—had held that a priori judgments could involve only analytic statements and that a posteriori judgments were cast in the grammar of synthetic ones. Kant, however, believed also in the existence of a priori synthetic judgments; indeed, to demonstrate their existence is the whole point of the *Critique of Pure Reason*. He wrote: "That the straight line between two points in the shortest is a synthetic proposition. For my concept of *straight* contains nothing of quantity, but only of quality."[27] Natural science, he continued, contains such judgments as principles and it should be the business of metaphysics, "even if we look upon it as having hitherto failed in all its endeavors," to "extend our *a priori* knowledge," and should consist "at least in *intention*, entirely of *a priori* synthetic propositions."[28]

Kant's identification of the laws of reality with the rules governing human thought opened up an entire universe of transcendent possibilities for imaginative successors like Hegel, who abandoned the-thing-in-itself and built logical fantasies from purest speculation. Yet, despite its influence, Kant's proofs for the existence of a synthetic a priori lacked the cogency of his first step, the distinction of phenomena from the-thing-in-itself. "Kant's inconsistencies," said Bertrand Russell, "were such as to make it inevitable that philosophers influenced by him should develop

[26] Kant, p. 25.

[27] Kant, p. 34. As will be shown, however, the development of non-Euclidean geometry completely undercut Kant's premise.

[28] Kant, pp. 35–36.

rapidly either in the empirical or in the absolutist direction."[29] Hegel had done the second, Auguste Comte the first.

His philosophy, for which Comte invented the term "Positivism" as a description, took as its first precept the impossibility of knowing anything at all except through sensation or the discovery of analytic relations. This went far beyond the skepticism of Kant for whom it was still possible to speak of things-in-themselves as meaningful even though they lay beyond the realms of ordinary perception or scientific understanding. Comte simply would not accept as meaningful any statement that could not, at least in principle, be verified by the methods of empirical science. His attitude towards science, therefore, was positive where Kant's had been critical. Kant had been hostile to "speculative metaphysics"; Comte rejected metaphysics altogether. The model for cognition in Comte's approach to life was science and he employed it "flatly and explicitly as an ideological tool for destroying all unscientific modes of thought,"[30] rejecting the propositions of traditional theology and metaphysics simply on the ground that they were unscientific. Of course, if religion were purified of its illusions by Positivism it might become edifying in a rational way. To make this clear Comte went on to create an entire Positivist Religion and even appointed "apostles" to preach the doctrine. But such ambivalences need not detain us here. What is important is the whole-hearted acceptance of science as a model of cognition.

It may seem that nothing more is involved than an increasing reputation for science. After all, the effects of its methods were not nearly so evident when Kant was writing as they were a half-century later, in 1831, when Comte's first volume appeared. Actually, a great deal more is involved. For the prestige of scientific values among the intelligentsia has far more to do with social norms than it has to do with intellectual content.

During the late nineteenth century Positivism in philosophy, as well as Realism and Impressionism in painting and Naturalism in literature, were recognized corollaries of political democracy. And they were so identified by both the right wing and the left. It was not only Proudhon, Champfleury, and Zola who made claims parallel to Courbet's famous one of being a socialist, a democrat, and a republican, "in a word, a partisan of revolution and, above all, a realist, that is, the sincere friend of the real

[29] Bertrand Russell, *A History of Western Philosophy* (New York, 1945), p. 718.
[30] Henry D. Aiken, *The Age of Ideology* (New York, 1956), p. 117.

truth," but conservatives like Gustave Planche also admitted that resisting naturalism was equivalent to supporting the prevailing order and rejecting materialism and democratic rule.[31] What tied all of those "evils" together was, of course, the radical empiricism that was common to them all. It is no accident that Comte invented the term "sociology," that Zola led the fight to save Dreyfus, or that Impressionism opposed itself to a style of vision that was, quite literally, official. Invariably, it was the opponent of the status quo who held onto the ideal of utter empirical objectivity.

Kant's system had preserved the orderliness and hierarchical nature of traditional philosophy. In that regard he was conservative. His preservation of the spirit, if not the letter, of old-fashioned moral philosophy corresponded to the attempts of the European middle classes to sustain the elitist social structure that gave their ambition meaning while at the same time they made nonsense of its medieval forms with a brutally realistic ethic that judged all men by material accomplishment.

It was perfectly obvious to everyone that basing judgments on hard evidence could throw into question every notion of political and moral stability. A conservative, Ernest Renan, who granted the "scientific" idea that everything in the world is frivolous and without genuine foundation, asked "who knows whether truth is not sad," expressing for all time the dreadful skepticism which lies at the root of bourgeois life. The whole program of Impressionism was, in a sense, directed against the fear of uninterpreted evidence. Its exponents not only accepted the consequences of taking things at face value, they relished the discovery of new values on the surface of nature.

Renan stood in relation to Comte as Manet's teacher Couture (Fig. 9) stood in relation to his pupil. Couture detested the academy and opposed its methods with his own. But he was a *juste milieu* artist, an orthodox heretic who could not surrender lofty ideals to a mere Realism made up of trifling commonplaces.

> For . . . the *juste milieu* group—painters striving to conciliate avant-garde and conservative tendencies—compromise was a source of painful confusion. . . . Less confident than, for example, Delacroix or Courbet, they nervously sought a style capable of reconciling their longing for traditional forms with their anxiety to be modern.[32]

[31] See Émile Bouvier, *La Bataille réaliste* (Paris, 1913), p. 248.
[32] Albert Boime, "Thomas Couture and the Evolution of Painting in Nineteenth-Century France," *The Art Bulletin*, 51, no. 1 (March, 1969): 48.

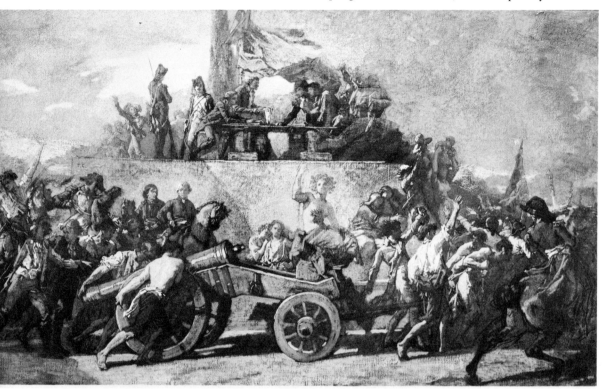

But traditional forms, being social and aesthetic holdovers from the middle ages, did not suit the character of the modern world. Those forms were the recognized antagonists of reality even where defended best; that they disguised the ugliness of mundane existence was made their principal justification.

The obvious antidote to aristocratic hauteur and bourgeois hypocrisy lay in absolute candor, in a passionate and unquestioning acceptance of overtness. That this attitude was in harmony with the superficial habits of informality and fastidiousness cultivated by the boulevardier disturbed the avant-garde no more than overblown pretentiousness unsettled academicians. Where Classicism was supported by Platonic Idealism and reinforced by Hegel, the new view saw its champion in the scientific method.

Comte had attempted to apply what he knew of physical science to the study of man in society.[33] The prestige of his attempt was immensely enhanced by *Origin of Species* (1859) which showed that the destinies

[33] See Auguste Comte, *Positive Philosophy*, trans. and ed. Harriet Martineau (London, 1853), 2 vols.

of living organisms could be explained by the same systematic causality that accounted for the changes and patterns of inorganic nature. Darwin resolved what had seemed, since the time of Aristotle, an intrinsic difference between living things and inert matter. His achievement seemed to confirm the correctness of Positivism and its literary offspring.

That the literary realists—the Naturalists—had Comte in mind is quite evident. We find Balzac, a pioneer of the genre, paying homage to the Positivists in his 1842 preface to *La Comédie humaine* where he attempts to vindicate the coarseness of his characters by saying that he is a student of "social species." The claim is echoed over and over again by novelists in the naturalist tradition. Even Gustave Flaubert, who would never have admitted to being a realist, believed that art had reached a "positivistic" stage. His major opus became the bible of the Naturalists.

Madame Bovary was published in 1856, the year Edouard Manet left the studio of Couture to work independently. And the parallels between it and the Impressionism yet to come are really quite striking.

Like Manet and Monet, Flaubert avoided extremes and preferred to deal in minute distinctions. In molding his characters he did not judge them good or bad; he refused to let any moral theses or apparent sympathies intervene in his rendition of the facts of the case, and he tried to convey those facts as directly as possible. The reader is "offered sensations instead of sentiments."[34] The creation of such a confrontative narrative requires a concern for nuances, for the finely discriminated sensations and shades of meaning that go to make up individual scenes. Hence, the functions of the single word, the phrase, the sentence, the units of operation in writing, took on a more concrete, exact, and evident character than they had ever had before. There is nothing surprising in Flaubert's interminable search for the "mot juste," the unique and absolutely correct word to signify a specific sensation. His use of words was exactly like an Impressionist's use of tones and brushstrokes, except that he was incomparably more scrupulous about it. In 1866 he wrote one page a day, then twenty in thirty days, then two in a week.[35]

In view of his conscientiousness about individual words, it is of some interest to note that Flaubert seems to have little regard for the "person" assumed by the narrator of *Madame Bovary*. The narration is inconsistent

[34] Harry Levin, "—But Unhappy Emma Still Exists," *The New York Times Book Review*, April 14, 1957, p. 4.

[35] See Francis Steegmuller, *Flaubert and Madam Bovary: A Double Portrait* (New York, 1939), p. 142.

in this regard. The first line of the novel reads: "We were in class when the head master came in. . . ."[36] For several more pages the narrator runs on in first person plural. Shortly, he becomes an omniscient, saying things like, "Madame Bovary noticed that many ladies had not put their gloves in their glasses,"[37] and continues on as such except when, now and again, he turns into a nameless spectator, observing a scene from behind bushes or up a riding path. The spectator or narrator, though, no matter what his "person," is always uncommitted and completely indifferent. For instance, consider the remark about the gloves in the wineglasses. The narrator seldom or never comments on the meaning of his observations and, even in 1856, many readers were unable to interpret the meaning of the story. As it happens, in respectable provincial society a hundred years ago a woman who was comme il faut never drank wine, but the custom was ignored by the more advanced court society, several members of which are at the party Madame Bovary is attending. "Flaubert is telling us, even though glamorous to the provincial Emma, the party was in itself provincial."[38] Even in such small matters as this Flaubert strived for something very much like pure painting; he dedicated himself to grasping the world as a series of contiguous observations without the intervention of ideas or feelings about the represented events. His narrator is comparable to the mobile spectator of Impressionism, able to choose sites and viewpoints at will, depending on the sensational effect desired.

It was Emile Zola, of course, who carried out the literary program called Naturalism. It was he who proclaimed in his *Le Roman expérimental* that "a like determination will govern the stones of the roadway and the brain of man." In every respect he considered art a servant of science. Flaubert also believed in the merit of scientific exactitude, and he was at pains to stress the scientific-medical aspect of his investigation of Emma Bovary's sad fate. But he considered himself an artist above all, just as the Impressionists considered themselves artists. Zola, contrarywise, envisaged himself as a sort of research worker; to the degree that he did he is more akin, perhaps, to a painter like Seurat than he is to his friends Manet and Cézanne. Still, in a story like *Nana* one can find the presentiments of an authentic Impressionism.

[36] Gustave Flaubert, *Madame Bovary*, trans. Eleanor Marx-Aveling (New York, 1952), p. 1.

[37] Flaubert, p. 51.

[38] Francis Steegmuller, "The Translator Too Must Search for le Mot Juste," *New York Times Book Review*, April 14, 1957, pp. 4–5.

What is most fascinating about these few parallels is that they are continuous. Scientific philosophies, beginning with Comte, stressed the matter-of-factness of empirical measure. Prominent researchers, too, contended that it was mistaken to try to find pre-established harmonies between the laws of thought and the material operations of nature.[39] Of course, it is true that science does not require such harmony for its work. But it is important to remark that as science grew more empirical and detached itself from metaphysical notions it also became less and less materialistic while, at the same time, scientists became more and more conscious of its hypothetical nature and dependence on deductive logic. From classical mechanics and euclidean space, physics proceeded to Relativity and the absence of any space at all. As scientific ideas were simplified the operations of physical science became more and more arcane.

An analogous situation obtained within the arts. The rather simpleminded Realism of Courbet gave rise to the search for exquisite sensation which culminated in Monet's paintings of the water lilies. Thus, the mask of mere appearances sponsored an interest in the nature of illusion. And it was that interest which led Cézanne, and then Picasso and Braque, into investigations of artistic form that are nearly as esoteric as the works of Einstein and his peers. Nor were the literary arts left behind in this movement from obviousness to obscurity. After all, it was an enthusiasm for reproducing human sentiment that led James Joyce to write something as generally incomprehensible and superficially "unrealistic" as *Finnegan's Wake*.

All of it grew from empiricist attitudes that, towards the end of the nineteenth century, came into a sort of suzerainty. In contrast to the romanticism and classicism of the immediate past, all the advanced thought of the Second Empire was constructive, reflective, and analytical. Everywhere technical problems were in the forefront and in every field of endeavor philosophies dedicated to empirical truth vied with the presumptions of tradition. Because of their thoroughgoing commitments to the strictly technical sides of art and because their aesthetic reflected a preoccupation with freedom and mobility, Impressionist and Naturalist styles came ultimately to reign supreme. Similarly, the direction scientific thought set for itself at this time, when it turned away from naive materialism to analyze phenomena and the laws of thought, set the course of serious investigation from that time to the present.

[39] See, for example, Helmholtz, p. 24.

Cézanne and the Dissolution of A Priori Space

T HOUGH Paul Cézanne exhibited with the Impressionists and, in fact, considered himself one of their group, he is usually called a "Post-Impressionist." The term is a cumbersome one. It was not invented until four years after the painter's death when Roger Fry used it as a slogan in 1910 for a show of recent French painting in London.[1] Devised to accommodate all art following Impressionism, it might fairly be called a "steamer trunk" word, so great is its capacity. Besides Cézanne, it contains Renoir and such proto-expressionists as van Gogh and Gauguin. The sole values of the label lie in indicating that all of the separate artists included are making the same general voyage to modernity, and in the implied recognition that without the Impressionist mystique that voyage could never have begun.

In our time Cézanne holds a sovereign position among the esteemed umpires of taste. That is not only because his art is the genesis of so much succeeding it. It also seems in some strange, almost eerie way to imitate its generation. Within the austere majesty of forms whose configurations are at once confining and robust one comprehends an art like that of Giotto; it contains the face of all the coming century and it is still the measure of everything that it has wrought. That property of genuine essentiality was what Renoir recognized in saying that "these paintings have I do not know what quality like the things of Pompeii, so crude and so admirable."[2]

The magnitude of Cézanne's accomplishment can be understood

[1] Roger Fry, *Cézanne* (New York, 1950), p. 5.
[2] In *Camille Pissarro, Letters to His Son Lucien*, ed. John Rewald (New York, 1943), p. 276.

33

only in terms of the two great currents of French art, Impressionism and the ancient tradition of Classical painting. Not a mere confluence of these traditions—except in a very few specifics—his style was sensitive to each while surmounting both. It was his announced intention to "vivify Poussin after nature."[3] By this Cézanne meant to indicate that although he, as much as any Impressionist, disdained the seventeenth-century method of composition, he was attracted by its substantial sense of order and completeness.

The notion of completeness here is crucial. Leonardo's *Last Supper* (Fig. 10), because its elements are confined to the essential and necessary, is a clear example of the meaning of "completeness" to Cézanne and to critics of his day. In this Renaissance mural all of the standard methods of resolving conflict are at work and all at work together. No confusion exists between the disposition of the shapes upon the painted surface and their relation to one another in the illusionistic space beyond the picture plane. The perspective is correct; the lines perpendicular to the viewer's eye converge on a single spot and the parallels are ordered in mathematical sequence of recessions. The infinity towards which Leonardo's lines converge and to which the eye is drawn is the head of the central figure, Christ. And the sequence of parallel darks and lights along the walls is reflected in the rhythms of the figures arranged at the table. Nothing in space is without its reference point, no dark is without its corresponding light, and there is no placement of a figure nor any posture that does not contribute to the symbolic content of the whole. Nowhere is there an arbitrary form, nowhere an element of order that has no expressive justification. The composition—its symmetry, its play of tones, its very drama —pivots upon the perspective scheme and that entire system of order is centered, as was the tale, upon the head of Christ. How different this Leonardo is from Impressionist paintings with their glamorous facades and random satisfactions. Its mood is eternal rather than momentary.

The permanent and orderly aspect of a Leonardo proceeds in part from the application of a priori principles to the solution of painterly problems. Perspective, for example, is such a system. Ordinarily, we mean by a priori a proposition or set of propositions whose truth can be determined without recourse to sensory experience. Now, even a blind man can comprehend the principles of perspective although he could not

[3] Quoted by Émile Bernard, "Une Conversation avec Cézanne," *Mercure de France*, 148, no. 551 (June 1, 1921): 38.

10. Leonardo da Vinci, *The Last Supper*, 1495–97.
Tempera on plaster. 28′ 3″ x 14′ 5″. Santa Maria delle Grazie, Milan. (Photo Fratelli Alinari, Florence.)

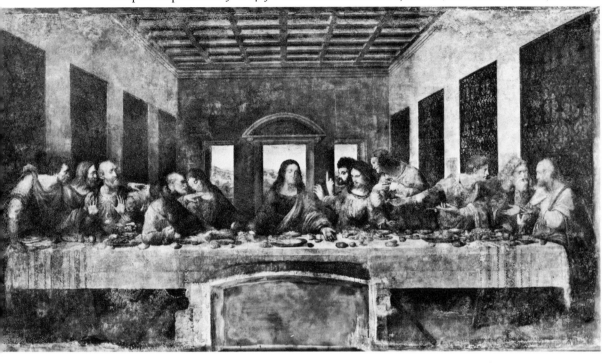

imagine their pictorial description because the principles are the mathematics of central projection. Beyond this, a system of propositions that can be described graphically has an a priori function artistically in that it is a set of general principles that can be applied to any given problem. Once the geometry of perspective is mastered the capable artist can always order pictorial space in a relatively satisfying and compelling way, simply because an absolute and predictable order is embodied in the mathematics of the system. And it is more a means to proper structure than it is a mimetic device; the human eye, in its ordinary life, never sees space so beautifully composed. Helmholtz demonstrated that. Perspective substitutes measurement and theorems for the intuitive comprehension of space; that is to say, it orders space mathematically.

As we pointed out earlier, the Impressionists had no use for perspective. They felt that the artist had been duped by such abstract principles for centuries and that his vision and sensational responses were hampered by them. They did not, however, change the principles; they simply ignored them. A Degas is not without its perspective; its perspective is only bizarre. An Impressionist canvas may be charming, it may be sensitively rendered, but it is never majestic in the old sense.

35

Although Cézanne shared the Impressionists' almost sentimental regard for modernity and personal freedom, he soon became disenchanted with the relative formlessness of their art. His transformation of that art from a fulgent spectacle into a chromatic fugue as intricate and grandiose as the music of the Baroque is one of the most astonishing occurrences in the history of artistic innovation. It was accomplished without any a priori system, without geometric armatures,[4] without even a clear delineation of elements. Speaking of a Cézanne still life, Meyer Schapiro characterized the whole of Cézanne's art: "The musicality and perfection . . . overwhelm us. Wonderfully constructed, minutely considered, full of patterns yet without a prior governing pattern, precise yet unexpected in detail, it is rich in variation like life itself."[5]

If the work is lifelike in this sense, the method of creating it is like a way of life; possibly it can be learned through dedication and reflection but no prior scheme will fit a painter to it. Nothing of its form is derived from images privileged in status. Geometric solids play no greater role here than they do in *Quattrocento* pictures.[6] Cézanne's innovation is more than a dialectical stage, a synthesis of Renaissance formalism and Impressionist color. Its presumptions are not those of a Neo-Classicism. It possesses all of the idiomatic traits of Impressionism and yet does not assume their formal limitations. Pictorial order in Cézanne's work (Fig. 11) is a matter of expressive invention rather than the result of applying some hermetically derived geometry, the invention of an ideal color range or, for that matter, the establishment of any kind of preordained condition of relation. Nothing in his pictures is the result of accident, ineptitude, or whimsy. Every deformity has its formal justification.

One must understand that, strictly speaking, distortion is not a characteristic of certain styles of painting; it is an attribute of pictorial order. A perspective drawing warps the world by mathematically re-

[4] Pictures by Cézanne in which an armature appears—such as his *Bathers*—are often used as examples of his work. The author does not deny their merit as works of art in ignoring them. Rather he feels that they are not exemplary by any means but, to the contrary, are exceptional.

[5] Meyer Schapiro, *Cézanne* (New York, 1952), p. 60.

[6] Much has been made of Cézanne's seeing in nature "the cylinder, the sphere, the cone, putting everything in proper perspective so that each side of an object is directed toward a central point," but this cannot be the basis of his art any more than Japanese painting is the basis of Impressionism. If anything, his paintings are filled with little cubes, a geometrical form unmentioned in his letter. Besides, the absence of a vanishing point is evident to any viewer. He probably means only that if one wishes to see volumes within the world of light, one has to attend the masses of things from a station appropriate to their study.

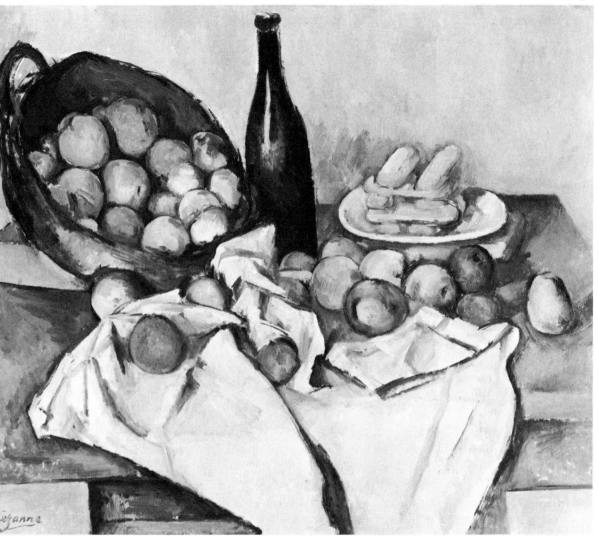

formulating it. Foreshortening in drawing and photography sometimes makes people's hands bigger than their heads. Oftentimes a seen magnitude of this kind is "redistorted"—perhaps the hand shrunken—to make the pictorial image more nearly correspond to actual, known proportions.[7] Even a simple line drawing has already an extremely opaque relation to reality; obviously, things are not dead white and covered with long thin marks. Paul Cézanne, who was unique in the kinds of distortions he arrived at and in the uses to which he put them, was quite ordinary

[7] Cf. E. H. Gombrich, *Art and Illusion* (New York, 1961), pp. 250–58.

37

12. A schematic drawing based on *The Basket of Apples*.

in that he used the principle of distortion. The discernible alterations of nature in the old masters resulted from the submission of forms to prior governing principles, such as perspective. In Cézanne the alterations are adjustments to what was just done, to what was about to be done, and to what was seen at every moment of painting.

It must be remembered that it was "after nature" that Cézanne wished to "vivify Poussin" and that this desire afforded no opportunity for the invention of a pure nonrepresentational form concerned with the problem of ordering only. For him realization of pictures necessarily involved the realizations of mountains and apples and tables.

A comparison of two schematics (Figs. 12 and 13) should serve to illustrate the magnitude and meaning of Cézanne's departure from traditional draftsmanship. One thing is apparent at a glance; of the two, the "Cézanne" (Fig. 12) is by far the more stable. It is more like the space it fills, its linear components are reminiscent of the outline of the rectangle containing them and, as individual items, have a uniquely permanent and interrelated character. Figure 13, a mean composition, drawn in accordance with the projective techniques of geometric perspective, has

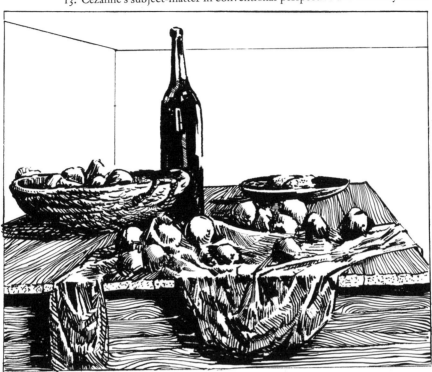

13. Cézanne's subject-matter in conventional perspective and ordinary form.

no comparable suitability to its particular space. It does, however, make up what it lacks in composure with a highly dramatic and effective space. By contrast Figure 12 is monumental and "stand-offish," like a wall detached from the beholder. Its space is not dramatic. But the relationships *within* the space are. Their drama resides in the viewer's consciousness of the picture in a state of "becoming," in his awareness that a table seen in just this way has no prior existence. After all, the lines of Cézanne's table exist only when rendered, unlike the projected table in Figure 13. And the queer, broken line of the table edge belongs, like everything else, to a whole series of relationships. Thus the formative process of the picture coming into being is depicted and that process is itself coherent. The interplay of stable and unstable elements, of continuous and discontinuous lines, of harmonious asymmetries and transposed similarities, makes the final resolution of the picture a clear evidence of the artist's achievement rather than the imitation of an equilibrium already existing in nature or in theory.[8] In Cézanne the alterations are adjustments to what

[8] Cf. Schapiro, *Cézanne*, p. 90.

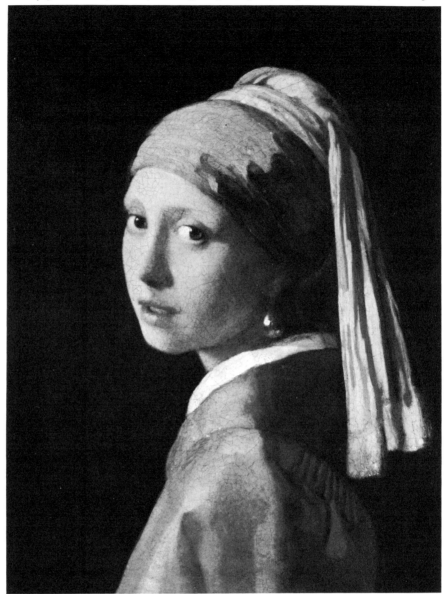

was just done, to what was about to be done, and to what was seen at every moment of painting.

It is precisely this sort of decisiveness, combining conditions of lyrical expression and those of the most calculated enterprise that reveals to us our own sensibilities, our inclination to gamble composure against disorder. That is the moving and dramatic *content* of modern art, the armed encounter which draws our imaginations to modernity, the true subject matter that perennially eludes conservative critics of abstract painting. And Cézanne's highest and most revolutionary achievement, his

establishment of solid forms and great spaces through what Roger Fry called "plastic color," involved the same order of risk and resolution one discerns in the linear and formal appointments of his drawing.[9]

Cézanne's use of color, however, cannot be understood without comparing the volumnar effects in his work with those of traditional painting. Consider, therefore, Figure 14.

Jan Vermeer van Delft, possibly the greatest master of light and shade, modeled his forms with such certainty that his *Head of a Young Girl* seems extant in space as no real head can ever be. The volumes are so explicit that one knows exactly how this head would look if the girl

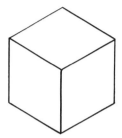

15. "Y" in hexagon.

16. Cube.

were in profile or if she were looking up or down. Now this is not sheer mimeticism; nature's volumes do not come so well packaged. Nor is there anything elementary about such painting; its techniques require great skill and a highly developed spatial intuition. On the other hand, there is nothing at all baffling about any mode of depiction that depends simply upon contrasts of tones. Its authenticity proceeds from the fact that actual light and shadow model shapes for us in a similar, though far less orderly and resolved way. The physiology of vision is far too complex for cursory examination, but a nontechnical discussion of how chiaroscuro effects its illusions is possible.

Whenever in painting a light meets a dark an accent is obtained, just as a contrast in tone creates an accent in a musical sequence. When this accent is formed by the junction of two areas, one uniformly light relative to another that is uniformly dark, an apparent change of planar direction occurs. In other words, if no forces have been introduced to oppose the illusion, the contrast is read as though it were a corner carved from space. For example, Figure 15 is a "Y" inscribed by a hexagon, but with one segment darkened it becomes Figure 16, a cube.

[9] See Roger Fry, *Cézanne, A Study of His Development* (London, 1927), pp. 74–83.

Whether such a corner seems carved into or out of space depends on its relation to the other contrasts. Thus, had Vermeer darkened the top of his young lady's nose instead of its side the nose would appear to be a hideously deep scar. As this suggests, darkening the nose on its side—the side corresponding to the dark side of the face—made it stand away from the head. Likewise, placing a contiguous series of accents over the turban, down the forehead, by the eye, down the neck, and across the shoulder, gave the impression that the planes to either side were moving back into a dark void. Thus the girl's head and body constitute one large volume, containing smaller volumes (like noses and ears), and are not merely aggregations of little elements.

The description does not do justice to either the technical accomplishments or the clarity of vision of a seventeenth-century artist whose subtleties are far more interesting than his masterful execution of an elementary drawing principle. It should, however, serve to illustrate the principle.

The explanation of chiaroscuro as a method of simulating volume can be extended to account for the traditional ways of articulating open space apart from the geometry of perspective. The reason that the nose of Vermeer's girl seems further away than her cheek is not due to its placement alone. One reason that this head is so much more effective than those by lesser artists is that Vermeer makes use of aerial perspective even in very shallow spaces. Notice, there is less contrast between the nose and its surroundings than there is between the light and dark of the cheek. *Things high in contrast appear closer than things low in contrast.* Thus, in a conventional landscape (Fig. 17), the leaves of nearby oaks are deep veridian in shadow and bright yellow where they catch the light; the middle ground is rendered with middle range lights and moderate darks, while the cathedral in the distance catches only muted light and casts the palest of shade. The eye is led back to the cathedral through passages of diminishing contrast.[10]

In principle the correct or ideal sequence of tones is determinable before the painter's brush is ever set to his palette. Renoir—who is often given credit for more inventiveness than he possessed—accepted the ef-

[10] What is important to the illusion, however, is the decrease of contrast *between* lights and darks. One could simply make all of the lights grow darker, leaving an impression of the distance shrouded in gloom. Conversely, a painter might lighten the receding darks and suggest far off things lost in a luminous haze.

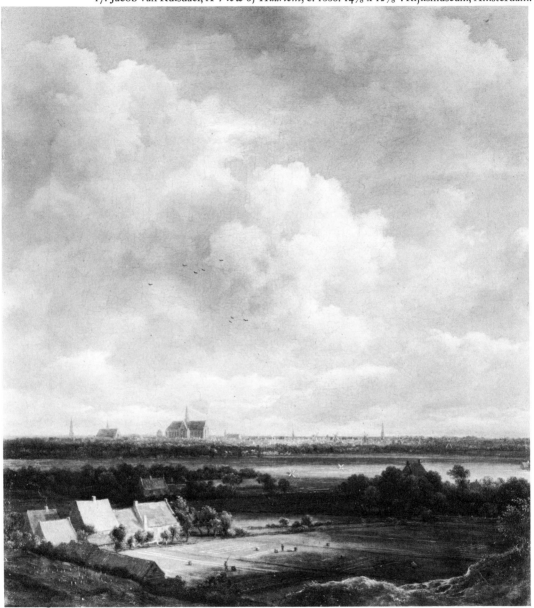

fects of aerial perspective and chiaroscuro, modifying only the kind of
tonality used by exploiting tones native to certain combinations of hues.
Cézanne broke away from the priorities of all external governing systems
and retained only the principles of accent, plane, and diminishing contrast
essential to the illusion of three-dimensionality.

43

Let us examine the panoramic *Mont Sainte-Victoire* (Fig. 18) from the collection of the Metropolitan Museum. At the base of a lone central tree lies a dark clump of brush juxtaposed against the ochre wall of a nearby house. The house, because its ridge pole and gable are a single line, constitutes one large plane. Almost as if it were unbroken it leads the eye back into the picture from the accent of the brush. But it is not unbroken. It is divided by hue into two parts, the ochre of the wall, the lavender of the rooftop. From this simple division emerge the myriad relationships that in concert identify a Cézanne.

The warm ochre separates, retreating from the cool green shrub that, standing in higher contrast, appears nearer to us. Space, thereby, comes to exist *within* a receding plane and not merely around it. But this effect has another face. Put together, colors dissimilar in hue "temperature" but of approximately the same tonality, suggest a folding of space, that is, they create the illusion of an angle. For that reason, the single segmented plane of the house can also be viewed as composed of a wall parallel to the viewer and a rooftop slanting away from him.[11] Having such a duality of recession, the form is doubly cogent. Moreover, the plane of the little house is but a section of a larger plane which penetrates the house, the trees on the left, and drifts into the groundplane of the valley. These planes, of which the entire work is composed, are like great slabs of light superimposed over the volumes of the landscape, at once binding them together and giving them their forms. Were not each integrated with all its neighbors and they to one another the effects would not obtain.

Cézanne's method was not systematic even though it may seem to have been. The procedure of painting depended on constant modification. Systematization destroys it entirely. Gauguin, a man overimpressed with the virtues of aesthetic theory, seems to have felt that Cézanne had stumbled onto a step-by-step way to masterpieces. But when he exercised what he took to be the theory in a series of "Cézannesque" still lifes, the results were appealing but not at all profound. Gauguin's warms and cools lie in a previously devised sequence and they are all of the same scope. Inevitably, the pictures turned out to be decorative. They are attractive,

[11] The author has had this analysis confirmed in the most convincing, not to say embarrassing, way. Some years ago I used the same example in a magazine article illustrated with black and white half-tones. But the distinction between the lavender and ochre areas is scarcely visible when seen in terms of black and white. I received numerous complaints from people who failed not only to detect the distinction but were unable even to discover anything that they could construe as a house.

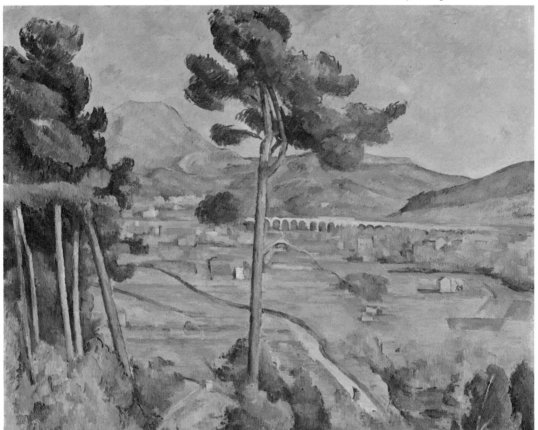

that's all. In a Cézanne, passage from one level to another, over a series of humps and corners, depends upon a kind of unpredictable sensitivity to minute changes in stress. It is like a piece by Bach; solemn contemplation of each part and its relation to the whole is requisite to appreciation. And it is like Bach's art in one other regard; it is contrapuntal.

Music is said to be contrapuntal when its several voices follow separate courses simultaneously. Cézanne's brushstrokes build planes which follow two different courses at once—that is, they move back into space and remain frontal at the same time. The illusion of depth and the fact of the canvas surface are both made manifest. It is as if the world were behind a transparent screen and were related to it so that marks on the glass are indistinguishable from the world.

Maintenance of frontality in Cézanne stems partly from his use of distortions and partly from the fact that elements of the foreground

45

participate in the simulation of deep space. For example, the bit of foliage to the left of the lone pine belongs to the tree and also acts as an accent for a plane that tips up and backwards to become Mont Sainte-Victoire. A branch on the right of the trunk projects a corresponding spot of green out over the landscape, and this spot is an accent for a plane that passes along the branch to the viaduct. Numerous elements of this kind predominate, tied to the surface and organized together by the force of linear consistency. The projecting branch aligns the two green spots and also lies parallel to the general direction of the distant river and to the roof of the little house. The meanderings of the river are almost exactly repeated in the line of the mountain range against the sky. The entire shape between the river and the mountaintops can be relished as an independent segment of the whole that reflects the form of the uppermost foliage of the central tree. This sequence of visual analogies spans the whole space, crosses every zone of far and near, and compels the viewer to acknowledge the picture surface and to attend the activity of the painter. There are, of course, countermovements at work absorbing the high diagonalization of this particular series.

The ultimate completeness of the picture shows itself in a play of different orders of frontalization. Oddly enough, the right hand side of the composition seems *more* frontal than the portion viewed between the trees, even though we are as conscious of the picture surface in the one case as in the other. Not only are the depicted masses closer, but the picture surface itself seems nearer. The discontinuous line of the viaduct and the differential in ranges of contrast contribute to the attainment of the effect, but the "how" of it is not so interesting as the "why." The equilibrium of the picture pivots on this shift in "sensed" levels. Cézanne weighted a pale, expansive frontality that contains all the phenomena of distance against the density of the nearby grove of trees at the extreme left. He posed what he saw at fifteen feet on the left against what he did at arm's length on the right, framing a recessive space between two equally advancing but differently weighted areas.

Given the Impressionist viewpoint, could a Poussin be more thoroughgoing in its order? *Mont Sainte-Victoire* is, even to contemporary eyes, as complete in its harmonies, as monumental in its command of the visual world as the Renaissance and Baroque masterpieces. Even Cézanne's still lifes have this property, although when the method is applied to small-scale objects the spatial effects are not very evident.

Apart from its role in the history of art the importance of Cézanne's art lies in its illustration of nineteenth-century impatience with a priori governing systems formerly believed external to the minds of men. The mood was all-pervading and influenced to some degree every aspect of Western culture. But in the arts the attempt to flee the boundaries of the eternal classical form generally led to the exquisite (as in the poetry of Verlaine) or to the Impressionistic (as in Monet, Flaubert, and Zola). There are exceptions. The dancer Isadora Duncan removed her ballet slippers, broke with the rigid posturing that so appealed to Degas, and created a new form based on kinesthesis and a sort of ordered impulsiveness. But nowhere appeared an artistic phenomenon comparable to Cézanne with his power to achieve absolute order outside absolute conditions.

In mathematics, science, and philosophy—where the issues of freedom and order were most clearly drawn—many developments parallel the attitude and, to some extent, the formal procedures of Cézanne. Certainly, the most significant of these is the invention of non-Euclidean geometry. This itself may seem odd, since the geometries were invented prior to the invention of Impressionism. But their acceptance came much later, during the close of the century. Not that there can be any question of their having had an influence on the painter's thought. Cézanne had no use for ontological speculation about the arts; in a letter to Camoin, he once wrote: "One says more and perhaps better things about painting when facing the motif than when discussing purely speculative theories—in which, as often as not, one loses oneself."[12] Art, unlike geometry, is without axioms and contains not a single postulate to guide its innovators. Still, the achievements of Cézanne and the non-Euclidean geometers are similar. Both showed that alternative articulations of space are as satisfying structurally as the old a priori articulations.

The skepticism with ideas of self-evident, eternal, ultimate truths which blanketed the nineteenth century sets it apart from most periods of history. Not since the time of Zeno (335–265 B.C.) had there been such a sweeping critical re-examination of fundamental beliefs. Whether this change in the intellectual milieu was prompted by the blind impulse of social change or by the constant advance of human knowledge since the Enlightenment is impossible to determine. One thing is certain: the frame of mind requisite to the great critique of ancient wisdom amounts

12 Paul Cézanne, *Letters*, ed. John Rewald (London, 1941), p. 218.

to an authentic Zeitgeist, that is, a "spirit of the age." This is borne out by the fact that three men, Karl Friedrich Gauss, Nicolai Lobatchevsky, and John Bolyai, with no knowledge of one another's work, discovered the possibility of a non-Euclidean geometry within a few years of one another.[13]

Of these three men only Gauss was celebrated in his time. And he, though his name ranks with that of Newton, so feared traditional scholastic opinion that he refrained from publishing his opinions on the subject. There was good reason for his fear; similar thoughts and conclusions, published in 1840, were to cost the Russian, Lobatchevsky, his position as rector of the University of Kasan. Except for this his work had no immediate consequence. Earlier, Bolyai's work published in Austria in 1833 as an appendix to a geometry treatise by his father, had been greeted with indifference. When, about thirty years later, Gauss's correspondence on non-Euclidean geometry was published posthumously, his prestige attracted readers and the work of Bolyai and Lobatchevsky was rediscovered by the mathematical world.[14]

Despite the mood of the nineteenth century, the non-Euclidean geometries were at first dismissed as "crackpot" notions. And it is not surprising that they were. The ten axioms on which Euclid founded his geometry appear so self-evidently true that no sound mind would question them. Moreover, they generate out of themselves more "truths"—called *postulates*—as compelling as the axioms. And the successes of Newtonian physics made the soundness and reliability of the truths virtually incontrovertible. The man of science, the great philosopher, the village school teacher, and every knowledgeable citizen accepted as a priori truths the axioms and theorems Euclid had established.

There is evidence that Euclid himself had not been so sure of his truths as those who followed.[15] He was particularly disturbed by the seemingly innocuous postulate on parallels which says that through a point P not on a line L there passes one and only one line M (coplanar with P and L) that does not meet L no matter how far the lines are extended. The other assumptions seemed commonsensical but this one did not. He realized that in this case he was simply making an assumption;

[13] Morris Kline, *Mathematics in Western Culture* (New York, 1953), p. 413.
[14] Kline, pp. 414–15.
[15] See Howard Eves, *An Introduction to the History of Mathematics* (New York, 1964), pp. 124–25.

he does not even use the parallel postulate until he absolutely has to—proving all of the theorems up to Proposition I 29 without making any reference to it. Revealing his anxiety about the assumption, he tried to *prove* it, that is, he attempted to deduce it from the others. He failed, but his attempt established a precedent. For the next twenty-one centuries mathematicians struggled to prove the parallel postulate.[16]

Nearly everyone assumed that the connections among the axioms and postulates were a priori, just as arithmetical associations are. That confidence was the very thing that inspired Kant to use a proposition dependent upon the parallel postulate as his evidence of a synthetic a priori. He believed the theorems of Euclid's geometry were apodictic truths, imposed by the laws of thought, that they carried with them their own necessity even if not a priori in an analytic sense. The parallel postulate, the theorem that a straight line is the shortest distance between two points, the one holding that lines perpendicular to the same line do not meet, and so on all seemed vitally necessary and yet no one had been able to prove the postulate itself.

The whole question depends upon on whether or not any particular axiom or postulate is logically necessary. And the answer to that question turns on whether or not it is possible to substitute for Euclid's parallel postulate either the assumption that (*a*) more than one line can be drawn through a given point parallel to a given line, or the assumption that (*b*) no line can be drawn through a given point parallel to a given line, and yet derive a system that contains *within itself no contradictions*. If that could be done one could conclude that the postulate on parallels is itself not an inviolate truth, insusceptible to doubt.

In 1733 Giolamo Saccheri, a professor at the University of Pavia, had published a book entitled *Euclides ab omane naevo vindicatus* (Euclid vindicated of all doubt). In it he demonstrated that, while the postulate could be deduced from no others, no alternative to it was possible. Use of assumptions (*a*) or (*b*) led to results that Saccheri characterized as "absolutely false, because they are repugnant to the nature of the straight line."[17] Today we know that no contradiction with the other axioms would have arisen were it not that Saccheri used unawares an assumption

[16] Edna E. Kramer, *The Mainstream of Mathematics* (New York, 1952), p. 258.

[17] Roberto Bonola, *Non-Euclidean Geometry* (New York, 1955), p. 43. This work contains translations of Lobatchevsky's *Theory of Parallels* and Bolyai's *Science Absolute of Space* and forms the basis of the succeeding remarks.

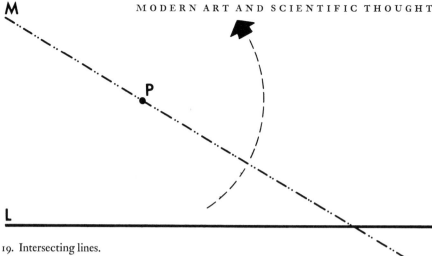

19. Intersecting lines.

equivalent to the parallel postulate. But the correct interpretation of his work was not to appear until Bolyai and Lobatchevsky created a geometry founded on contradiction of the parallel postulate. Both of them assumed that (*a*) was the case, that more than one line can be drawn parallel to a given line through a given point.

Their assumption strikes many people as an outlandish, if not altogether specious trick on common sense. Actually, the Lobatchevsky postulate may be just as commonsensical as Euclid's; except for force of habit it would be no more difficult to visualize the one than the other. The reader, however, should be cautioned that the Russian and Hungarian were mathematicians and as such realized that mathematical truths are in no way contingent on ability to visualize them. Few notions in arithmetic are more plausible to the layman than that there are as many squares of numbers as there are numbers; yet no human intelligence can visualize an infinite series of this kind, it can only grasp the arithmetical sense of the supposition.

Imagine a thin rod of perfect straightness, absolute rigidity, and infinite extension. This will be given line *L*. Above it conceive an identical rod attached to some manner of pivot so that it can be rotated only within the plane containing *L*. The pivot upon which this second line *M* turns shall be considered the given point *P*. At present *M* is so turned that its right branch intersects *L* (Fig. 19). Suppose, then, that *M* is in motion, slowly turning counterclockwise. As it turns the point of intersection moves out, out, out and the angle between *M* and *L* becomes more and more acute. The point at which *M* intersects *L* continues to slide along *L* until, eventually, the angle between the two lines ceases entirely to exist. The lines have parted at their most extreme right hand extension. Never stopping, *M* proceeds in its determined counterclockwise motion until

20. Lobatchevsky's hypothesis.

finally its left branch intersects L at L's left hand extension. Now, in *all* of its positions between the times the right branch of M parted from L at one end and the left branch of M intersected L at the other the two lines were parallel.

According to Euclid there is only *one* position in M's passage during which the lines are parallel. For only a single instant is M simultaneously disengaged from both ends of the line L; that instant occurs *at the very moment* M disconnects from L. If it turns at all after the moment of disconnection M connects to the other end of L, no matter how slight the degree of rotation, no matter if it is but a billionth of a degree. Does that sound so commonsensical, so plausible? Certainly the ends of lines in our experience do not behave this way. What reason (independent of Euclidean geometry) is there to assume it is the case with lines of infinite extension? Why not say that M must pass through some tremendously small arc of its revolution between the time its right branch leaves L and the time its left intersects L? That is what Lobatchevsky, in particular, supposed.

He assumed that for M to transfer its point of intersection with L from the right to the left it had to pass through a finite angle (Fig. 20). The angle is delimited by two lines, M and N, both of which are parallel to line L since neither intersects L. Clearly, any line between M and N—in this case Q—also is parallel to L. Therefore, Lobatchevsky's axiom affirms the existence of an infinite set of parallels to L through P. The diagram, of course, fails to demonstrate any such thing; on a flat sheet of paper the lines will meet if extended far enough. But Lobatchevsky was not concerned with graphic representations since the theorems derived from his axioms depended on reasoning only and not on any accord with drawings.

Fortunately for nonmathematicians there is a way out of this dia-

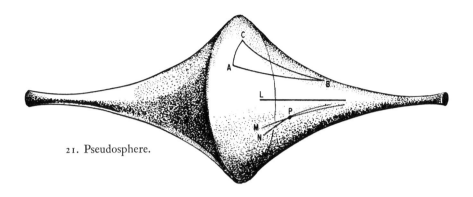

21. Pseudosphere.

gramless geometry. Although its existence doesn't in itself influence the logic of the argument, there is a surface known as a pseudosphere to which Lobatchevsky's geometry can be visually applied. None of the lines on the pseudosphere (Fig. 21) are "straight" in terms of a Euclidean model, but given the space they are logically the same. They are geodesics, the shortest paths between the points they join. Furthermore, since the term "plane" need not be interpreted to mean "Euclidean plane" it can be applied to any surface of constant curvature. On a pseudosphere all of the theorems of Euclid not proved by use of the parallel postulate are automatically those of Lobatchevsky. Thus, all vertical angles are equal; only one line can be drawn perpendicular to a line from a given point; and in a triangle with equal sides opposite angles are equal. In the same fashion, theorems that do depend on the parallel postulate differ in Lobatchevsky's geometry and, indeed, are applicable *only* to the inverse curves of a pseudosphere. On this surface lines M and N never intersect L, although in one direction M approaches L asymptotically, that is, M gets nearer and nearer and nearer to L but never meets it. That all triangles are made of inverse curves which impinge on their points leads to the perhaps unexpected conclusion that the sum of the angles of any triangle is always *less* than 180°. Moreover, since as the triangles expand the curves of their sides deepen and still further narrow the angle of each point, the triangle with the larger area has the smaller angle sum. Most astonishing of all, all triangles having the same shape must also be congruent! Thus, a vital part of Euclid's system is annihilated.

Most laymen, confronted by Lobatchevsky's first principle of non-parallelism will contend that, given the situation in Figure 20, line M must

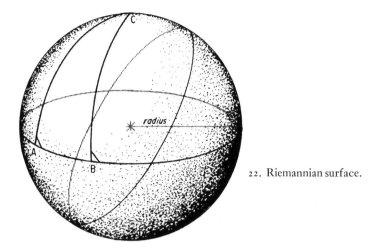

22. Riemannian surface.

turn an *infinitesimal degree* since the lines themselves are infinite in length. One might then, in argument, ask what the arc would be if the lines were apart one inch, five hundred miles, or an infinity since in application this distance influences all other magnitudes. But there is neither a defense nor a challenge for Euclid in this line of debate. Actually, the axiom purported to assert that a straight line can be infinitely extended does not say that at all. It implies, rather, that it may be produced indefinitely, that it is endless.

A later non-Euclidean geometry, invented by Bernhard Riemann incidental to an analysis of all geometric hypotheses,[18] begins with a distinction between infinitude and endlessness. All lines, Riemann argued, may be finite in length but endless, like circles. This assumption suggested that he could also assert a parallel postulate to the effect that there are no such things as parallel lines. From this point he went on to construct a geometry having theorems such as: all the perpendiculars to a straight line meet in a point; two straight lines always enclose an area; and similar triangles are also congruent. His other theorems on triangles are exactly the opposite of Lobatchevsky's.[19] Anyone who has traveled by aircraft or ocean vessel over a long distance is already familiar with the strange world of Bernhard Riemann, for his space is the space of navigation and its plane surface the surface of a globe (Fig. 22). As everyone knows, the shortest distance between two points on a sphere is the arc of a great circle, that is, a circle whose center is the center of the sphere. And great circles are endless but finite. Moreover, they always meet one another (twice as it happens) and so there are no parallel lines. Lines of latitude are not parallel

[18] See Carl B. Boyer, *A History of Mathematics* (New York, 1968), pp. 588–90.
[19] Cf. Kline, pp. 423–25.

because they cannot be considered straight lines in even the geodesic sense used here. Longitudinal lines on a globe are perpendicular to the equatorial great circle and they meet at the north and south poles. The triangle any two of them form with the equator as a base has more than 180°, because the sides are obverse curves and the angles of the points widened. From the vantage point of today's knowledge it is a curious comment on human nature that so many thinkers of the past had been walking about all of their lives on a Riemannian surface, even using projective geometry for navigation at sea, musing all the while about the incontrovertible truth of Euclid's postulates.

Yet, it is not because it agrees with the surface of the earth that the space of Riemannian geometry is significant. That space—and the space of Lobatchevsky's geometry—is important because it is derived logically from its axioms. As Richard von Mises put it, "The study of the axiomatics of geometry has proved that a consistent system of geometry not obeying the parallel axiom and not agreeing with Euclidean geometry can be constructed; thus the assertion that the customary geometry is logically inevitable, apodictically certain, and independent of any experience, is disproved."[20]

Art historians customarily treat the non-Euclidean geometries, when they mention them, as justifications for later abstract art, the idea being that Lobatchevsky and Riemann dispelled the view that geometry was a "conceptual photograph" of the external world.[21] But non-Euclidean geometry does not really stand as a proof that mathematics is independent of experience. It is true that Kant's view of knowledge amounted to asserting that space was Euclidean per se. But thinkers as far back as Plato had known that there were no straight or truly parallel lines in nature and that the beauty of mathematics lay in its abstractness.[22] Besides, as has been shown, Riemann's geometry is far more closely allied with the external world of matter than is its Euclidean counterpart. None of these empirical relations is of consequence mathematically—they are at best convenient for certain kinds of human activity, like navigation and surveying or carpentry and pattern-making.

What the non-Euclideans proved was that there were alternative articulations of space as logically compelling as Euclid's and that "far from

[20] Richard von Mises, *Positivism: A Study in Human Understanding* (Cambridge, 1951), p. 110.

[21] Cf. Schapiro, "The Nature of Abstract Art," p. 78.

[22] Cf. Plato, *Dialogues of Plato*, trans. Benjamin Jowett (Chicago, 1951), pp. 393-94.

having an existence and a validity apart from the human species all mathematical concepts are 'free inventions of the human intellect.' "[23] In this respect they are closer to Cézanne than to any other artist, for his paintings showed that alternative articulations of the world-space and picture-space were as structurally sound as the old a priori articulations.

A further similarity lies in the influences Cézanne and the new geometers had on their respective fields. The new geometries, no less than Euclid's, were structured according to the rules of logic, the validity of their axioms and new theorems tested against their internal logical consistency with one another. Following their invention, David Hilbert in 1880 created an axiomatic form for this branch of mathematics.[24] While Euclid's geometry derived largely from intuitive notions of spatial objects, Hilbert's referred instead to modes of connection, betweenness, congruence, parallelism, and continuity. This axiomatization of geometry rigorously carried through the principle that the elementary concepts are defined by the axioms themselves.[25] All of this followed from the profound analysis of geometric propositions that would have been impossible without the example of non-Euclidean geometries.

What is more, the analysis contained the past as well as its future. For had the new geometries been merely novel—different and only that—their relevance to the history of mathematical thought would have been quite tenuous. In fact, they laid the bases for a more comprehensive and all-inclusive geometry that, in Einstein, helped describe the external universe. Where Cézanne sought to combine the authority of tradition with the decisiveness of a modern spirit, Bernhard Riemann brought within the ambit of non-Euclidean geometries the thought of the ancients and gave even to Euclid a new clarity and new pertinence.

Cézanne, in making the formal problems of composition primary rather than secondary, and in considering the function of each element of line, form, and color defined by the more-or-less axiomatic conditions of canvas shape, thematic content,[26] and painterly activity, made internal

[23] Leslie A. White, "The Locus of Mathematical Reality: An Anthropological Footnote," *The World of Mathematics*, Vol. 4 (New York, 1956), p. 2355.

[24] Boyer, pp. 657 f.

[25] Mises, p. 109.

[26] Thematic content in Cézanne is itself a study of some interest. See particularly Meyer Schapiro, "The Apples of Cézanne: An Essay on the Meaning of Still-Life," *The Avant-Garde*, eds. Thomas B. Hess and John Ashbery (New York, 1969), pp. 34–53 and John Adkins Richardson and John I. Ades, "D. H. Lawrence on Cézanne: A Study in the Psychology of Critical Intuition," *The Journal of Aesthetics and Art Criticism*, 28, no. 4 (Summer, 1970): 441–54.

consistency the final test of a picture. His art led future painters to make the "role of structure or coherence" more evident and to extend "the range of its applications to new elements."[27] Without it Cubism, Neo-Plasticism, Suprematism, and even Surrealism, would have been unimaginable. Nothing that happens in the fine arts after 1880 can be understood without Cézanne. Similarly, without an awareness of the purely constructual nature of non-Euclidean geometry, one would be at a loss to comprehend the quarrels and developments in science and philosophy from the end of the nineteenth century on.

[27] Meyer Schapiro, "The Liberating Quality of Avant-Garde Art," *Art News* 56, no. 4 (Summer, 1957): 38.

Seurat and the Convenient Fiction

Both Karl Fredrich Gauss and Nicholai Lobatchevsky had attempted to prove non-Euclidean geometry valid through the exercise of empirical procedures. Gauss's attempt to discover whether the space of experience is Euclidean or not is the better known:

> He tried to measure directly by an ordinary triangulation with surveying equipment whether the sum of the angles of a large triangle amounts to two right angles or not. Accordingly, he surveyed a triangle formed by three mountains. . . . Needless to say, he did not detect any deviation from 180° within the margin of error and thus concluded that the structure of actual space is Euclidean as far as experience can show.[1]

Lobatchevsky felt that if there were empirical deviations from Euclidean space, they could be detected only on an astronomical scale. Therefore, when he performed an experiment similar to Gauss's, he used a triangle whose base was the orbit of the earth and whose apex was the star Sirius. Like Gauss's, Lobatchevsky's attempt to secure empirical evidence for a non-Euclidean structure for space came to nothing. For all practical purposes, he concluded, only Euclidean geometry was of any value. Thus, he wrote, "However it be, the new geometry whose foundations are laid in this work, though without application to nature, can nevertheless be the object of our imagination; though not used in real

[1] Max Jammer, *Concepts of Space: The History of Theories of Space in Physics* (Cambridge, 1954), p. 145.

measurements, it opens a new field for the application of geometry to analysis and vice versa."[2]

The new geometries, then, were considered "conceptual fictions." They were rather comparable in status to a literary work like Lewis Carroll's *Alice in Wonderland*: interesting though fanciful, logical enough given the premises, but wholly unrelated to the real world of matter and magnitudes.

With the publication of Riemann's famous treatise "On the hypotheses which lie at the basis of geometry," it became apparent that *all* geometries—even Euclid's—could be considered "fictitious" insofar as their relevance to physical space was concerned. Of course, this merely brought the geometries in line with such ancient mathematical "fictions" as the notions of negative and imaginary numbers. And it had nothing whatever to say about the philosophical question of whether certain mental concepts more nearly correspond to prosaic reality than others. And yet, the fact that of all geometries the Euclidean seems more commonsensical was not due to mere happenstance; even Riemann's conception of geometry gave to Euclid's space a somewhat privileged position.

Riemann, by approaching the geometries axiomatically rather than constructively—that is, by looking upon them as intellectual constructions whose axioms had functions rather than meanings—was able to show that the space of Euclidean geometry and the space of Lobatchevsky's geometry were nothing more than specific instances of the idea of a generalized space of constant curvature.[3] The introduction of his own geometry proved that there were at least three such instances of constant curvature, namely, negative (Lobatchevskian), zero (Euclidean), and positive (Riemannian). As for the relation of this conclusion to the character of physical space, it is easy to see that we normally conceive our space to be Euclidean because of our scale relative to that of the globe. Except in special circumstances one does not perceive the curvature of the earth and thinks of his surroundings in terms of zero curvature. Even for the jet transport navigator, if the earth on which he conducts his measurements were to swell indefinitely all of the characteristics of Riemann's geometry would fade away and tend to become Euclidean. Precisely the same sort of thing would occur if one lived upon a pseudosphere. Generally speak-

[2] N. I. Lobachevsky, "Neue Anfangsgründe der Geometrie mit einer vollständigen Theorie der Parallellinien," *Kasaner Gelehrten Schriften* (1835–1838), p. 24. This passage is also quoted in Jammer whose translation I have appropriated here.

[3] See Boyer, pp. 588–90.

ing, measurements of its surface would approximate those of Lobatchevsky's geometry. But if it were to grow sufficiently large the characteristics of a negative space would be lost and would be supplanted by those of a Euclidean plane. In a sense, then, Euclidean geometry is the dividing line between the two varieties of non-Euclidean geometry.

> For this reason Euclidean geometry has a uniqueness about it that is denied to the non-Euclidean varieties. These latter constitute a class of geometries; and the precise type of geometry we may happen to be discussing is determined by the intensity of the curvature of the sphere or pseudosphere to which it pertains. We also see why it is so difficult to determine by empirical methods whether the space of the universe is truly Euclidean or not. It is because both Riemannian and Lobatchewskian geometry merge by insensible gradations into Euclidean geometry.[4]

Toward the end of the century, the French mathematician, Poincaré, demonstrated the futility of *any* controversy over what geometry applied in real space:

> Measurement, he [Poincaré] insists, is never of space itself, but always of empirically given physical objects in space, whether rigid rods or light rays. Regarding the structure of space as such, experiment can tell us nothing; it can tell us only of the relations that hold among material objects. Suppose, Poincaré says, a deviation from two right angles had occurred in the triangulation carried out by Gauss, would this necessarily have constituted a refutation of Euclidean geometry? For there would have been nothing to prevent us from continuing to use Euclidean geometry on the assumption that light rays are curved. Nothing could disprove such an assumption. What geometry one chooses is, for Poincaré, merely a matter of convenience, a convention.[5]

One cannot know if space, ultimately, is one or the other, but one can treat it *as if* it were Euclidean, Riemannian, or Lobatchevskian. All are fictions, though not all are equally practical to "believe" in. As it happens, in ordinary intercourse with nature, the Euclidean doctrine provides us with the most convenient structure for our purposes. But it is not the only possible structure; indeed, it is not invariably the most convenient,

[4] A. d'Abro, *The Evolution of Scientific Thought from Newton to Einstein* (New York, 1950), p. 66.
[5] Jammer, p. 163.

as has been proved by the later development of the General Theory of Relativity with its heterogeneous space.[6] Hence, every geometry can be considered a conceptual construction, a "fiction." And, as a matter of fact, one may consider space itself such a construction.

Albert Einstein posited two primitive conceptions of space, one "relational," the other "absolute." The first sees space as positional quality of material objects; in this instance without objects one has no space. The second conception conceives of space as the container of material objects; in this case material objects cannot exist except in space. The first seems more commonsensical but it was clear to Newton—in contrast to Leibniz and Huygens—that it would not suffice to provide a foundation for the inertia principle and the law of motion. So, in classical mechanics, space is assigned the role of an absolute. "This role is absolute in the sense that space . . . acts on all material objects, while these do not in turn exert any reaction on space."[7]

Because it seemed theoretically essential, the concept of absolute space was among the bricks at the base of theoretical physics. Yet, by the middle of the nineteenth century it was completely absent from practical, experimental physics. There was, after all, no way to determine its existence empirically. Clerk Maxwell, the famous experimental physicist, remarked: "There is nothing to distinguish one part of space from another except its relation to the place of material bodies. . . . All our knowledge, both of time and space, is essentially relative."[8]

Not only had absolute space evaded every means of experimental detection, after the discovery of non-Euclidean geometry no particular kind of space could be asserted as an intellectual, deductive necessity. The concept of an absolute space was completely abandoned by the physical sciences during the latter part of the nineteenth century. In its place stood the "conceptual constructions" of the scientific method. There was, for example, Ludwig Lange's concept of the "inertial system," put forth in 1885:

> Let there be given a mass-point A whose motion is arbitrary (even curvilinear). Then it is always possible to move a coördinate system S in such a manner that A moves relative to S along a straight line a. If in addition, a second point B and a third point C are given with

[6] Cf. d'Abro, pp. 69–70.
[7] Albert Einstein in the Forward to Jammer, p. xv.
[8] J. C. Maxwell, *Matter and Motion* (New York, n.d.), p. 12.

arbitrary motions, the coördinate system can still be moved in such a way that all three mass-points, relative to S, move along straight lines a, b, c. . . . The physical contents of the law of inertia . . . is equivalent to the contention that any fourth mass-point, left to itself also moves along a straight line relative to S. In short, an "inertial system" is a coördinate system in respect to which Newton's law of inertia holds.[9]

Notice how unlike absolute space Lange's system is. It was not proposed as a ghostly entity, as a palpable container of things, or as a system of preordained relations; it was put forth as a mode of explanation, that is, as a way of accounting for the contents of Newton's law of inertia. A scientific convenience, it was proffered as such, without any pretension to finality. Such a constructed system gives a picture of physical reality but this picture always remains a *plan*, not a *copy*. It is capable of change despite the fact that as a system it corresponds to the constant concepts of geometry and physics. Such conceptual constructions are introduced in order to survey the facts more easily, they have no immediate objective correlate in empirical fact. The sole proof any of them can have is that they are more convenient than some other alternative.

The principles and laws which direct the controlled procedures of organized inquiry into natural phenomena came to be regarded as conventions, conveniences, conceptual fictions. After 1880 scientific writing is characterized by a consciousness of the scientist's reliance on arbitrary assumptions. Helmholtz constantly drew distinctions between the absolute truths of "being," and the constructed truths of science.[10] But nowhere is the mood more apparent than in the philosophy of "Empirico-Criticism" expounded by Ernst Mach.

Mach—the scientific prestige of whose name is revealed in the term "mach number"—held that "explanation" in science is not fundamentally different from the layman's depiction of facts, that is, from what is usually called "description," except in that this special form of description is incomparably more economical, unified, systematic and conclusive.[11] He believed that all concepts (even those of the "self") are symbols for groups of sensations. Matter, for instance, was not in his view the raw

9 Jammer, p. 130.

10 See Herman von Helmholtz, *Popular Lectures on Scientific Subjects* (London, 1893), *passim.*

11 For an introduction to Mach's philosophy see Ernst Mach, *The Analysis of Sensation*, trans. C. M. Williams (Chicago, 1914).

substance of the world; he characterized it, instead, as a mere complex of sensations. Space is simply the connection among certain kinds of sensations, and even the notion of infinity is derived from sensational experience, specifically, from the experience of motion. Mach says, in this relation, "A *fixed* animal possesses *necessarily* a bounded space. Whether that space be symmetrical or unsymmetrical depends upon the conditions of symmetry of its own body. . . . If the animal acquired the power of moving freely about, it would obtain in this way in addition an *infinite* physiological space; for the sensations of movement always admit of being produced anew when not prevented by accidental external hindrances."[12] All those concepts that do not result from the impress of direct sensation but are admissible into science on deductive grounds or because of theoretical necessity are convenient fictions. Mach apparently regarded the molecule as such a fiction even after the discovery of Brownian Movement.

None of Mach's views are equivalent to denying that things have an existence independent of the observer. He wasn't saying that everything exists only in the mind of man; he was merely asserting that we have no access to the world of matter except through sensations and the concepts they provoke. Since nothing can ever be known except through the intervention of intellect, the job of the scientist is to describe the irreducible contents of consciousness. In other words, God—assuming there is such a being—may know that the inertial system is in fact a misrepresentation of the real space of the universe, but this doesn't matter for science so long as the fiction is justifiable on practical grounds. Legitimate misrepresentations are, in Mach's view, both necessary to scientific investigation and sufficient for its purposes.[13] A theory, a law, or a postulate does not have to be true in order to operate *as if* it were true.[14] Science is not a body of

[12] Ernst Mach, *Space and Geometry* (Chicago, 1906), p. 30.

[13] Nikolai Lenin's reaction to Mach's work provides us with an interesting historical aside. The only extensive work on Marxist philosophy done by the architect of Russian Communism is a polemic directed against the philosophy of Empirico-Criticism. The book, written while Lenin was in exile, is entitled *Materialism and Empirico-Criticism* and consists of one blunder after another. Lenin completely misunderstood Mach's actual position, believing that it represented a sort of subjective-idealism. *Materialism and Empirico-Criticism* is rarely mentioned in Communist literature; it must be nearly as embarrassing to Soviet apologists as Theodore Dreiser's *New Republic* attack on the Jews was to American Party members.

[14] Probably the most extreme and "popular" treatment of this idea occurs in Hans Vaihinger's *The Philosophy of "As If,"* where it receives an idealistic twist. Vaihinger (1852–1933) argued that every domain of inquiry, from science to religion, involves the

observed facts that correspond to the extraphenomenal world of things, bodies, and substances. It is a controlled method of securing knowledge of the natural world through the exact description of sensation.

The recognition that the intellectual foundations of science are essentially epistemological rather than metaphysical was, of course, already present in Kant and Hume, but it is not until the end of the nineteenth century that this insight is fully realized. Mach, in re-examining and clarifying the results achieved in physical science, made the discovery of relations among symbols and conceptual constructions the primary aim of science. By treating the world in terms of denotations and dealing with physical mechanics in terms of the intellectual requirements of scientific methodology, he laid the foundations for the empirical conception of all branches of science.[15]

The importance of Ernst Mach's work to the development of formal scientific theory can hardly be overestimated. There are those who believe that the first intimations of the General Theory of Relativity occur in his *Mechanik*.[16] But his prominence is not the sole reason to consider him. His philosophy has been outlined above preliminary to discussion of a development in painting initiated by the painter Georges Seurat.

Seurat's style—termed variously, "divisionism," "pointillism," and "neo-Impressionism"—was considered by the inventor himself a "scientific" method of painting. Above all else it is essential to understand just what kind of science Seurat had in mind. To associate him with the viewpoint of classical Newtonian physics is somewhat misleading. It is that sort of association that has led so many critics to treat Seurat unfairly, to take an attitude towards him similar to the one Bernard Berenson assumed toward Paolo Uccello,[17] disparaging him as an artist of mean creativity who managed to "get by" in history's eyes with a bag of optical tricks and bizarre stylistic affectations. This view of Seurat pictures him as a sort of laboratory technician who merely followed color theories devised by other men. In fact, however, it is not a passive acceptance of theory that makes Seurat scientific; rather, it is his scientific temperament. And that

use of "as if" statements, that is, convenient mental fictions. Therefore, the claims of science to provide valid knowledge are no more defensible than the claims of any other discipline. See Hans Vaihinger, *The Philosophy of "As If"* (London, 1954).

[15] Cf. Mises, *Positivism*, pp. 87 and 361.

[16] See, for example, W. Wien, *Die Relativitätstheorie* (Leipzig, 1921), p. 31.

[17] See Bernard Berenson, *Aesthetics and History* (Garden City, N. Y., 1954), pp. 89–90.

temperament is the temperament of a generation that included Mach, William James, John Dewey, Poincaré, Avenarius, and Vaihinger.[18] Mach's writings, in particular, could almost be considered a statement of principles underlying Seurat's approach to pictures. For that matter, the goal of both men was the same: the methodical control and systematic description of sensation.

Seurat once said of some visitors to his studio: "They see poetry in what I have done. No, I apply my method and that is all there is to it."[19] Though uttered by the painter himself, these words do not represent an accurate assessment of his art. They are a bit of a brag, a statement of faith in a procedure invented by the speaker. The visitors were more correct than he. But Seurat put all of his faith in a methodology that rationalized the activity of painting and presented its lyrical side in a highly systematic and structured way. Partly this was due to his social circumstances; for him art was not a means to self-expression so much as a promise of self-improvement. He was poor, the son of a puritanical one-armed bailiff, and could "hardly maintain the impressionistic art of a Monet or a Sisley or a Degas, all sons of wealthy merchant families, predisposed to an art of delightful sensations . . . and to witty improvisation."[20] Derived from an age of more advanced industrial development, born into a class with a profound respect for rationalized work, it was by no means unnatural for him to think of progress in terms of scientific techniques and invention.

In Seurat there was no sense of science and art as antagonistic value systems and therefore it is not possible to disparage his technical method as a trivial element in his style. For him "technical method and formal conception were inseparable; the precision of the one was the counterpart of the other."[21] The formal conception was very near to Mach's notion of the legitimate misrepresentation. When Seurat set out to paint his masterpiece, *La Grande Jatte* (Fig. 23), he took a considerably narrower view of the idea of artistic manufacture than had anyone before him. Leonardo

[18] The year of Seurat's birth—1859—is a coincidence of important birthdates. Seurat, Henri Bergson, John Dewey, and Husserl were all born in that year. In one way or another each of these men was concerned with the limited nature of scientific truth. Bergson distrusted science because of its "as if" order of truth; Dewey saw the world in terms of operational problems; and Husserl makes everything except the *most* introspective experiences empirical.

[19] Quoted in Gustave Coquiot, *Georges Seurat* (Paris, 1924), p. 41.

[20] Meyer Schapiro, "Seurat and 'La Grande Jatte,'" *Columbia Review*, Vol. 17, 1935, p. 15.

[21] Schapiro, "Seurat and 'La Grande Jatte,'" p. 9.

had believed the signs and symbols he put down on panels and paper had some sort of one-to-one correspondence with the objects they stood for or at least that sort of relationship to the hidden substructure of nature. Seurat, having examples of Impressionist as well as classical mimesis before him, was alert to the precedence of structure over representation and aware of the arbitrary relation of depicted forms to the real world. For him a picture was a constructed fiction which stood for but could never copy reality, a construction whose peculiar form was built according to its own rigorous logic. And the logic was derived from empirical fact. In an article published in 1880, which Seurat considered a confirmation of his own theories, David Sutter wrote, "There are colorists' eyes as there are tenor voices, but these gifts of nature have to be stimulated by science to develop to the full. . . . Despite their absolute character, rules do not hamper the spontaneity of invention or execution. Science delivers us from every form of uncertainty and enables us to move freely within a wide circle; it would be an injury both to art and science to believe that one necessarily excludes the other. . . . In art everything should be willed."[22]

More than anything else it is Seurat's predilection for the absolute certainty associated with scientific procedures that makes the complete orderliness of his works so different from the orderliness of a Cézanne. Unlike Cézanne, who began his career as a Romantic, from the very first enamoured of stresses, strains, and imbalances, Seurat began as a Classicist whose aim, first, last and always, was the attainment of harmony. A painting by Cézanne, born in a fierce clash of opposing natures, is the more imposing for here a greater disorder has been conquered by the modern temperament. But in Seurat there is the majesty of a great scheme at work controlling numerous variables; *La Grande Jatte* is like a formal statistical theory with all variables controlled and every operation completed.

Seurat had several followers, among them Signac, Cross, and Angrand, who appropriated his mannerisms. None of their works has the formal appeal of *La Grande Jatte*; few of them are more than travesties of the style. The technique, the style, the outlook, belong to one man, Georges Seurat.

His use of thousands of separate dots of color instead of traditional brushstrokes is the most evident thing about his pictures. Viewers of his

[22] David Sutter, "Les phénomènes de la vision," *L'Art*, 1890, quoted in John Rewald, *Georges Seurat* (New York, 1946), pp. 60–61.

day, even those who admired him, were often disturbed by the overtures made to one's attention by those small particles. It is certainly not true that the dots were "destined to fuse at a certain distance";[23] you can't get them to merge and yet stay near enough to comprehend the painting as a painting. Seurat, no less than Renoir, wanted the activity of painting to predominate. His object was not to deceive the observer. Yet, in his use of the stroke, he could hardly have been more different from his Impressionist colleagues.

In the art of Manet and Monet the brushstroke denoted a color sensation, directly given. Its character did not change greatly under Cézanne's management except insofar as it was adapted to the requirements of monumentality and order. In Seurat the function of the stroke changed. His art expressed a really radical transformation of attitude towards the unit of operation. He himself never said that this was the case in so many words nor, so far as I know, has anyone else. But when one contrasts what he did with what had been done before it becomes quite obvious that an altogether new posture was required.

To Seurat a stroke was *not* a denotation of a sensation. Clearly, he regarded each stroke as a colored mark that *itself* produced sensations, even if it stood in the vastness of a canvas otherwise bare. After all, there is no difference, so far as optical receptivity is concerned, between light reflected from a green leaf on a living tree and that reflected from dead pigment of the same hue, if both are viewed under similar conditions. This being the case, a picture surface can be considered as much a part of the phenomenal world as any other object, subject to the same laws of vision and open to the same kind of optical analysis. This is obvious, of course, but pictures are not often looked at from quite this point of view. Looking at them in just this way became the fundamental basis for Seurat's execution of his works. Remember that he was attracted by the idea of modernity, then represented by Impressionism, and also that his was a classical background and a scientific temperament. Together, these elements of his personality led him to apply himself to the science of optics and to devise a set of principles to guide his intuition. These principles, largely derived from the writings of Rood and Chevruel, were later jotted down by Lucien Pissarro for his own use. Among these, of which a few are but barely sketched out in the notes, is the following:

[23] John Rewald, *Post-Impressionism from Van Gogh to Gauguin* (New York, 1956), p. 84.

Two complementaries mixed in unequal portions destroy each other partially and produce a broken color which is a variety of grey, a tertiary color. The law of complementaries permits a color to be toned down or intensified without becoming dirty; while not touching the color itself one can fortify or neutralize it by changing the adjacent colors.[24]

Seurat was exploiting to his advantage, among other phenomena, that of simultaneous contrast. The Impressionists had sought out fugitive effects of this kind in nature and attempted to render the illusion as they perceived it. Seurat's art is, by no stretch of the imagination, the passive art of an Impressionist. Following Sutter's dictates, as it were, he "willed" everything, reversing the procedure of Monet. Instead of rendering illusions, he created them. Not content with Impressionism's fabricated copies of the phenomenal world, he aimed at constructing a phenomenal image first hand, an image that would possess all the brilliance and variability of the world of light itself because it was constructed with regard to the laws governing the visual mechanics of that world.

The stroke as a unit of operation became an extremely crucial factor since it was *the* sensational unit. From Seurat's standpoint one had before one, in the form of a methodically arranged oil palette, color sensations which had only to be united in different ways to produce an almost unbounded series of impressions. In a certain sense the stroke preceded the representation; it had priority over anything it helped constitute just as for the retina the nuance of light has a priority over anything it helps describe. Furthermore, inasmuch as each stroke needed a certain autonomy in order to function as an area of color, and since the juxtaposition of areas had to be deliberate and exact, each stroke tended to assume the status of an object.

The dot as an object is not only a technical device, it is also an integral part of the formal conception of the painting. The little point of paint represents the smallest unit in a series of varying magnitudes that are in constant relationship. One passes from the unit of the dot to groupings of dots and from groupings to the largest masses through many close intervals. The method of execution is not, however, quite so dogmatic and absolute as disdainful critics would have us believe. Sometimes the dots are not applied in a uniform way; many times we find, as in the case of

[24] Quoted in Rewald, *Post-Impressionism from Van Gogh to Gauguin*, citing Lucien Pissarro's private notes.

the tree limbs in *La Parade*, that elements have been painted in directly and are not compilations of individual dots at all.

There was nothing new about the chromatic theories Seurat cited and used. (When it came to doctrinizing he was not surprisingly original, ever. His definition of art as harmony which "is the analogy of contrary and of similar elements of *tone* of *color* and of *line*"[25] contains not one original word; it is all taken from Charles Blanc's well-known *Grammaire du dessin*.) What is really unique about *La Grande Jatte*, for example, is the ideal of deliberate, systematic, rationalized construction coupled with the conscious thoroughness of its creation. Daniel C. Rich, who did a most thorough analysis of the work, observed, "At a time when many paintings were done in a day by brushes priding themselves on cleverness, this picture took nearly two years to construct, and we know that about seventy preliminary drawings, painted sketches, and studies went in its careful building."[26]

In the course of this construction Seurat employed three separate kinds of sketches and studies. The first, done in conté crayon, were those which reduced his observations to the categories of tone and line. The second class consisted of what he called *croquetons* (literally, "sketchettes"), painted sketches measuring exactly 6¼ inches by 9¾ inches. They reproduce parts of the landscape and are in nearly perfect proportion to the finished work. Finally, there were three large studies on canvas, marking definite steps in the resolution of the composition into a whole.[27] Rich comments that there was really nothing very unusual in this, that the old masters worked largely in the same fashion and that Seurat had simply returned to their system. "Poussin," he writes, ". . . spent hours in the *campagna* sketching among its ruins. From these first hand notes Poussin would return to his studio to build, stone by stone, pillar by pillar, the splendidly proportioned monuments of his art."[28] The comparison is really not quite fair.

Poussin was accumulating motifs and vantage points which he then set up in his studio to study, eliminating some, utilizing others. Once he had mastered all of those relationships he painted the picture. In contrast, Seurat composed with a mutual interpenetration of studio study and direct observation. He began with data sketches which are done in tech-

[25] Quoted in Rewald, *Georges Seurat*, p. 61.
[26] Daniel Catton Rich, *Seurat and the Evolution of "La Grande Jatte."*
[27] See Rich, pp. 16–17. [28] Rich, p. 47.

niques different from the final painting, thereby suggesting two different levels of method: one for the directly observed, another for the deliberated and constructed. Then, various aspects of the design were isolated as matters for consideration; as Rich points out, Seurat even isolated the spatial receptacle of the landscape as a thing to be studied. Then, after all of this, he modified his original plan. But even then he returned to the site to secure data for additions and modifications. In the end, the final work doesn't look like any single sketch but has elements of each one.

Seurat painted his pictures the way a scientist might fashion a theory. No other artist is so neatly characterized by mathematician Richard von Mises's description of the artist as a person who "expresses himself *about* a subject, *about* an occurrence, and uses in this process certain conventional means; he acts in this respect similarly to the scientist who invents a 'theory' for a group of phenomena."[29] Mises states that "All exact science starts with observations, which at the outset are formulated in ordinary language; then these inexact formulations are made more and more precise and are finally replaced by axiomatic assumptions, which at the time yield definitions of the basic concepts; tautological transformations are then the means of deducing from the axioms conclusions, which after retranslation into common language are tested by new observations."[30] This interaction between observation and formulation and reformulation and reobservation which produces transformations of the first approach is quite analogous to Seurat's method.

And what did these elaborations produce? *La Grande Jatte* is so obviously a construction, so "architectonic" in its disposition of areas, that one is tempted to consider it a colonnade of forms across the facade of the canvas surface. Yet, it is too varied for architecture. And, as for graphic art, never in a traditional figure painting of this scale were the members of a crowd so isolated as individual entities. Seurat's people are neither confined in a classical armature nor bound together with the grand curves and connecting arabesques of older art. The forms have not been related to one another by a prior governing system or an assumed paradigm. Instead, they have been assembled with reference to one another. In this respect, they are precisely like their component spots of color.

The picture attains coherence by virtue of several families of relationships. To begin with, the silhouette of the prominent couple on the right may be considered a metaphorical statement of the linear organiza-

[29] Mises, p. 304. [30] Mises, p. 147.

tion of the picture space. The line of the young woman's back, curiously modified by her bustle, is not too difficult to find repeated elsewhere. The curve of the bustle appears again in the line formed by the back of the seated hatless girl to the immediate left and is continued in the parasol held aloft by her companion. That curve joins the hip of an oncoming mother in a way that is analogous to the coincidence of the bustle and its wearer's back. This linear development is carried over the picture to its furthest left edge where another young lady similarly dressed stands fishing at the water's edge. The tree behind her is joined by a parasol in just the way that the mother's hip was joined by another. As for this parasol shape, it is repeated in the curve of the sniffing dog's tail, in hats, in skirts, and other objects throughout. The arc and the modified straight line predominate, creating a constantly varying pattern of minor associations and connections.

Very often these connections are extremely tenuous, as in the case of the hip and the parasol. Were they to appear in a Renaissance painting they would be very annoying because connections of this sort set up points of tension that tie elements together on a single plane and destroy the illusion of depth achieved through overlapping other planes. But, of course, Seurat's intention was to tie his figures all together on a single plane. He, no less than the Impressionists and Cézanne, was in love with the surface on which he worked. It was this sentiment for frontality that allowed him to use as a means of organization juxtapositions that older painters would have avoided.

Surely, the youngest apprentice in the Florentine Guild would not have painted a man's hat in such a way that it serves to pot a large tree. But Seurat, by prolonging a line, has done exactly that; on the far left a seated gentleman supports a tree on his top hat. Until is is pointed out this curiosity is hardly noticeable at all. Once seen, a variety of such superpositions become apparent. Everything is connected to something else in some way. On the left a sailboat completes the curve of a far-off tree; the boat sits on its reflection; the reflection touches a girl's hat; that girl's skirt joins her comrade's; her comrade is seated on a little path that runs parallel to the tree trunk; on the path stands a younger girl whose parasol evidently holds up a racing scull; the line of the scull passes through the tree, a distant figure, and stabs the back of a man wearing what appears to be a pith helmet. The linking of things goes on and on. Everything is hung together, as it were, and so remains on the picture surface.

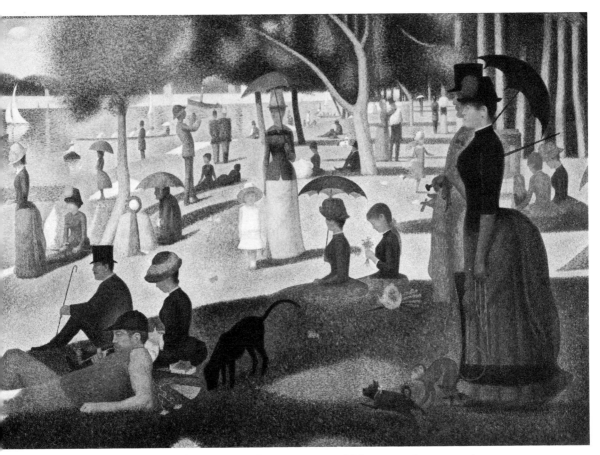

Probably the frequency of contacts would be upsetting were it not for the fact that the prolonged lines are not only edges of numerous objects but also boundaries of large spaces. The areas between the figures are no less dramatic in their outlines than the figures themselves; they, too, are shapes that were designed. They are not mere accidents resulting from the placement of figures. Many small points of contact are contained within massive areas through which run greater horizontal and vertical bandings of walls, trees, lines and shadows. This largeness of the composition, which is merely the culmination of a set of intervals begun with the little dots, resolves what might otherwise be an extremely agitated surface. So, in the end, the picture is a harmonious integration of contrary and similar elements on a grand scale—just as Seurat (and Blanc) said that it should be.

In fashioning a complete order from tiny units of sensation and from the simplest most essential elements of line, form, and color, Seurat was forced to revise the human silhouette so radically that it became dehumanized. *La Grande Jatte* does not contain real people; the riverbank is populated with life-sized mannequins and giant dolls. Notice how many of them look out of the picture to the left. Usually we read the glance in a painting as a directional force, probably because of our identification of

the eye's purpose. In conventional art the artist will balance these unseen but strongly felt forces against one another. But in *La Grande Jatte* the viewer is not conscious of the glance as an element of stress. Here the focus of the eye is indefinable; each eye has its own tranquility in its own axis and focus reposes somewhere within it. These people are not looking *at* anything, they just have their eyes open. They are nothing more than costumed forms built from sensation-provoking units. In this connection, Seurat's willingness to make human beings fit a nonhuman scheme is remarkable. Constantly radical revisions of anatomy for the sake of design occur. Obviously the shape of the nurse seated at the base of the left-hand tree has very little to do with the shape of a woman.

Not only is everything depicted conceived of as a mere object built of smaller items, dots, but light and shade are also viewed as *conditions* of the object. In *La Grande Jatte* light is not something cast upon an object by the solar disc, it is the "state of being" of the object. Shadow, likewise, is a state of being rather than an absence of sunlight. Degrees of illumination are the result of the varying densities and colorations of hundreds of tiny dots. Thus, even the reproduction of the modeling effect of light is reduced to a matter of arranging basic units and is seen, not as a rendering problem, but as a problem of construction.

So much emphasis on the rationalized procedure of creating pictures was bound to limit in some measure the arena of emotions that Seurat could communicate. Of course, *La Grande Jatte* has an emotive content strongly suggestive of the artist's temperament. But the feelings conveyed are those of the soul in repose. The mood of the golden mean would seem quite acceptable as a continuing temper of the style—one sentiment being no less artistic per se than any other—but Seurat, persuaded by the spirit of the age that neither art nor life held any secrets inaccessible to science, did not find it so.

After the completion of *La Grande Jatte* he was introduced by a scientist-poet named Charles Henry to an aesthetic based on the "scientific" theory of energy states. That theory held, generally, that there are three conditions of energy: gay, calm, and sad, and that these conditions correspond to the three primary colors, red, yellow, and blue, and also to linear directions. It was with this theory in mind that Seurat wrote:

> Gaiety of *tone* is given by the luminous dominant; of *color*, by the warm dominant; of *line*, by lines above the horizontal.

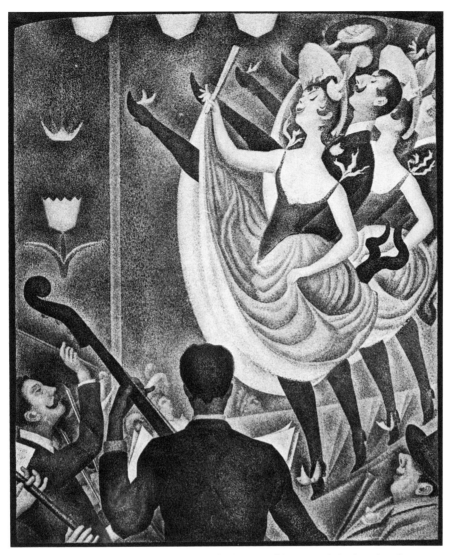

Calm of *tone* is given by an equivalence of light and dark; of *color*, by an equivalence of warm and cold; and of *line*, by horizontals.

Sadness of *tone* is given by the dominance of dark; of *color*, by the dominance of cold colors; and of *line*, by downward directions.[31]

In *La Parade* and the pictures following it, such as *Le Cahut* (Fig. 24), Seurat endeavored to apply Henry's theories so as to incorporate all elements into his system that might prove valuable to his art. He was certain that by following the theory he could conceive of the whole of the picture as a total *Gestalt* of gaiety, sadness, calm, or any interpenetration of the three. In this he was mistaken. The paintings look calm no matter

[31] Seurat in a letter to Maurice Beaubourg, August 28, 1890, reproduced in Rewald, *Georges Seurat*, facing page 60.

what his intention was because they are quite clearly the studied products of a reflective intelligence. Certainly, there is something to the idea that the human organism reacts to visual expression of sensation in terms of mood, but the interaction of the seen and the sensed is evidently far more complex than either Henry or Seurat supposed. Still, it is worth noting the remarkable lengths to which Seurat would go to rationalize the activity of painting, the utter thoroughness of his attempts to control every variety of sensation by some technical means. More important, though, is his acceptance of the idea that the provocation of a mood is a function of the formal properties of art, of an unconditional image, that is, one without thematic conditions and not tied to concrete evidences of sentiment and nostalgia.

Signac, Angrand, Cross, and the other members of the school held technology in the same high esteem as Seurat, but from their work it seems that they never understood the principles of his art at all. Compared to his their works are lacking in delicacy and finesse. Especially in the case of Signac (Fig. 25), neo-Impressionism tends to be unsubtle and short of inventiveness. Apart from the fact that they probably possessed less native talent than Seurat, his followers failed in their appropriation of his technique because none of them had his scientific temperament nor any insight into the character of modern science. The idea of scientific control was as appealing to them as it was to their leader, but their view of science was the view of earlier centuries. They, like Leonardo and Newton, conceived the laws of physics to be exact models of the natural world. It is not surprising, then, to find them utilizing Seurat's technique as a means simply of rendering the phenomenal world. Cross and Signac both definitely stated that they were obsessed with the desire to liberate themselves from the imitation of nature.[32] Yet, their paintings are like those of the Impressionists except that they substituted dots for strokes and cited specific theories instead of intuition as a justification for their art. In a more dogmatic way than Monet they set down their "naive impressions" of a scene. Unfortunately, their impressions have none of the quality of Monet's inspired improvisations. Even when departures into the fantastic occur, as in Signac's outrageously titled *Against the Enamel of a Background Rhythmic with Beats and Angles, Tones and Colors, Portrait of M. Félix Fénéon in 1890* the presumably *created* world looks more like a clumsily re-created theatrical spectacle.

[32] Cf. Rewald, *Post-Impressionism from Van Gogh to Gauguin*, p. 130.

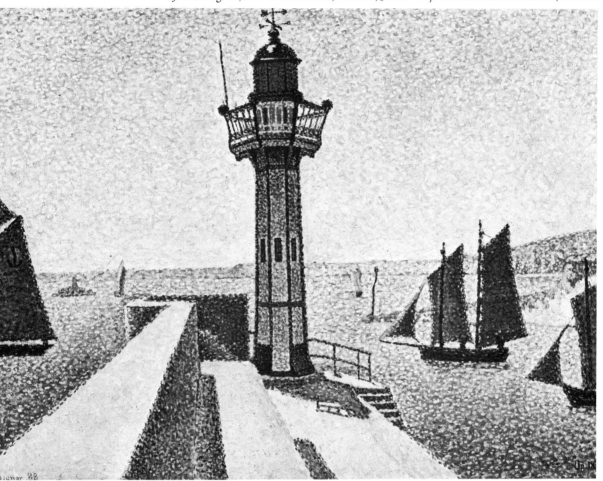

Seurat, emotionally as well as intellectually committed to the opinion that art cannot copy reality, constructed fictions that are not much like the real world in their overt appearance but can be considered phenomenal descriptions of the operations of the real world. Indeed, since their effects belong to nature's realm, the paintings may be regarded as equivalents of the visual world of everyday experience.

Although we can see in Seurat's art a real feeling for the poetic emergence of the whole (that he himself did not apprehend) it is also true that his method of composition, no less than his technique, is analogous to science. There is the same probing of the intellect, the same questioning of assumptions, the same revision of basic concepts as work proceeds. And all of this is controlled by a systematic methodology.

Seurat's outlook towards art was astonishingly similar to Mach's pic-

ture of the physical sciences. Both men, anxious not to lose their ways in a tangle of minor causes and unrelated contingencies, reduced complicated processes to their essential elements by developing hypothetical schemes that represented, without reproducing, reality. Seurat's art, as much as Mach's Empirico-Criticism, illustrates the nineteenth century's awareness of mankind's dependence on arbitrary assumptions and convenient mental fictions which can be applied only to certain kinds of processes.

CHAPTER FOUR

Alienation and the Rise of
Projective Psychology

As WITH most things, the weltanschauung that spawned neo-Impression-
ism had a negative as well as positive side. Seurat's reduction of his figures
to isolated mannequins who cannot communicate with each other is a
stylistic device. But it is a symbol that matches the mood of his decades.
Already in Monet the most "truthful" view of nature was presumed to be
the private one. The principle of visual subjectivity, which recognizes
that things may vary in their objective appearances depending upon con-
ditons of light and atmosphere and the situation and formation of one's
retina, characterizes the human receptor as fundamentally singular, en-
closed, and only peripherally associated with his fellows. Impressionism
amounted to a sort of "collective solipsism." Such views of life run
through all of modern art and literature; they are part of the special do-
main of modern individualism.

The conception of the individual as invincibly insulated from others
is ancillary to the cultural experience of loneliness and has as one of its
prerequisites the existence of the modern metropolis. Of all the sensations
associated with modernity the most familiar and yet uncanny is that of
being alone in a crowd. Preoccupation with modes of personal alienation
is particularly apparent among the intelligentsia in centers of great popu-
lation growth such as Paris, which more than doubled its size between the
end of the eighteenth century and the middle of the nineteenth. It was
during the urbanization of central Europe that a sense of profound loneli-
ness and isolation, of social estrangement, came to be seen as characteristic
of human life. In previous times loneliness had been experienced in actual

26. Honoré Daumier, *They Say the Parisians Are Hard to Please*,
1864. Lithograph 10¼ x 11¼″. Courtesy, Museum of Fine Arts, Boston.

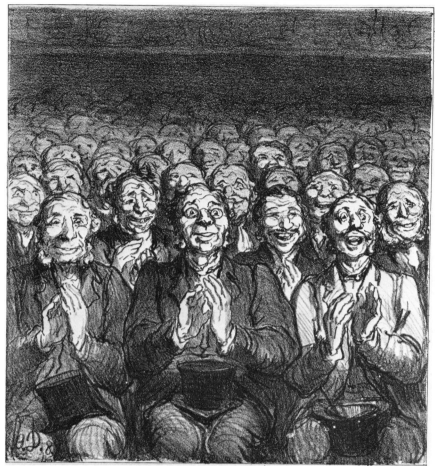

solitude or, when not the consequence of physical remoteness, as a kind
of Romantic detachment. After the middle of the nineteenth century,
though, every serious person seems to think of loneliness as a primary fact
of human existence. The recognition of the impossibility of ever coming
really to understand another person, the conviction that each is locked in
the prison of his own being, enters into the fine arts as a fundamental the-
matic and constitutional factor. It featured quite evidently in the crowd
scenes of the Impressionists.

Alienation of the urban dweller is not a raw fact of modern life, it is
a conception of life. Daumier, one of the first draftsmen to capture and be
captivated by the modern scene, portrayed the crowd of Paris as a univer-
sal spectator constituted of many individuals focused on the same thing, a
theatrical spectacle, an oratorical contest in the Champer of Deputies, or
on a gallery of prints (Fig. 26). The midcentury crowds we encounter in
the works of Manet, Monet, Sisley, and Degas are mere aggregations,

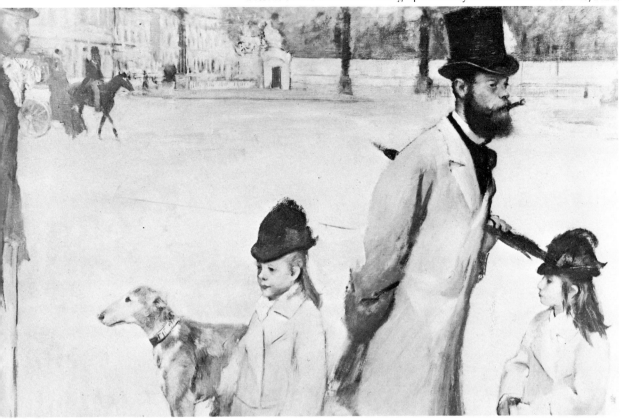

as fragmented as Impressionism's constantly changing outdoor world. Among these Frenchmen depicted in situations of social contact there is little communication; when they speak to one another in the café each avoids the other's glance; on the boulevard the human traffic moves at random in many directions, like the population of an anthill that constantly changing appears always to be the same. And what is true of large groups is true also of smaller ones. Virtually all of Manet's people seem disengaged, only vaguely aware of one another. There is a family group by Degas, *Place de la Concorde* (Fig. 27), in which M. le Vicomte Lepic and his two daughters are shown at the very instant of moving away from one another. Only the family wolfhound takes notice of another creature, in this case a man entering the picture from the left and looking not at the curiously disrupted family but beyond them to yet another intersection. The viewer, too, is excluded from psychological contact for, although the figures seem to be astonishingly close, they do not notice us at all. The Impressionists show us social groups broken up into isolated spectators who enjoy together but do not communicate with their companions. Eventually even those spectators disappeared from the Parisian idyll and

79

28. Vincent van Gogh, *The Starry Night*, 1889. 29 x 36¼".
Collection, The Museum of Modern Art, New York. Lillie P. Bliss Bequest.

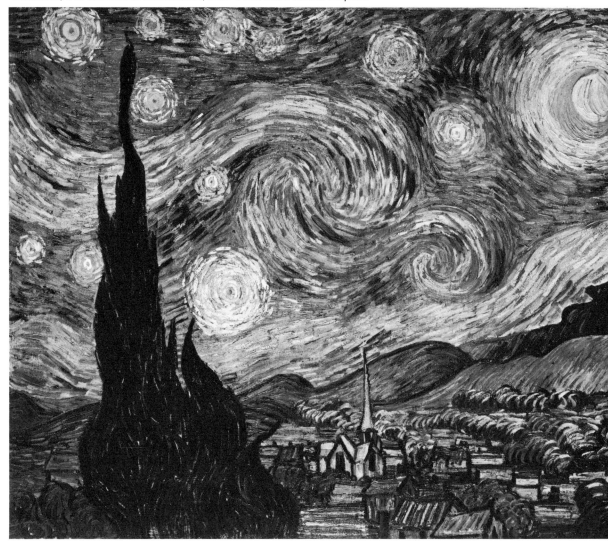

there was nothing left but the private spectacle of nature as we find it in Cézanne's landscapes and Monet's haystacks and lily ponds.

As Schapiro has argued so convincingly, the shift of the contexts of bourgeois sociability from community, family, and church to the boulevard, café, and resort entailed a "resulting consciousness of individual freedom [that] involved more and more an estrangement from older ties; and those imaginative members of the middle class who accepted the forms of freedom but lacked the economic means to attain them, were spiritually torn by a sense of isolation in an anonymous mass."[1] The most tortured of them transformed dispassionate Impressionism into an art of vehement self-expression.

[1] Schapiro, "Nature of Abstract Art," p. 83.

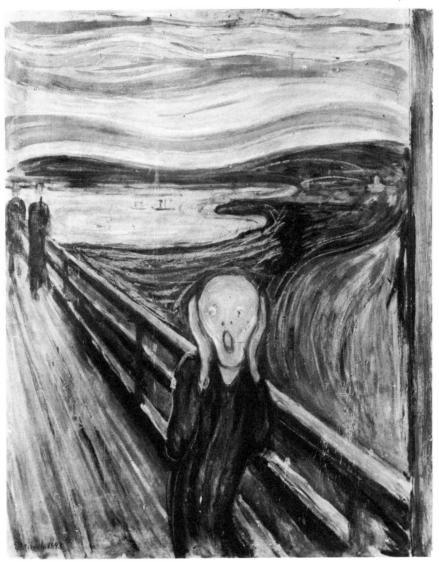

From that transformation emerge Vincent van Gogh's olive trees, writhing like souls in torment, his nebulae raging across the heavens of the night (Fig. 28), and Edward Munch's terrorized creature of *The Scream* (Fig. 29). Nowhere is the character of the new trend more evident than in this latter picture by the Norwegian painter. It would seem as if far more than the two decades separate this view of a bridge from those of Monet and Pissarro. And it is hardly possible to find "sunset moods" more disparate than Munch's and Monet's.

"Munch once said—and it is the index of his divergence from the Impressionist formula—'I paint not what I see, but what I saw.' "[2] Here is not the sun of Impressionism which conjured up a mood of nostalgic contemplation. In *The Scream* some terrible tension has been released, released so explosively that the emotion creates visible disturbances in the atmosphere and space. It is as if the lowering sun had cast a heavy shadow across a soul strung taut and snapped it in two, disturbing all that partakes of the spirit, even its environment. This same shrill cry, this same glaring light infested the whole subterranean world of fin de siècle bohemian existence.

On the continent the last two decades of the century were a period of profoundly felt personal and economic crises. The worker's strikes that were to forge the temper of Lenin's new world swept over Russia in the eighties. In 1893, the year of Marx's death, Belgium suffered an awful crash followed by a decade of demonstrations in the streets, during one of which 75,000 people marched in a single day! In France it was an age of despair entirely disenchanted with the democratic promise held out by the events of 1789 and subsequently by the revolutions of 1830, '48, and '71. Perhaps Alexis de Tocqueville's hyperbole is really applicable here as an explanation of the emergence of the new artistic and philosophical concerns:

> Democratic nations dread all violent disturbances. The love of pub-
> lic tranquillity is frequently the only passion which these nations re-
> tain and it becomes more active and powerful amongst them as all
> other passions droop and die. This naturally disposes the members
> of the community constantly to give or to surrender additional
> rights to the central power, which alone seems to be interested in
> defending them by the same means that it uses to defend itself.[3]

Out of turmoil and uncertainty arose an almost desperate drive to-
wards some sort of overriding totality.[4] The ideologies of communism, fascism, and anarchism were lighting fires in men's imaginations all over the Western world at this time. Furthermore, the seventies, eighties, and nineties were years of gradual accretion of power by the supra-individual state, the one institution from which men cannot resign. In France the

[2] Carl Zigrosser, *The Expressionists* (New York, 1957), p. 10.

[3] Alexis de Tocqueville, *Democracy in America*, trans. Henry Reeve (New York, 1945), Vol. II, pp. 293–94.

[4] For a splendid treatment of this subject see Hannah Arendt, *The Origins of Totalitarianism* (New York, 1951).

conditions were being set for the outbreak of bureaucratic and public insanity that in 1894 would send the Jew, Dreyfus, to Devil's Island convicted of crimes against the state on the bases of accusations that were supported by the most tenuous and unsubstantiated evidences imaginable.[5]

In view of the conditions, it is not surprising that the great men of the time appear to be not only those with the highest incidence of personal problems—men like Nietzsche, Strindberg, Wagner, van Gogh, Munch, Rimbaud, Gauguin, Vuillard, and Lautrémont—but also those with the greatest insight into themselves.[6] Their instability corresponded to a mass instability, their disaffection from society to the general disillusion. Yet, it was from this horror of instability and intolerable tension— and probably because of it—that the art of the twentieth century was generated. In no other context is it possible to conceive of the inquiry into the self—no, better "inquisition into the self"—and urgency to communicate its discoveries that characterizes so much artistic creation from the 1880's to the present.

The internal being of the artist, his feelings about the world, was of course not itself a theme new to art. In Delacroix and Gericault, and even in Rodin, there were moods having to do with the spirit turned in upon itself, themes of despair and disaster. But the painting of the end of the century is not merely a revival of Romanticism disguised with Impressionist trappings, for this later painting does not depend on a portrayal of the human being in turmoil and despair. Here, the self is reflected either in its reaction to sorrow, depression, and anxiety, or in its revision of the world of natural things to fit the matrix of its feelings. And those feelings have little to do with the weltschmerz of Goethe's Werther or the generalized nostalgia of Romanticism.

The "self" that serves as the theme of the later painting is the self in a specialized, pathetic character. It is the self of Dostoevsky's *Notes from the Underground*, of Ibsen's *Doll's House*, of Strindberg's *Miss Julie* and *The Inferno*, of repression, intolerable solitude, and tension. It is a self to whom the indifferent objects of the material world are presented as emotional elements. It is, for example, the personal world of van Gogh for

[5] See Nicholas Halasz, *Captain Dreyfus: The Story of a Mass Hysteria* (New York, 1955), pp. 1–54.

[6] Freud, according to his biographer, Ernest Jones, often said that Nietzsche had a more pentrating knowledge of himself than any man who had ever lived or was likely to live. And the philosopher Jaspers has pointed out that van Gogh's insight into his psychosis was uncanny.

whom a café is not at all a spectacle of artificial light and synthetic atmosphere, but "a place where one can ruin oneself, run mad, or commit a crime," who says his color is not "locally true from the point of view of the stereoscopic realist, but is colour to suggest the emotion of an ardent temperament."[7]

For the painters of the eighties and nineties each person is, contrary to John Donne, "an island entire of himself"; each has his own world, his own space born of the aura of his experience, which magnifies or diminishes the world around him. For these painters, each man lives in a world that he makes and remakes with every change of mood. They feared the kind of expression that strives towards stereoscopic mimesis because to them the accurately projected is foreign to the human being, something illusory and specious.

Van Gogh approached objectivity as if it were a mode of the subjective attitude or, more properly, as if truth were a fusion of the objective condition of the world and the subjective relation of men to it. When he painted his *Olive Trees at Saint-Rémy* (Fig. 30), a view only a few steps from the asylum to which he had committed himself, he selected a theme which had to be exaggerated only a very little to convey the sense of his private, compulsive universe. With land already convulsed by the ancient shudders of the earth, van Gogh did not have to "invent the whole picture"; on the contrary he found it already there—it was just a question of "picking out what one wanted from nature."[8] The landscape is the personality of the artist.

As is usual in ages of doubt and uncertainty, melancholy and foreboding, people everywhere exhibited strong inclinations towards spiritualism and a predilection for the certainties of religion. Like America's Henry Adams, they sought an escape from the relative universe of Spencer, Darwin, and the Dynamo into the domain symbolized by the unity of Medieval culture, the Trinity, and the Virgin.[9] Yet, to many, the God of the Jews and Christians was dead. As Nietzsche's Zarathustra had announced, all gods had laughed themselves to death!

> That came to pass when, by a God himself, the most ungodly word was uttered, the word: "there is but one God! Thou shalt have no other gods before me."

[7] Vincent van Gogh, *Dear Theo*, ed. Irving Stone (Boston, 1937), p. 455.
[8] Rewald, *Post-Impressionism from Van Gogh to Gauguin*, p. 218.
[9] See Henry Adams, *The Education of Henry Adams* (Boston, 1922), *passim.*

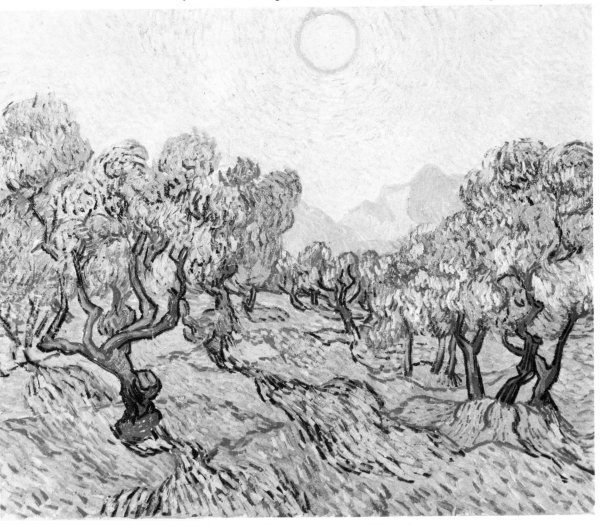

30. Vincent van Gogh, *Olive Trees*, 1889. 29 x 36½". The Minneapolis Institute of Arts.

An old grim beard of a God, a jealous one, forgot himself thus.
And then all Gods laughed and shook on their chairs and cried:
"Is godliness not just that there are Gods, but no God?"
Whoever hath ears let him hear.
Thus spake Zarathustra.[10]

He said, in tones befitting the times: "If there are Gods how could I bear
to be no God? *Consequently*, there are no Gods." Had ever the self been
given more prestige? Its own conceits now constituted an ontological dis-

[10] Friedrich Nietzsche, *Thus Spake Zarathustra* (New York, n.d.), p. 263.

proof of God! Partly, such statements are parts of an iconoclastic pose. But such hilarious atheism would have been incomprehensible at any time before.

At a time when the personality could be expressed with such power its expression was bound to condition not only the blasphemous but also the beliefs of the devout. Nietzsche's contrary is found in William James's *Varieties of Religious Experience*, where a multitude of gods and religious experiences are supposed, each of which contains an element of truth. In the pragmatic philosophy of James, where evidence of a theoretical or scientfic kind is lacking, one's vital interests make the choice: "If there be any life that it is really better that we should lead, and if there be any idea which, if believed in, would help us to lead that life then it would be really *better for us* to believe in that idea, *unless, indeed, belief in it incidentally clashed with other greater vital benefits.*[11] In such philosophies—and James's is by no means singular in holding a position of this general type—God, heaven, belief itself become individual conveniences, moral fictions, conventions.

Considering the history of Western man, the universality of organized religion, and the persistence of the belief in God, it is remarkable that so many laymen now felt that they were their own best touchstones to heaven, their best mediator the ego and not a priest. It was, no doubt, the knowledge of the self as a free agent setting its own goals in the post-revolutionary world that made this confidence in one's personal preferences possible. That goes a long way toward explaining the initial success of nineteenth-century evangelism. But by the eighties the heightened concern over the social forces that constrain individual choice had become so urgent that many serious people seem to have been constitutionally incapable of recourse to organized religious experience of any sort. Their religious beliefs were, like their artistic choices, deeply personal.

Hence, when the theme of the religious was reintroduced into serious painting, after an absence of over twenty years, it was no longer an institutional theme but was, instead, intensely individual. After 1885 an important painter is rarely paid to paint a religious picture. Such a man worked from his own need, and his painting became a spontaneous non-confessional representation of belief. In point of fact, the very act of painting was sometimes thought of as, itself, an act of devotion to some-

[11] William James, *Pragmatism, A New Name for Old Ways of Thinking* (New York, 1907), p. 78.

thing *higher* and *more* universal than a Godhead. Van Gogh, coming to art from the lay ministry, spoke of his art as if it were the gospel and of his activity as if he were still preaching to the poor miners of the Bourinage, saying that in pictures he wanted to convey something comforting, that he "wanted to paint men and women with that something of the eternal which the halo used to symbolize." Yet his point of view is utterly secular: "I can do without God both in my life and in my painting, but I cannot, ill as I am, do without something which is greater than I, which is my life—the power to create. And if, defrauded of the power to create physically, a man tries to create thoughts in the place of children, he is still part of humanity."[12] Another time he wrote to Bernard, saying that the old forms of religious art were impossible to attain. "The realities of today have so taken hold of us that . . . our meditations are broken into by the minor events of our daily life and we are brought back forcibly by our own experiences into the world of personal sensations.[13] He was, by indirection, criticizing the deliberately iconical images of Bernard and Gauguin. Van Gogh saw clearly the personal crises inherent in the conflict between the desire for religious certainty and condolence on the one hand and, on the other, the demands of secular life and personal sensation.

The conflict appears in a far more troubled form in James Ensor's *Entrance of Christ into Brussels in 1889* (Fig. 31), a satirical work. The theme is based partly on the Biblical story which provides Christians with their Palm Sunday, and partly on a carnival that actually does take place in Brussels just before Lent each year. Christ stands in the same relation to the picture that he stands in relation to the modern human being; he is obscured by the crowd and its political banners which say things like "Doctrinal Fanfares!" and *"Vive la Sociale."* Everything is fantastic, depressing, cruel, and grotesque.

Ensor selected a religious spectacle for his subject, but it was a spectacle with unique characteristics. In the first place, Belgium, having undergone a terrible economic crisis, was a turmoil of religious and political opinion with both the left and the right claiming Christ as their patron. In the picture he is prevailed upon in varying ways by the terrible multitudes. Secondly, the crowd that participates in religious carnivals is a most unconstrained crowd. Religious carnivals of the *Mardi Gras* variety al-

[12] Van Gogh, p. 454.
[13] In a letter to Bernard, December 1889, cited in Rewald, *Post-Impressionism from Van Gogh to Gauguin*, pp. 307–308.

ways precede an ascetic condition, Lent, and are moral holidays. The word "carnival" means "farewell to flesh." One is allowed to "blow off steam," to dress like a member of the opposite sex, to act destructively in a permissible fashion. Furthermore, one gets a role. Since people in life seldom have the roles they want, selection of a mask allows them to do all sorts of things they ordinarily could not. The overt facade one gives the world as oneself is destroyed by the mask and the covert self is manifested in a hideous or fanciful costume. The proper matron becomes a slattern, the broker plays Pan's pipes, the poor child dresses as a princess or a prince, and so on, and so on. Thus, in Ensor's work, Christ is lost among a thousand pretenses. What he symbolizes is taken as nothing more than an excuse for delusion, aggression, and sensuality. Religion has been subsumed beneath the demands of the organic, made a squeamish participant in Ensor's world of filth, hate, and disgust.

In the famous painting upon which this etching is based the very complicated relationship of the self to the crowd and to the demands of Christianity is made evident (and clarified) by a sign over Christ's head. I.N.R.I. (Jesus of Nazareth, King of the Jews) over the head of Jesus in genuine crucifixes had already an element of irony because of his situation and its context. James Joyce, in his novel *Ulysses*, made it a mockery by having Bloom, the Jewish advertising canvasser, interpret it as meaning "Iron Nails Run In."[14] Ensor, however, had gone Joyce one better beforehand. In his painting he has substituted for the traditional initials the words "En Sors," which are not only his name, but also a pun—in French the words mean "Get Out!" Here, as in all of Ensor —and as later in Rouault—the body of Christ and the spirit of the self are looked upon as a common field of persecution by hostile elements. In all of Ensor's many etchings and lithographs the only respectable person is Christ. Ensor identified with the person of Christ but simultaneously punished the crowd for ridiculing his art by reducing the whole populace to a mass of subhumans.

He not only caricatured the people of the cities by exaggerating their corruptness, he also caricatured the mode of representation. He loved the aggressiveness of the etching medium. Acid is corrosive, biting; the needle used to lay bare the metal scratches, pricks, "defiles" the surface. Besides torturing the human form by turning men into beasts and hiding human beings behind the kinds of masks that reveal rather than disguise brutality,

[14] See James Joyce, *Ulysses* (New York, 1934), p. 80.

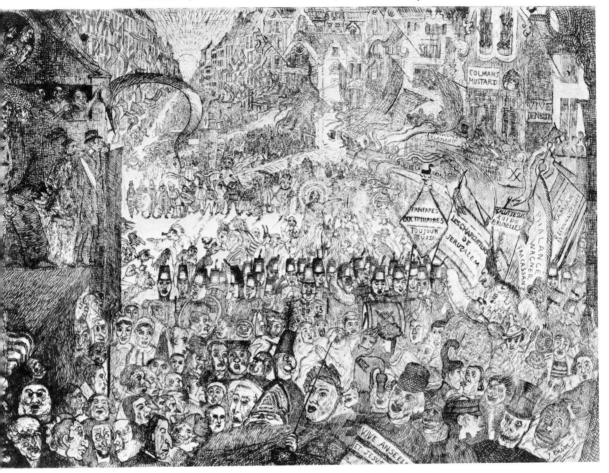

he also tortured the formal means of rendering the people. He used paint in an intensely brutal and coarse way that is almost insulting; he considered the corrosive action of his acids a personal expression of hostility towards the world, its people, and its things. Every stroke of the brush, every slash of the palette knife, every immersion of a plate was for him a genuine attack on the culture. The tools of the craftsman became, in his hands, instruments of aggression.

Ensor's strokes, and those of van Gogh and Munch, assumed an independent status in somewhat the way that the dots of their contemporary, Seurat, had. But where in neo-Impressionism the function of autonomy had been the provocation of visual impulses, it now became a corollary of the communication of emotive presentiments towards the space of the world. No longer concerned with the visual impulses of

89

passive discrimination, the stroke no longer denoted a nuance nor existed as one. It lost its relation to the phenomenal and became, like the gesture of one's hand, an element of affirmation. An expression of impetuosity, directed by moments of feeling, its patterns as important as the pattern of nature, this new stroke must be comprehended not as the caresslike touch of Impressionism but as the end-product of an artist's impulse.

The space of the pictures that embody these kinesthetic elements is a space of profound emotion which has an autonomy of its own. At times van Gogh's world seems rushing away from the viewer, the earth plunged into a dizzying race with sky while at others the viewer experiences a reflective calm almost like that of Japanese watercolor. All objects within his realm are conditioned by his temperament and are represented to us as emotional conditions. His *Starry Night* (Fig. 28) has a sweeping compelling character. The picture seems everywhere within a state of agitation; the tree moves upward like a dark flame, the sky swirls in a torrent of brushstrokes.

This obsessive preoccupation with internal feelings is apparent, too, in the tendency of strokes to resemble drawn lines. These lines are never primarily lines of boundary as in older painting; rather, they are long marks which either represent long narrow objects, sheer movement, or *correspond* to boundaries. When they do correspond to boundaries, however, they have a quality unto themselves that is not dependent on bounding. Outlines have been made into strokes, substances, so that the boundaries of the same quality as the rest of the surface. In painting which has become so calligraphic, so concerned with high activation of the overall surface, the convictions of the artist are concretely felt and apprehended immediately.

It is important to remark that *Starry Night* is not merely an outburst of unrestrained emotion. Works of art simply do not come into being spontaneously under the violent, unconditioned gesture of a brush. Van Gogh's study for *Starry Night* (Fig. 32) is amateurish in its fervor; everything is intertwined, sinuous, and overwrought. In the final work this violence of feeling has been curtailed. The painting has been ordered, resolved, and made richer by pitting stable lines against the wavy ones. The sketch it typical of sophomoric "expressionistic" painting, the oil painting is a prototype of excellence.

Now, it must be admitted that the preceding discussion of the stroke is not entirely accurate as a characterization. There was as well a tendency

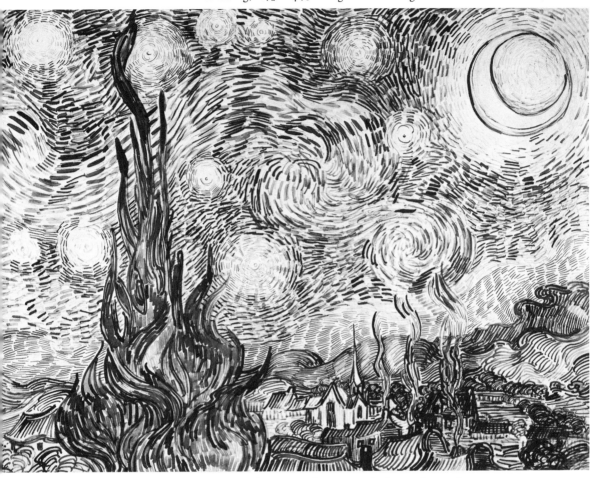

to minimize the prominence of the stroke as an independent element.
Munch minimizes the stroke and so does Gauguin. Van Gogh and Ensor
do so at times. But whenever that happens things look as if they were *made*
of paint; in other words, the homogeneous texture of pigment replaces the
heterogeneous texture of things in a far more obvious way than in Impres-
sionism. In van Gogh the stroke as a result of motor operation is ex-
tremely apparent at all times. His surfaces are sometimes nearly an inch
thick and the impasto has been sculptured by the brush or palette knife;
occasionally, the paint is laid on as a ribbon straight out of the tube. But
in a work like *L'Arlésienne* (Fig. 33) strokes as individual units, while
clearly visible at close range, exist in an unbroken field of one color and
so lose their identities as units of visual operation and operate instead as
units of fabrication. The stroke so used may retain all its kinesthetic prop-

erties, but they are not seen instantly by the onlooker. What is immediately grasped, and what conveys meaning and emotional content, is the impact of one area against another, the shock of a silhouette against its surroundings.

"I am always in one of two currents of thought," said van Gogh, "first, the material difficulties . . . and second, the study of color. I am always in hope of making a discovery there, to express the love of two lovers by a marriage of two complementary colors, their mingling and their opposition, the mysterious vibrations of kindred tones; to express the thought of a brow by the radiance of some star, the eagerness of a soul by a sunset radiance."[15]

Different in character, and more successful than Seurat's scientifically construed emotions, these moods also depend on vibrations of color, directions of line, formal relationships. They, by implication, presume an emotional content resident in the visual form quite apart from the representation of situations which, through association, bring to mind some mood. To say this is not to repeat the fable that in such works the subject was merely a pretext for manipulation of pigment. When these works do not involve direct depiction of the self in states of tension, they at least exist as manifestations of the self in urgent response to *seen* things.

Of the movement towards impulsive self-expression van Gogh was both the genesis and the genius. He strove to convey and very often in looking at his work one feels something akin to the sensation of listening to someone speak a foreign language so vehemently that it simply *must* be understood. In the art of van Gogh, and in that of Ensor and Munch, and to some extent in that of Gauguin and Toulouse-Lautrec, artistic expression became a psychic necessity to individual well-being. And, yet, the thing most common to them all is rage: "They rage against everything that gives permanence and continuity to life and they rage against themselves, as if they were anxious to exterminate everything in their own nature which they have in common with others."[16]

Art became for them more important than human companionship or creature comfort; they all subjected themselves to cruel monastic discipline and forwent the personal and private happiness that normal society

[15] Van Gogh, p. 454.
[16] Hauser, *The Social History of Art*, p. 894.

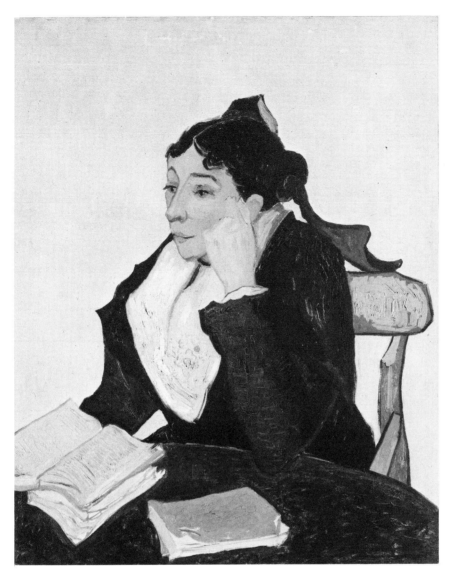

affords.[17] Ensor sold his soul to art and the salon, then attacked both, making his virtuosity into an instrument of destruction and symbolically annihilating whole herds of philistines. Van Gogh became a saint, a fanatically inspired genius, demanding money from his brother despite

[17] For those who believe that Paul Gauguin escaped a stultified middle-class environment for an idyllic life in the South Seas there is an antidotal work by Bengt Danielsson, *Gauguin in the South Seas*, trans. Reginald Spink (Garden City, 1966) that virtually proves that the artist lived as a colonial European rather than a noble savage. He visited Tahiti one hundred years too late. An artist could not live by fishing, his liasons with native girls were marred by their revulsion of his *chancres*, he couldn't stomach the native cuisine and sank into debt to Chinese storekeepers who stocked white bread, wine, cigarettes, and tinned goods. But Gauguin's pride would not let him reveal any of this. *Noa Noa* is full of lies. Gauguin was an outcast from both native and colonial worlds.

everything and then spending it on brushes and canvas while he subsisted mostly on coffee and alcohol. All led dreadful lives, fell into sordid sexual entanglements, companioned criminals, died of venereal disease, went insane, or committed suicide. Still, they were great creators in spite of, not because of, their disturbances. Only a man in a most lucid frame of mind could have painted the *oeuvre* of Vincent van Gogh; even when undergoing seizures he acted towards his crises with more intensity, intelligence and will than do other schizophrenics.

Art was all that tied these men to reality; without it life was insufferable; with it they were able to appease the poignant longing for personal distinctiveness that was general among their generation. The notion of anonymity to which this longing was related is today quite commonplace. The aspects of its first appearance, however, are both terrifying and provocative. In the late nineteenth century surface differences among people actually tended to be eliminated; the degree of conformity among middle-class people was so complete as to be eerily disconcerting. It is improbable, certainly, but nonetheless true that people of the time all looked alike. Inspect the old daguerreotypes. There is no more variation in appearance here than one expects to find among the figures in a sixth-century mosaic. The conventions are equally distinct; there are stratified postures, there is a standard grimace, a community of dark clothing. I believe that it was Baudelaire who spoke of the entire period being clothed to attend a funeral.

The very notion of self-revelation as the object of creative experience and the end of art presumes that the "real" personality, or self, is hidden, not readily available even to its possessor. Such a view takes for granted profound doubts about the individual's relationship to the whole of society. The idea of a covert personality, hidden from all the world but more authentic than the patent one, and detectable only in unconscious processes, could never have gained wide currency without the social conditions that had reduced men in all modern nations to commodities, units of labor, representatives of their stations, facades.

Perceptive individuals had written of associations now considered "unconscious" or "sub-conscious" long before Hartmann or Freud. Gibbon, for example, writing of his sister in the second chapter of his autobiography, says that he is convinced there is something essentially incestuous in any brother-sister relationship. Sibling love is of a singular nature, he believed, because it is sponsored by the "secret influence of

sex, but pure from any mixture of sensual desire. . . ."[18] Gibbon died in 1794; he would never have written a book on this subject. It is only after 1880 that this sort of thing seriously interests artists and writers. Presumably, Freud and all that follows him is an expression of the interest. Social circumstances promoted the believability of an Unconscious mind. That is not to say men of other times were what they seemed to be; poets had made use of the "Freudian slip of the tongue" to indicate hidden impulses long before Vienna existed. It is only to suppose that the views of the self held by van Gogh, Hartmann, or Freud would have been hardly plausible before the fin de siècle and not widely acceptable until the second quarter of the twentieth century.

Eduard von Hartmann is typically thought of in connection with the pessimistic philosopher Arthur Schopenhauer because of the prominence in both men's work of the notion of Will. Hartmann is of singular interest, however, because he devised a complete doctrine of the Unconscious.[19] First enunciated in 1869, it was proposed as an extension of ideas that were almost commonplace to science and philosophy. But in 1901 he published *Die Moderne Psycholgie*, a review and a critique of the major psychological studies of the nineteenth century. Its purpose was to show how much psychology had lost by failing to employ his doctrine:

> The immediate response was very small, but as time progressed Hartmann was not only read by *the general public which supported him at first*, but also granted a hearing by more competent audiences. In the present state of affairs no one is anxious either to reassert Hartmann's doctrine or to deny that he powerfully influenced the development of nineteenth-century thought. Whatever Hartmann said always came back to the one and only essential conclusion—the Unconscious must be accepted. And it has been accepted. . . . The soberest psychology of the twentieth century is leavened by these ideas. In the analysis of conduct, normal or abnormal, the idea that consciousness does not really act, but rather serves to recognize and appropriate the actions of an unconscious force, is everywhere to be met.[20] [Italics mine.]

As is well known, Sigmund Freud regarded the concept of the

[18] Edward Gibbon, *The Autobiographies of Edward Gibbon*, ed. John M. Murray (London, 1896), pp. 28–29.

[19] See Eduard von Hartmann, *The Philosophy of the Unconscious*, trans. William Chatterton Coupland (London, 1893), *passim*.

[20] G. S. Brett, *History of Psychology*, ed. R. S. Peters (London, 1953), p. 553.

"unconscious" as a mainstay of his theory. And he, more than any other figure, is responsible for the model of the human mind that seems plausible to most intelligent laymen. There is a very good reason that this should be. Freud, ostensibly, was a practicing physician, preoccupied with practical therapeutic problems, and he was led to devise ways of driving home psychological insights to his patients and to the public of a discontented civilization. For all its therapeutic merit, psychoanalysis is more properly considered dramatic than scientific. Freud himself suggested as much.[21] Consequently, his theories are difficult to outline systematically. We shall deal but briefly with but a single postulate, the mechanism of "projection."

"Projection" in psychologic terms is the tendency to impose upon others our own reactions, to perceive in terms of our own limited and highly conditioned frame of reference. Thus, one who is essentially hostile will see his colleagues as behaving in his likeness and will treat the most benevolently intended overture as malevolent, hostile, and aggressive and will react defensively. We are all familiar with the "dirty mindedness" of the puritanical censor who projects his own lasciviousness onto every other citizen. The term "projection" had been introduced by Freud in 1894[22] and elaborated on in a paper "On the Defense Neuropsychoses" in 1896.[23] Finally, in *Totem and Taboo* he gave the word a larger, more all-embracing sense: "The projection of inner perceptions to the outside is a primitive mechanism which, for instance, also influences our sense-perceptions so that it normally has the greatest share in shaping our outer world."[24] Freud applied these notions to specific artists and works of art in a brief study of Michelangelo's *Moses*, published anonymously in 1914,[25] and in his famous little book on Leonardo, *Eine Kindheitserinnerung des Leonardo da Vinci* (A Childhood Reminiscence of Leonardo da Vinci),[26] the last being the premier example of the divination of an artist's personality by means of his work.[27] Generally, he argued that the

[21] See Sigmund Freud, *A General Introduction to Psycho-Analysis*, trans. Joan Riviere (Garden City, 1953), pp. 19–28.

[22] See Sigmund Freud, "The Anxiety Neurosis," *Collected Papers* (London, 1940), Vol. I.

[23] See Sigmund Freud, *Neuropsychoses* (London, 1940), Vol. I.

[24] Sigmund Freud, *Totem and Taboo* in *Basic Writings of Sigmund Freud*, ed. A. A. Brill (New York, 1938), p. 857.

[25] See Sigmund Freud, "The Moses of Michelangelo," trans. Alix Strachey, *On Creativity and the Unconscious*, ed. Benjamin Nelson (New York, 1958).

[26] In the series: *Schriften zur angewandten Seelenkunde*, Vol. 7 (Leipzig, 1910).

[27] For an extraordinary critique of the treatment see Meyer Schapiro, "Leonardo

unique disposition of formal elements and thematic features of the works are projections of their creator's unconscious. The relationship of this interpretation to the character of avant-garde painting contemporary with Freud is too obvious to be missed.

Another synchronism of related interest is the rationalization in 1880 of the techniques of connoisseurship by an Italian amateur, Giovani Morelli.[28] In order to make correct attributions of anonymous paintings, or suspected copies or forgeries, Morelli explained that it was necessary to reverse the usual aesthetic reaction. Aspects of the paintings which are of artistic importance—composition, proportion, color—are easily imitated.

> To identify the hand of the master, and distinguish it from the hand of a copyist, we must pay attention to small idiosyncrasies which seem inessential, subordinate features which look so irrelevant that they would not engage the attention of any imitator, restorer, or forger: the shape of a finger-nail or the lobe of an ear. . . . This is the core of Morelli's argument; an artist's personal instinct for form will appear at its purest in the least significant parts of his work because they are the least laboured.
>
> Quite apart from questions of preservation, the Romantic in Morelli has distrusted the finished work and its conventions. Whatever smacked of academic rule or aesthetic commonplace he dismissed as deceptive . . . and withdrew from it to those intimate, private and minute perception which he felt to be the only safeguard of pure sensibility.[29]

The attributions achieved by Morelli and his principal follower, Bernard Berenson, were spectacular. Forty-six paintings in the Dresden Gallery were reassigned because of them and the upheaval in other museums was similarly convulsive. The method is now taught in every school of art history. Although independent of psychoanalytical thought it is, in effect, a mechanistic and purely descriptive version of what Freud called projection.

It was inevitable that it should occur to psychologists to make

and Freud: An Art-Historical Study," *Journal of the History of Ideas*, 17, no. 2 (April, 1956): 147–78.

[28] See Giovanni Morelli, *Italian Painters: Critical Studies of Their Works*, trans. C. J. Ffoulkes (London, 1892).

[29] Edgar Wind, "Critique of Connoisseurship," *The Listener*, 64, no. 1653 (Dec. 1, 1960), pp. 975–76.

diagnostic use of the tendency to project unconscious pressures onto indifferent subject matter. For, if a person customarily sees clouds, for example, in terms of genitalia and fencing matches rather than the customary range of animals, towered citadels, mountains, and trees it suggests something about his personality structure. The Swiss psychologist Alfred Binet was first to use inkblots and ambiguous pictures with an eye to diagnosis and, while his explorations were not systematic, he paved the way for the use of "projective techniques" in clinical psychology. "The basic assumption in the use of these tests is that the subject is presented with a number of ambiguous stimuli and then invited to respond to these stimuli. By such means it is assumed that the subject projects his own needs and press and that these will appear as responses to the ambiguous stimuli."[30] To a trained observer the responses are revelatory of the hidden or latent drives of the subject. Included among such tests is the well-known Rorschach Test, consisting of ten symmetrical blots, and the Thematic Apperception Test which attempts to elicit meaningful responses to ten or twelve ambiguous pictures.

The Rorschach Test did not come into general use until a year before its author's death in 1922, but its emergence coincides with the rise of the new art and its associated psychology. During the middle of the nineteenth century a half-mad poet, Justinus Kerner, had used "inkblots on folded paper to stir his imagination and that of his friends and wrote a number of poems on the weird apparitions which these products suggested to him."[31] The invention of the Thematic Apperception Test is credited to its description in 1935 by Murray and Cristiana Morgan. H. L. Brittain, however, had published a study describing essentially the same thing as early as 1907.[32]

This vast commonality of interest is probably a direct outgrowth of specific social conditions. Freud, Nietzsche, Van Gogh and the others have been burdened with the cult of irrationalism that dominated the turn of the century but that is something of a slander. Actually they only exposed the degree to which modern civilization requires men to conceal and distort the real motives of their feelings and actions. In con-

[30] Leopold Bellak, "On the Problems of the Concept of Projection," *Projective Psychology*, eds. Lawrence Edwin Abt and Leopold Bellak (New York, 1959), p. 9.
[31] Gombrich, *Art and Illusion*, p. 186.
[32] See H. L. Brittain, "A Study in Imagination," *Pedagogical Seminary*, 14 (1907): 137–207.

trast to a tribal culture or to static feudal ones, postcapitalist societies require considerable individuation on the parts of their members. Individualism would support the dynamics of any system which relied for its survival on inventiveness and personal risk. But most of what goes on in an industrial society takes place where people are concentrated in huge masses, and accommodation of personal differences is impossible for the physical and political structures of any city. One of the realities of urban existence is that behind apparent uniformity, conflict always hides. To survive, each city dweller suppresses certain distinctive features of the self while maintaining his goal of individual distinction. Only the elite and the deviate can give in to idiosyncrasy. The habituated experience of self-repression intensifies the suspicion that behind every manifest world a latent one is hidden, and behind all consciousness an unconscious. The desire to unmask thought and to expose the antithetical natures of consciousness and being was part of the property of the late nineteenth century. Freud was not so much dependent on Hartmann, van Gogh not so much on Nietzsche, as all were dependent on a general atmosphere of crisis which marked their decades.

Just after the turn of the century there was a resurgence of the values of Impressionism, a renaissance of the enjoying spectator which, nonetheless, possessed some of the characteristics of the movement of the 1880's. First signalized in the now celebrated *Salon d'Automnes* of 1905 and 1906 this rebirth of the pleasure principle was carried through by the painters Matisse, Derain, Vlaminck, Braque, Dufy, and others. Influenced by the self-contained areas and the bright, intense colors of van Gogh and Gauguin, the paintings exhibited radical departures from tradition; they were full of what seemed "color madness." Here was a face split down the center, one segment vermilion the other bright green; there hung Vlaminck's view of the Seine barely discernible beneath splashes of pure pigment that even the most liberal of the nineteenth-century painters would have inveighed against as utterly fantastic.

Immediately the painters were labeled "Fauves," that is, "Wild Beasts," in derision.[33] Mostly, they were not wild beasts but playful puppies. Fauvism was simply an expression of joyous, pagan self-affirmation,

[33] Credit for coining the name "Fauve" usually goes to the critic Louis Vauxcelles. Supposedly, after seeing a small bronze in the Renaissance style set in the gallery reserved for the radicals, he remarked, *"Donatello au milieu des Fauves!"* (Donatello among the wild beasts!). There are, however, a number of other versions.

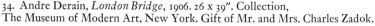
34. Andre Derain, *London Bridge*, 1906. 26 x 39". Collection,
The Museum of Modern Art, New York. Gift of Mr. and Mrs. Charles Zadok.

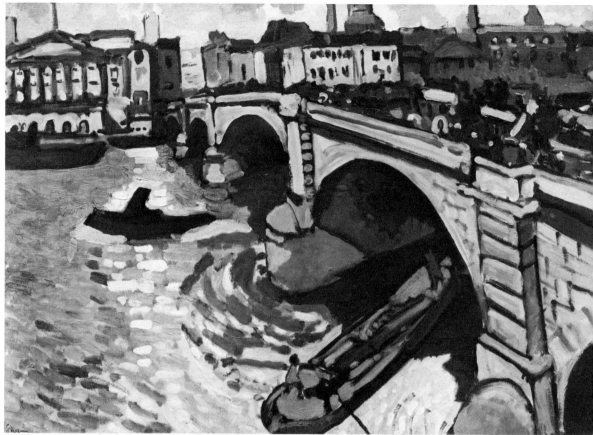

a distinctly youthful expression of rebellion and pure delight. Its paint-
ings shout their contents at you because each section of reality tends to
be seen as a single color area in drastic juxtaposition against another (Fig.
34). The world itself is accepted as having a sort of pattern based on
large massings of color. Many of the Fauves' paintings are sincere, forceful
pictures. Likable, but not of a very high order, today they seem super-
ficial, almost frivolous. This does not hold for Matisse, however; as early
as 1904 his paintings had the weight of a pondered search and a serious-
ness that had little in common with the outbursts of his compatriots. Of
the movement he said:

> Fauvism at first was a brief time when we thought it was necessary
> to exalt all colors together, sacrificing none of them. Later we went
> back to nuances, which gave us more supple elements than the flat
> even tones.

The Impressionist's aesthetic seemed just as insufficient to us as the techniques of the Louvre, and we wanted to go directly to our needs for expression. The artist, encumbered with all the techniques of the past and present, asking himself: "What do I Want?" This was the dominating anxiety of Fauvism. If he starts from within himself, and makes just three spots of color, he finds the beginnings of a release from such constraints.[34]

For Matisse the act of creation had a function that was, at once, exactly like the function it had for van Gogh and Munch and, paradoxically, precisely the opposite. Van Gogh's exertions were in accord with Schopenhauer's ideas; creativity was an escape from the interminable pain of the exterior world. As far as Matisse was concerned, the sources of joy lay within a man himself, if he could but release his feelings. His notion of expression was a translation into positive terms of the despair of the eighties. Matisse's was the painting of the self—but of the abundant, congenial self. His themes often related to the primitive but, unlike those of Gauguin, they had no contact with the mysterious or foreboding. Instead, they were pagan, joyous, completely permeated with a sense of emancipation.

In *Joy of Life* (Fig. 35), a huge canvas completed in 1907, Matisse assembled themes that had already appeared in smaller works. Joy is the theme and even the trees are characterized by an undulation that is not the fragile waviness of the 1880's, but is a robust, healthy movement. The abandon of the figures conforms to the painter's faith in spontaneous instinct as the ground for a unified view of nature. Matisse believed that reason, applied to art, would produce nothing but artifice. "Those who work in an affected style," he said, "deliberately turning their backs on nature, are in error—an artist must recognize that when he uses his reason his picture is an artifice and that when he paints he must feel that he is copying nature—and even when he consciously departs from nature he must do it with the conviction that it is only the better to interpret her."[35]

Everything must be done naturally, without affectation, in accord with the predispositions of intuition. What he was after above all, he said, was expression; he was unable to distinguish between the feeling he had for life and his way of expressing it: "All that is not useful in the picture

[34] Quoted by E. Teriade in "Matisse Speaks," *Art News Annual*, no. 21 (1952): 42–43.

[35] Henri Matisse, "Notes of a Painter," *Henri Matisse Retrospecitve Exhibition*, text and catalog by Alfred Barr, Jr. (New York, 1931), p. 35.

is detrimental," because, "Underneath this succession of moments which constitutes the superficial existence of things animate and inanimate and which is continually obscuring and transforming them, it is yet possible to search for a truer, more essential character which the artist will seize so that he may give to reality a more lasting interpretation."[36]

Small wonder that Matisse should be so often connected with the philosopher Henri Bergson who also invited everyone to capture the un-changing element in change. Bergson uses this same sort of language and his picture of the world is similar. He was an irrationalist, an eloquent spokesman for the kind of anti-intellectualism already encountered in van Gogh's cafe, in Hartmann's Unconscious, and in Nietzsche's curious dis-proofs of God. But where these others spoke for an agonized group of outcasts, Bergson represented a more polished opposition to logic and science: "In renouncing the factitious unity which the understanding im-poses on nature from the outside, we shall perhaps find its true, inward and living unity. For the effort we make to transcend pure understanding introduces us into that more vast something out of which our under-standing is cut, and from which it has detached itself. . . ."[37]

The significant factor, conscious to both Matisse and Bergson, is that both were looking for a simple and self-sufficient experience. They were not concerned with only one experience but with any such expe-rience that was truly an expression of will and not of the primacy of the intellect.

This general trend towards primitivism—in the sense of a desire for unconditioned, intuitive experience—and antirationalism can also be seen in the writings of D. H. Lawrence who asserted his literary "fauvism" in ringing tones, a somewhat embarrassing form of expression: "Let us hesi-tate no longer to announce that the sensual passions and mysteries are equally sacred with the spiritual mysteries and passions. . . . Let man only approach his own self with a deep respect, even reverence for all that the creative soul, the God-mystery within us, puts forth. Then we shall all be sound and free."[38]

Insofar as the novels of Lawrence and the paintings of Matisse reflect the values expressed in André Gide's *Les Nourritures Terrestres* and in the literary movement of Naturism they fall within a general tendency

[36] Matisse, p. 31.
[37] Henri Bergson, *Creative Evolution*, trans. Arthur Mitchell (London, 1938), p. 190.
[38] D. H. Lawrence, *Women in Love* (New York, 1920), p. v.

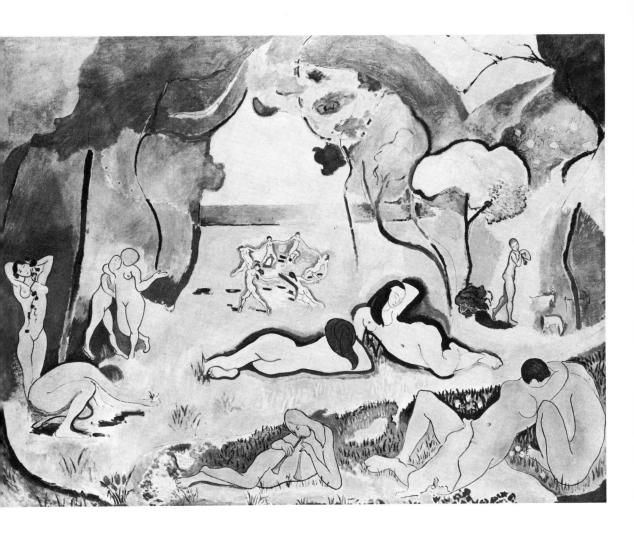

toward atavistic thought that was unfolding during the late nineteenth
and early twentieth centuries. And, to the extent that they trust intuition
over reason, they are parallel to that movement and also to the general
sentiments and, in some ways, to the actual assertions of Henri Bergson.
Of course there is nothing mysterious about this correspondence; the
whole intellectual climate was antagonistic to reasoned approaches.

It would be a canard to accuse Freud and his colleagues of anti-
intellectualism. They were physicians dedicated to curing those afflicted
with minds that did not function normally. It does appear to be the case,
however, that except in earth so fertile for the seeds of alienation and mad-
ness the systematic rationalization of unreason should never have begun.
And it is surely not mere accident that it was a popular audience that first
supported Hartmann's conception of the Unconscious, nor that artists
and poets were aware of how the projected self modified perception long
before Freud coined the term "projection."

CHAPTER FIVE

Cubism and Logic

Cubism, invented so recently as 1908, is an art of the past which no one any longer practices. But everyone who has anything to do with modern art recognizes the importance of the style, an importance that goes beyond the quality of individual pictures and resides in their bearing on the entire tradition of the past. At no other time, with respect to no other style, does one find the same sureness and intensity of the production of entirely new forms. Its advent has been compared to the Renaissance but from a historical viewpoint it is absolutely singular, perhaps the most astounding transformation in the history of art. All previous developments of such a striking character had, like the transition from Medieval to Renaissance art, taken hundreds of years, or at least the lifetime of two or three artists to be accomplished. Cubism became at once the most influential movement on the continent and directly inspired a host of derivatives—such as Italian Futurism and *Der Blaue Reiter* of Munich. It needed but one decade to become the most vital force in the art world.

What is even more astonishing is the fact that the artists participating in the movement not only created a revolution, they surpassed it, going on to create other styles of an incredible range and dissimilarity, and even devised new forms and techniques in sculpture and the ceramic arts. The reason for this may seem self-evident. The artists most active in the movement—Picasso, Braque, Gris, Villon, for example—were people who had always been highly diverse in the matter of personal styles. The range of Picasso's styles was noted at his first one-man show when he was only twenty.[1] Reviewers were astonished to find Paris street scenes in the man-

¹ See Wilhelm Boeck and Jaime Sabartés, *Picasso* (New York, 1957), pp. 32–36, 118.

ner of Lautrec bearing the same date as a harlequin in a haunting romantic style. But the extraordinary inventiveness of the early century does not depend so much upon a fortuitous marshalling of talent as it does upon the primacy of the self.

Style, for these spiritual descendents of Post-Impressionism, was not a costume identifying one with others or merely marking out one's independence. To attain a style was part of a continuous process—a process of eliciting from the self constantly new attitudes towards art and life, and of disclosing novel relationships of the personality in kinship with artistry. Having invented some new mode, they considered it only the manifestation of a temporary immediate role. For men like Picasso, Braque, and Matisse the process of form creation had itself become inviting as a practice, had become aligned with the matter of self-fulfillment. Their ideal was the liberation of that process from the habituated methods and inhibiting traditions of any single form. This is almost an expected attitude from a man like Picasso, who had already mastered the world of traditional painting at the age of fourteen and who absorbed everything else at a glance.

Pablo Picasso was the most important practitioner of Cubism, but the style was also developed by Georges Braque who had followed Picasso's experiments with great interest. We cannot say for sure that the form had a cultural existence independent of its inventors, that Braque would have invented Cubism had Picasso never been born, but the conditions for it were certainly "in the air." It is odd, after all, that the two men worked in ways so similar that their Cubist works can be told apart only with difficulty. Too, the immediate impact of the style on the painting of the avant-garde, and even on its writing, is suggestive of some sort of inevitability.

If one wishes to find a parallel to Cubism in the sense of an inexorable force revolutionizing a field of intellectual endeavor, he will find the closest thing to it in modern physics. Not only was the impact similar, so was the apparent inevitability; it is possible to suppose that the theory of relativity would have been invented whether the genius Einstein had happened on the scene or not. Furthermore, as Hunter writes, "many analogies have been drawn between Cubism and modern science, between the 'simultaneity' of vision (or shifting points of view) Picasso and Braque applied to nature, and space-time physics."[2]

As it happens those analogies are as specious as they are ubiquitous.

[2] Sam Hunter, *Modern French Painting* (New York, 1956), p. 194.

They misrepresent both Cubism and modern physics. Because they emerge with great frequency in the contexts of cultural history and art criticism—pretending to serve as unitary principles of modernity—it is important that some energy be devoted to discrediting them. In order, however, to give a somewhat comprehensive coverage of the typical absurdities of critical thinking about Cubism it might be best to discuss the matter in terms of the notion of a "fourth dimension."

The term "fourth dimension" has a unique history. Supposed by many to be part of the esoteric vocabulary of contemporary science and only that, the term is as well a household word among many nonscientific groups connected with very exotic varieties of speculation. It was invented during the seventeenth century by an Englishman, Henry More, the most mystical of an obscure group of philosophers known as the Cambridge Platonists. In his *Enchiridion Metaphysicum* More proposed a fourth dimension as the realm necessary for the Platonic ideal to occupy.[3] Given this curious background it is not at all surprising that the term and the idea should have been cordially welcomed by an intellectual curiosity of recent times known, variously, as "psychic science," "occultism," "spiritualism," and "the lunatic fringe."

The most interesting, not to say bizarre, turn given the geometry of higher dimensions was in the 1870's by the Leipzig astronomer Zöllner. He was interested in the "experiments" of an American medium named Slate who claimed direct intercourse with the spirit world and whose exhibitions consisted of causing objects to disappear and reappear. To account for these phenomena the astronomer propounded a pseudomathematical theory that has come to be universally accepted by spiritualists, occultists and, most recently, by the "flying saucerists."

> He postulated that for the real physical phenomenon there is really a space of four or more dimensions, of which we, because of our limited endowment, can appreciate only a three-dimensional section $x_4=0$. He argued that an especially gifted medium who, perhaps, is in touch with beings outside this world of ours, can remove objects from it, which would then become invisible to us, or he can bring them back again. He attempts to make these relations clear by picturing beings who are restricted to a two-dimensional surface and whose perceptions have this limitation. We may think of the mode

[3] See Robert Zimmermann, *Henry More und die vierte Dimension des Raumes* (Vienna, 1881), *passim*.

of life of certain animals, e.g. mites. If an object is removed from the surface on which these creatures live, it would appear to them to disappear entirely (that is how it is conceived) and it was in an analogous fashion that Zöllner explained Slate's experiments.[4]

The idea that Cubism might have something to do with the fourth dimension was broached very early by Guillaume Apollinaire, the poet and champion of avant-garde art, who asserted this in a lecture in 1911[5] and in a little book on Cubism later on.[6] One might assume that Apollinaire, whose writing could never claim clarity as a virtue, was using the term "fourth dimension" metaphorically, in the way Susanne K. Langer uses "virtual space" to describe a space that is not the space of the world of conventional magnitude and yet has a sense of form and reality nonetheless.[7] From his words it seems far more probable that he was speaking of Cubism as an artistic formulation of Zöllner's theories, that is, as a depiction of a spatial realm not accessible to the ordinary senses.

Whether or not Zöllner and Apollinaire were correct about dimensionality and Cubism respectively no one but a genuine medium could guess. For the ordinary person it is an open—if curiously irrelevant—question. The other variation on the dimensionality theme, however, has to do with the Theory of Relativity and thereby stakes a claim to the absolutely monumental prestige of the principal scientific development of the twentieth century.

For people already familiar with the notion of the fourth dimension as an invisible set of relations it was only a short step to the idea of temporality as a fourth dimension. The development of the four-dimensional space-time world of modern physics afforded the opportunity to take that step. As it happened, it was a misstep, but the direction was very, very appealing. That can be seen in the work of one of the most popular novelists of the modern era.

In 1895 H. G. Wells introduces us to a fashionable dinner party where "the fire burned brightly, and the soft radiance of the incandescent lights in the lilies of silver caught the bubbles that flashed and passed in our glasses."[8] One of the group is the Time Traveler who sets out to contro-

[4] Felix Klein, *Elementary Mathematics from an Advanced Standpoint*, trans. Charles A. Noble (New York, 1939), vol. II, pp. 62–63.

[5] See Edward Fry, *Cubism* (New York, 1966), p. 119.

[6] See Guillaume Apollinaire, *Les Peintres Cubistes* (Paris, 1913), p. 25.

[7] See Susanne K. Langer, *Feeling and Form* (New York, 1953).

[8] H. G. Wells, *The Time Machine* (New York, 1932), pp. 3–4.

vert some ideas that are almost universally accepted. He begins by arguing that a mathematical line, a line of nil thickness, has no "real" existence (in the prosaic as opposed to abstract sense). All present agree. Nor, he says, has a mathematical plane. Again, agreement all around. Neither, then, he proceeds, can a cube which has only length, breadth, and thickness have a real existence. At this, of course, they protest. But, Time Traveler urges, can an *instantaneous* cube exist? "Clearly," he goes on, "any real body must have extension in four directions: it must have length, breadth, thickness *and* duration. . . . There are really four dimensions, three of which we call three planes of space, and the fourth, time."[9]

Thus, by the end of the nineteenth century, serious fiction as well as pseudo-scientific writing had prepared a certain segment of the reading public to accept the idea of time as a dimension. And the appearance of the space-time world of modern physics confirmed in these people's minds the justice of the notion.

The historical background of the idea of time as a dimension in science begins with the Michelson-Morely experiments which attempted to establish the velocity of light through a hypothetical "ether," involves the theoretical merit of the theories of Einstein and the value of the hypotheses of Lorentz, and, all in all, is extremely technical both in conception and lineage. Suffice it to say that the *popular* (and quite mistaken) view of space-time is embodied in the casual statement: "Time is the fourth dimension of space." That view assumes that the prosaic or historical meaning of time as past, present, and future states is destroyed. It holds, in other words, that time in the sense of duration or of a sequence of moments is an illusion. In this respect time is viewed similarly to Zöllner's mysterious fourth dimension. In effect, all that has ever happened or ever will happen is presumed to have occurred simultaneously. Thus, everything is, from the classical standpoint, coexistent; it is only because we perceive of it in segments that we say "time passes." Time, metaphorically speaking, is a yardstick, a given space; some people (e.g., Nero) are at fifteen inches, others are at two feet, and so on and so on. Of course, since no one can see the yardstick at all except as he moves on it we quite naturally term our sequence of perceptions "temporal."

The above description may make the popular notion of simultaneity seem slightly more ridiculous than it actually is, but it is set down here in

[9] Wells, p. 4.

its most adumbrate and least elaborate form. Actually, the bare skeleton of this conception is very ancient—at least as old as Zeno (335–265 B.C.) who composed the famous paradoxes to prove that time and change are illusory.

The idea that the scientific conception of simultaneity has something to do with both prosaic dimensionality and Cubism seems to have become more and more assimilated into thinking about the art of the period since the time it was first expressed. For example, so justifiably respected a critic as Sigfried Giedion talked about it in his famous Charles Eliot Norton Lectures during 1938 and 1939:

> Cubism breaks with Renaissance perspective. It views objects relatively: that is, from several points of view, no one of which has exclusive authority. And in so dissecting objects it sees them simultaneously from all sides—from above and below, from inside and outside. . . . Thus, to the three dimensions of the Renaissance which have held good as constituent facts throughout so many centuries there is added a fourth one—time. . . . The presentation of objects from several points of view introduces a principle which is intimately bound up with modern life—simultaneity. It is a temporal coincidence that Einstein should have begun his famous work, *Elektrodynamik bewegter Korper*, in 1905 with a careful definition of simultaneity.[10]

One finds this also in Kahnweiler's 1920 essay *The Way of Cubism*.[11] And almost the same interpretation recurs all through Moholy-Nagy's influential design text *Vision in Motion* of 1947.[12] It appears to have been something of an article of faith with the Bauhaus.

Giedion's opinion, however, had been expressed in a much more explicit way in an article written by the minor Cubist, Metzinger, very early in the century and hinted at in the book *Du Cubisme* by him and Gleizes later on.[13] His idea was to justify the Cubist method of drawing with the new physics by attempting to show that Cubism, while apparently irrelevant to reality did, in fact, present a truer picture of things because it represented time as the new theories did, as a dimension. According to Metzinger, what the Cubist did was to present as simultaneous, successive

[10] Sigfried Giedion, *Space, Time and Architecture* (Cambridge, 1941), p. 357.
[11] See Daniel Henry Kahnweiler, *Der Weg zum Kubismus* (Munich, 1920), pp. 29–31.
[12] See Laszlo Moholy-Nagy, *Vision in Motion* (Chicago, 1947), pp. 113–28, 266.
[13] See Albert Gleizes and Jean Metzinger, *Du Cubisme* (Paris, 1912), p. 13.

moments of vision.[14] The view has become increasingly fashionable since and is, indeed, a cliché of contemporary criticism.

Curiously enough, there has been from the very first a tendency to apply the ideas of physics to Cubism without any attempt to "check out" either the ideas themselves or their applications. And as a flagrant falsehood is perpetuated it begins to sound more and more reasonable since it is met with more and more often.

Now, one has only to examine Cubist painting by its major practitioners to observe that their forms could not possibly have been arrived at by the procedure outlined by Metzinger. No conceivable superpositioning of given objects would produce a *Ma Jolie* (Fig. 36) unless the fractioning of those elements were carried out to an extremity altogether uncalled for by the explanation. In fact, a Cubist image is made up not of elements of fractured objects but, instead, is built from fragments of elements. That is to say, one does not discover there a piece of a vessel, a segment of an eyeball, a part of a table; one finds instead no more than the lines and strokes that might represent such things were they brought into other relationships.

Still, what is most peculiar about Metzinger's theory, in view of its prominence, is that at the very time he was propounding it, Einstein was proving the impossibility of establishing the simultaneity of any two events that do not occur approximately, that is, side by side. So far as the Special Theory of Relativity is concerned, the sole difference between it and classical science lies precisely in Relativity's *denial* of the absoluteness of the simultaneity of spatially separated events. Had the Cubists really been consistent with the new developments in physics they would have demolished simultaneity! After all, the presentation of simultaneous images had been common practice in architectural and machine drawing since the Renaissance, by way of elevations and projections which showed at once the top, sides, front and back of an object.

What, then, is meant when a scientist says that time is the fourth dimension of space? It means that he is speaking very loosely; what he should say is: "Time is a fourth dimension of the space-time world," or more exactly: "Time is one of four space-time parameters in a physical theory." And what he then means has to do with mathematical expressions exclusively, for the Theory of Relativity sought to resolve all distinctions

[14] See Jean Metzinger, "Cubisme et tradition," *Paris-Journal* (18 August 1911); trans. in Edward Fry, *Cubism* (New York, 1966), pp. 66–67.

as to determinations of temporality and position into the unity of purely numerical determinations.

> The particularity of each "event" is expressed by the four numbers x_1, x_2, x_3, x_4, whereby those numbers among themselves have reference to no differences so that some of them x_1, x_2, x_3, cannot be brought into a special group of "spatial" coordinates and contrasted with the "time" coordinate x_4 The direction into the past and that into the future are distinguished from each other in this form of the concept of the world by nothing more than $+$ and $-$ directions in space, which we can determine by arbitrary definition.[15]

What has happened is that the concept of an inertial system has been displaced by that of a field which depends on the concept of the total field that Einstein said is "the only means of description of the real world. . . . The space aspect of things is then completely represented by a field, which depends on four coordinate parameters; it is a quality of this field. If we think of the field as being removed, there is no "space" which remains, since space does not have an independent existence."[16]

The author is no less aware than his reader that a thorough understanding of these matters presupposes a more than rudimentary grasp of the calculus. The point, though, is that that particular attainment is quite unnecessary to an understanding of Cubism. Surely, it must be obvious to any careful reader that the space of painting cannot accommodate the field concept of modern physics; those two things have nothing in common. What is more, the paintings do not represent such a concept symbolically. The fragmentations of Cubist art did not derive from simultaneous presentations of shifting points of view, but even if they had they would be unconnected with the Theory of Relativity. Thus, it can be argued that the entire notion of a hermetic connection between Einstein's theory and Cubism is false. And, in fact, Einstein himself voided the connection. Responding to an essay sent him in manuscript which argued more-or-less the position I have been attacking in these pages, Einstein—after a very generous explanation of his own sense for some real connection between art and science—commented: "Now, as to the comparison in your paper, the essence of the Theory of Relativity has been incor-

[15] Ernst Cassirer, *Substance and Function and Einstein's Theory of Relativity* (New York, 1953), pp. 448–49.

[16] Albert Einstein, *Generalization of Gravitation Theory*, Appendix II, from *The Meaning of Relativity* (Princeton, 1953), p. 163.

36. Pablo Picasso, *Ma Jolie*, 1911–12. 39⅜ x 25¾″. Collection, The Museum of Modern Art, New York. Acquired through the Lillie P. Bliss Bequest.

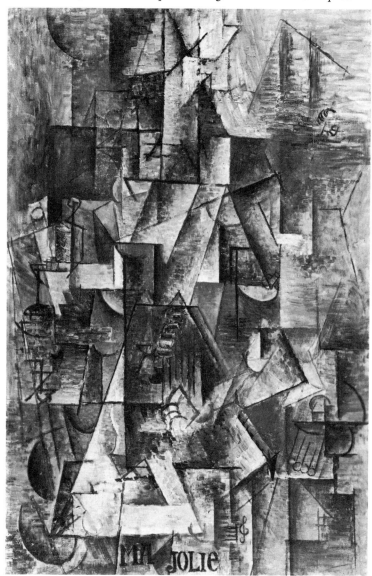

rectly understood in it, granted that this error is suggested by the attempts at popularization of the theory." He then said pretty much what has been said here regarding the theory and closes with the remark that "this new artistic 'language' has nothing in common with the Theory of Relativity."[17]

Cubism has nothing to do with the Theory of Relativity and that is the end of the matter. To argue this, however, is not to assert the absence of any significant relationship between the painting style and modern

[17] See Paul M. Laporte, "Cubism and Relativity," *Art Journal*, 25, no. 3 (Spring, 1966): 246–48 wherein the letter is quoted in full.

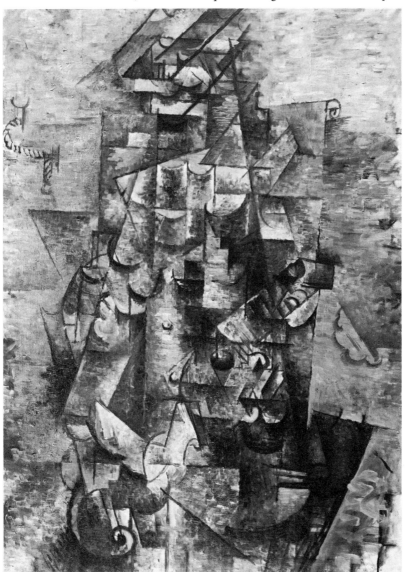

science—or, more definitively, between Cubism and the total culture to
which science has contributed so vast an influence. Besides, the promi-
nence of a belief in some kind of hermetic geometry associated with the
paintings done between 1909 and 1913 is inescapable and should somehow
be accounted for. It is due, most probably, to the sheer appearance of the
analytical Cubist works which, in their typical form, are possessed of a
peculiarly uncanny space.

In Cubism, Cézanne's method of rendering solid objects in such a
way that they retained both their volume and a frontal stability was
brought to a sort of zenith. In Picasso and in Braque (Fig. 37) the objects

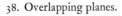

38. Overlapping planes.

or areas have a certain kind of stability but there is no enclosure of space in the old sense. Their fascination with continuities and discontinuities makes it very difficult for us to separate figures from their background. For anyone it is easy to see that in Figure 38 plane P lies between O and Q; the arrangement is of an ordered set. But with regard to Figure 39, a schematic drawing that takes the Cubist image as a point of departure, the viewer is unable to establish the position of P in space; possibly it lies both ahead and behind the other lines and planes. This ambiguity is not due to a transparency of the forms—to some curious crystallinity—but is instead the product of the arrangement of continuities and discontinuities. So it is in Cubist paintings. Lines are prolonged through planes, edges vanish before they intersect other edges. All this makes for an increased complexity of the frontal plane and for an unclearness of relations among the parts of the pictures. Therefore the space of a Cubist work becomes highly elusive. Although it affords a definite illusion of depth the space of Cubism is an uncanny sort of space on which the viewer can never put his finger or rest his mind. We cannot refer to the picture plane as a screen behind which objects, or parts of objects, exist. But neither can we say that the picture is without the illusion of space, merely frontal, for at times the space appears even to protrude out into the world. There is something here far more complex in its meanings than the old counterchange devices of the pattern-making arts in which figures, like the stripes of the zebra or the squares on a chessboard, are constantly competing with their backgrounds. Briefly, Cubism amounts to a maximization of the unordered set or series; it is a glorification of the non–a priori constructions of Paul

39. "Cubistic" relationships.

Cézanne. That aspect of the style has surely inspired a great deal of far-fetched speculation about its connection with seemingly mysterious inventions in the narrow regions of thought with which art historians are normally unfamiliar.

As a style, Cubism began and ended with the assumption that nature and art are two utterly dissimilar phenomena, the one absolutely accidental and informal, the other rigorously formal and self-sufficient. In this it was the summing up of all that had been present in the hygienic, detached art of Georges Seurat and represented the furthest extension of Cézanne's preoccupation with completeness and order. It was the first non-ornamental painting to represent nothing but itself, to assume that a painting is only a painting just as a building is a building and that a picture ought look no more like a segment of real space than a house ought to resemble a baker's roll.

It is interesting that in such formal painting, which represents the ultimate removal of art from the literary content of Classicism and Romanticism, actual words so often appear. The fact is instructive. For there is a world of difference between writing as a literary process and writing as script or printed type, that is, as lettering. A letter is just one sort of mark or combination of marks. And marks need not be judged by any relation to signification unless they are in a conventional context. The Cubists eliminated conventional relations from words–from, say, "Ma jolie," the title of a popular song—and treated them as visual forms, as shapes. Since a Cubist painting is subject to all the demands related to our perception of the work our sense of artistic form is not violated simply

because the day's dance hall tune has been introduced into the painting. None of this is like the syntax of Cézanne who had to realize the visible in order to realize the form. For the Cubists Cézanne's mimetic requirements did not exist. They divorced, for the first time in history, the means of representation from the objects represented.

The Cubists substituted for the objects rendered by the artist the objects created by him, that is, the pictures themselves. This is not to say that Cubism was without a class of themes. Its most frequent subjects are still-life objects drawn, like Cézanne's, from casual bohemian life. But in principle, at least, it did not matter what was painted. Picasso spoke of the mode of representation being distinct from anything represented: "Art has always been art and not nature. And from the point of view of art there are no concrete or abstract forms, but only forms which are more or less convincing lies. . . . Cubism is no different from any other school of painting."[18]

Looking back, one can see that the thing was bound to emerge from its past. Whistler and Pater had talked rather like that during the eighties. It was only a question of time before someone—if not Picasso or Braque, then Matisse—attempted to turn painting into an art of pure construction like musical composition. It was one of those ideas whose time had come. Moreover, the style ensigned the emergence of an utterly new critical attitude towards all art.

When Henri Matisse said that upon seeing the Giotto frescoes at Padua he did not trouble to recognize which scene of the life of Christ he had before him but perceived "instantly the sentiment which radiates from it and is instinct in every line and color,"[19] he was putting into a painter's language what "Formalist" critics Roger Fry and Clive Bell were calling "Significant Form." In 1914 Bell wrote: "The representative element in a work of art may or may not be harmful; always it is irrelevant. For, to appreciate a work of art we need bring with us nothing from life, no knowledge of its ideas and affairs, no familiarity with its emotions. Art transports us from the world of man's activity to a world of aesthetic exaltation. . . . It is a world with emotions of its own."[20] By 1928, in a new edition of his book, Bell was arguing that realistic forms in an otherwise good composition tended, because of their extra-aesthetic references, to

[18] Pablo Picasso in a statement quoted by Marius de Zayas in "Picasso Speaks," *The Arts* (New York, 1923), p. 319.

[19] Matisse, p. 32.

[20] Clive Bell, *Art* (London, 1914), p. 26.

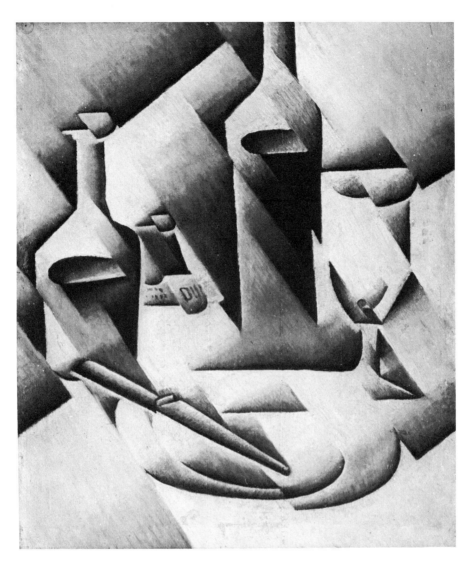

distract one from the relationships of lines and colors that constitute the picture. Formalism—which came to be the dominant school of art criticism in Anglo-Saxon nations—viewed every subject as a mere pretext. Where classical critics saw form as a condition of the contents, the Formalists saw the contents as, at best, merely the raw material of form, at worst as disruptive, and never as a constitutive element of artistic value.

Probably, Formalist convictions about the priority of pure form over subject-matter were reinforced by a development of the Cubist style that occurred between 1912 and the appearance of Bell's second edition. Around 1912 Cubist painting began to tend towards the elimination of modeling (Fig. 40), and shortly thereafter the collage made its appearance. *Collage* means "glued matter" and was an appropriate name for works in which materials other than paint were applied to the surface of

41. Georges Braque, *Guitar and Clarinet*, 1918. 30⅜ x 37⅜″.
Philadelphia Museum of Art. The Louise and Walter Arensberg Collection.

the canvas. The goal of the collage artist was the attainment of maximum
concreteness and the notion of painting as handicraft was, perhaps, real-
ized most completely in the *papier collés* of the Cubists. Prefabricated
pattern matter was used, but if it was something like a newspaper it could
not be read except as a formal element of the composition because it was
inverted, turned on its side, or smeared with pigment. And there was still
the ambiguous space of earlier work. In *Guitar and Clarinet* by Braque
(Fig. 41) we can't quite settle upon the true relationship of the paper to
the cardboard. Are the forms cut from the paper or are they the result of
the cardboard overlaying it? Or is one created in one way, and another in
the other? The work is clearly Cubist, but as Picasso and Braque began to
give to collage elements a new concreteness they also began to lend them
the function of reconstituting the picture plane that early Cubism had
destroyed.

By 1918 the process of de-spatializing things by breaking them up

into lines and marks had reversed itself. Out of the strokes the solid zone was reinstated. This period in the work of Picasso (Fig. 42), Braque, Gris, and Leger is often called "synthetic" Cubism (after Apollinaire, who also invented the term "analytic" Cubism for the earlier style). The paintings were still characterized by great artifice and ambiguity and were still conceived of as the composite results of the operations of the artist. Gris, in his letters, described the process as a matter of beginning with an abstraction and seeing something into it, the objects coming into being only by virtue of the abstract forms that existed beforehand in the mind of the painter.[21]

Certainly, it is hard to imagine Picasso painting his *The Red Table-cloth* in so strictly deductive a manner. The work is extremely rich in its orchestration of color, that is, in the transpositions and groupings of hues

[21] See Daniel Henry Kahnweiler, *Juan Gris, His Life and Work*, trans. Douglas Cooper (London, 1947), *passim*.

and tones. And it is never possible to find identical pairings or triplings. Still, Picasso always makes it obvious that the artist is at work imposing order on reality. He breaks up a border for no reason having anything to do with natural appearances or sunlight. He has painted the cast of a classical head black. And his melon is a pale violet. Only an exceptional painter would feel the need of a lavender melon there. Why not a red one to match the tablecloth? It lends itself to the hue, after all. Partly, I suppose, because this is the home of the successful Picasso, a wealthy aesthete, and in France watermelon are fed to the swine. But a violet melon? Is this curiously colored fruit a pure whim on the artist's part? No, the melon is part of a passage from the blue sky through the window to the tablecloth. One feels that it could not be else but lavender and yet be so absolutely right. Again, the ability to divorce the means from the subject-matter manifests itself in an original and exciting form. But it seems all too imaginative to be contained by Gris's explanation.

Probably, Gris's was not an accurate description of the method of other synthetic Cubists. But it is of great interest because it so clearly affirms the confidence of the artists in the priority of formal constructions independent of nature. Their assuredness parallels the faith of the Formalist critics. And these moderns had relatives in every field. Gertrude Stein's poetry, Schoenberg's music, the philosophical thought of Wittgenstein and the Vienna Circle, Cubism, and Formalist criticism all typify a general tendency in twentieth-century life towards the "construct" that is sufficient unto itself, ordered according to its own laws, dissociated from any moral cause, and associated exclusively with the hermetic experience of man confronted by man's creations. Nowhere is the tendency better exemplified than in physical science where the discipline of mathematics was being explored with a new passion for the purely structural, just as the Cubists explored painting in terms of its purely artistic side.

In the world of theoretical clarities the closest parallel to Cubism will be found in the modern logics, for they too separate the mode of representation from the thing represented.[22] Usually the three main schools of

[22] It should be clearly understood that the pursuit of mathematical knowledge has been forever undertaken without much regard for its extramathematical functions. To this extent parallels between the new mathematics and painting are strained compared to ones that might be drawn with modern music. For music has always been nonrepresentational and the new emphasis on formal structure inaugurated by Schoenberg, Stravinsky, and Hindemith merely reinforced awareness of the fact. A similar statement could be made about the relation of modern mathematical thought to its tradition. Thus, so far as their relation to the past was concerned, the Cubists and Gertrude Stein were far more radical

modern logic are discussed in terms of some differences that have provoked a considerable controversy among mathematicians of various persuasion and, no doubt, disparate temperaments. Of these schools none is more controversial than Intuitionism, born in 1908.

Though the word "intuitionism" conjures up ideas of Bergsonian rationalism, of mystical formulations (which are indeed present in the doctrine but can be disregarded as irrelevant), and heedless guesswork, Intuitionism in logic is very close to an ultimate empiricism. As a matter of fact its main effect was to separate clearly mathematics as a science from logic, a formal activity. The Dutch mathematician L. E. J. Brouwer, leader of the school, challenged the traditional view of mathematics as a pure tautology proceeding from certain premises: "In agreement with the empiricist conception of science, intuitionism holds that the source of mathematics is the insight which we intuitively comprehend from experience of the external world, but which cannot once and for all be collected in a closed system of axioms."[23]

Brouwer's conception of mathematics introduced, for the first time in centuries, new problems into elementary logic. And some of his followers—notably A. Heyting—developed, in fact, an Intuitionist logic. In either mathematics or logic, the most revolutionary part of Intuitionism was its denial of the law of the excluded middle, Aristotle's *tertium non datur*. This law is the either-or of logic. Besides the two statements "There is at least one rose in my garden" and "There are no roses in my garden" many people believe that Brouwer's theory introduces a third possibility, a *tertium quid*.[24] But that is not true. The validity of the law of the excluded middle is questioned in no case of extramathematical application. And even within mathematics it remains absolutely unshaken so long as one deals with finite sets. With regard to infinite sets, however, the situation is special.

In his *Evolution of Mathematical Thought*, Meschkowski uses an

than were contemporary mathematicians or musicians. What is of interest is the universality of the concern with pure form—re-emphasized in fields where one takes it for granted, emergent in those where its priority had previously been denied.

[23] Mises, *Positivism*, p. 129.

[24] The rule of the excluded middle has been most frequently attacked by the General Semanticists, whose bible is Alfred Korzybski's *Science and Sanity*, a "non-Aristotelian" work that emphasizes the application of semantics to problems of general sociology. The emphasis in their argument, however, is not on logic but on the influence language has on rational (as distinct from logical) thinking, a point often overlooked by the professional philosophers who tend to disparage the movement and also by popular writers such as Stuart Chase who tend to glorify it.

example from number theory to make this clear. In 1742 one C. Goldbach had conjectured that every even number, excepting 2, could be represented by the sum of two prime numbers. Thus $4=2+2$, $8=5+3$, $10=7+3$, $18=13+5$, and so forth. The fact is that there is no known even number for which the partitioning into primes is not possible, but that does not prove Goldbach's conjecture true. To prove it false, of course, all one has to do is to discover an even number for which the rule does not hold. It would appear, then, that either there is such a number or there is not, that is:

(1) *Either* all even numbers can be written as the sum of two prime numbers,

 Or there are even numbers for which this does not hold, *tertium non datur*.[25]

However, if the number theoretician wished to show that Goldbach was right, then he obviously cannot examine all the natural numbers. He would have to prove that it can be inferred from the characteristic of an even number that the number is equal to the sum of two primes. The either-or (1) would have to be formulated precisely:

(2) *Either* it can be inferred from the characteristic of an even number that the number can be written as the sum of two prime numbers,

 Or there exists a procedure for calculating a counterexample.

It is clear that there is no genuine alternative. Yet the two opposing statements are not contradictory. The validity of the choice in form (1) is indisputable if we restrict ourselves to a statement about a *finite* set of numbers, e.g., the Goldbach conjecture is *either* true *or* false for all of the even numbers in the Berlin telephone book. . . . However, it is an inadmissible generalization to carry over to infinite sets this inference which is justified for finite sets. The consideration of Goldbach's conjecture developed here is equally valid for other statements about natural numbers and also about elements of arbitrary infinite sets.[26]

One can see that, in dealing with infinite sets, it might well be that one could not find, on running through the numbers, one that is neither even but not reducible to two primes, nor a proof of the Goldbach conjecture derivable by means of mathematics.

[25] Herbert Meschkowski, *Evolution of Mathematical Thought*, trans. Jane H. Gayl (San Francisco, 1965), p. 56.
[26] Meschkowski, p. 56.

David Hilbert, who worked out the axiomatics of the non-Euclidean geometries, was also among the first to object to Brouwer's thesis. One of his motives in this seems to have been to defend the nature of what is called set theory, an invention of the German George Cantor whose particular contribution was his theory of infinite sets and transfinite numbers.[27] This development had given all of mathematical thought a purity and an autonomy denied to other forms of effective thinking and Hilbert swore: "No one shall drive us from the paradise which Cantor created for us."[28] In order not to be driven out by Intuitionism he and the Formalist school led by him presented a new foundation for mathematics which justified residence in Cantor's "paradise."

Hilbert acknowledged that the objections of the Intuitionists to unlimited application of the law of the excluded middle were just. But, not wishing to diminish mathematics because of that, he proceeded to "formalize" the method of proof in mathematics. His procedures could not possibly be understood by nonmathematicians unfamiliar with set theory and even a reasonable caricature using sentential logic would presuppose some sophistication about rules of implication, *modus ponens* and *modus tolens*. Suffice it to say that for the Formalists mathematics in the narrow sense is replaceable by an utterly mechanical method for deriving formulae and has nothing to do with the meaning or interpretation of the symbols used. Someone has described this kind of mathematics as "a game played according to simple rules with meaningless marks on paper." Of course, this is said facetiously; there was nothing arbitrary about Hilbert's procedures. Mises wrote that "Certain aggregates of symbols are assumed as premises; these are the axioms, and from them further groups of signs are derived according to the fixed rules in a purely mechanical manner, i.e., without the use of conclusions drawn from their interpretation; the new groups are then the provable theorems. Thus, the entire content of mathematics is, according to Hilbert, transformable, in principle, into a system of symbolic formulas."[29] Hence, the Formalist doctrine is almost exactly similar to the Cubist ideal except in that the one deals in axioms and rules for the combination of signs whereas the other deals in lines and marks and the "rules" for their combination.

As for the law of the excluded middle, which Hilbert was eager to

[27] Cf. Stephen F. Barker, *Philosophy of Mathematics* (Englewood Cliffs, N. J., 1964), p. 63.

[28] Quoted in Meschkowski, p. 47 and elsewhere.

[29] Mises, p. 132.

admit into his formal system, he wrote: "Operating with the infinite can only be made certain by the finite. The role which is left to the infinite is purely that of an idea—if in Kant's words an idea is understood to be a concept of reason, which exceeds all experience and by which the concrete in the sense of totality is completed—an idea, moreover, which we may trust without hesitation in the framework which has been fixed by theory outlined and upheld by me here."[30] In this connection it should be made clear that besides the system of formulas Hilbert proposed something else which serves as their justification and is called "metamathematics." This seems to comprise all of the arguments that lead to the proof of consistency in the formal system itself. "By a consistency proof is meant the proof that a certain 'false' formula, e.g., the formula '$1=2$' cannot be derived."[31] Hilbert hoped that he could conduct his consistency proof with "finite" methods that would be recognized by the Intuitionists, thus showing that even the unlimited use of the law of the excluded middle would not lead to an internal contradiction.

> But where do the intuitionists stand on this "synthesis"? Brouwer rejected Hilbert's program. In his view an incorrect theory that does not lead to a contradiction is on this account no less incorrect just as a criminal not condemned surely is still a criminal. Hilbert replied that to forbid a mathematician the use of the *tertium non datur* "would be like denying the astronomer the telescope or the boxer the use of his fists." It was always considered the special glory of mathematics that it recognizes no conflicts of opinion. It lost this renown by discussions of fundamental questions which reach into the realm of philosophy.[32]

In view of this extension into philosophy it is appropriate that the leader of the third party in the controversy over the foundations of mathematics should be best known, not as a mathematician, but as a philosopher. Too, he was an Englishman and the only philosopher of his nation since John Stuart Mill to combine so much intellectual power, wit, cultivation, and passion for liberty.[33] Moreover, he expressed himself on everything from education to war—not always very carefully—and he was one of the most distinguished masters of English prose of the last two

[30] Quoted in Meschkowski, p. 96.
[31] Mises, p. 133.
[32] Meschkowski, p. 97.
[33] Cf. Morton White, *The Age of Analysis* (New York, 1955), p. 194.

centuries. It may seem strange that the magnum opus of such a man is in the field of mathematics. But when the title is given—*Principia Mathematica*—nothing seems more plausible than that one of the authors was Lord Bertrand Russell.

In *Principia Mathematica* Russell, together with Alfred North Whitehead, attempted to reduce mathematics to its fundamental and most plausible elements. In doing so, he began with the preliminary studies of the mathematician Frege who had attempted to demonstrate that "arithmetic, and pure mathematics generally, is nothing but a prolongation of deductive logic."[34] As the synthetic Cubist, according to Gris, began with an abstraction into which he "read" objects, Russell and Whitehead began with a pure logic from which they developed a mathematics:

> It would have been out of the question to derive any part of mathematics from the traditional Aristotelian logic; a much more powerful system of logic than that is required. Frege and Whitehead and Russell contributed in very important ways to working out the laws of this modern and more powerful logic. It is essential to notice that, for their purposes, the terms "set" and "ordered pair" and the laws governing sets and ordered pairs were counted as belonging to logic rather than to mathematics.[35]

The content of *Principia Mathematica* is of an extreme profundity and is far beyond the scope of this book or the grasp of this author. But some notion of the character of Russell's work may be had from his handling of paradoxes. Paradox itself is a curiosity which seems to threaten the very foundations of logic and mathematics: "In Russell's opinion . . . the paradoxes originate from a vicious circle. Consequently, he ensured their elimination by meticulously applying the so-called *vicious-circle principle*, which is stated as follows: 'Whatever involves all of a collection must not be one of the collection.' "[36] When that principle is applied to certain nonmathematical paradoxes the notion seems so obvious as to be trivial. For instance, in the case of the ancient Epimenides the Cretan who

[34] Russell, p. 830.

[35] Barker, p. 80.

[36] Evert W. Beth, *The Foundations of Mathematics* (Amsterdam, 1959), p. 497. Beth does not consider Russell's most famous popular example of a paradox—the one which asks who shaves the barber in a village where all who do not shave themselves are shaved by the barber—an "authentic" paradox. For those with a serious interest in the three philosophies of mathematics, and particularly those interested in Intuitionism, this work by an authority in the field is extremely thorough.

says "I am lying" it is clear that if he lies then what he says is false and he must be speaking truthfully. On the other hand, if he speaks the truth he must, therefore, be lying. All that Russell's principle says is that such a problem is inadmissable. His *theory of logical types* which distinguishes between individuals, sets, families of sets, and so on, representing these, respectively, by variables $x_0, y_0, z_0, \ldots, x_1, y_1, \ldots, x_2, \ldots$, does not permit the admission of a formula such as $x_0(x_0)$, which is how the liar paradox would be symbolized. The arguments become very quickly hard to follow. This is not because Russell's language is opaque; if anything, his language is baffling in its clarity. But his insights are very close to the equivalents of the laws of purest thought and few of us can cope with this kind of strictness. That pristine ideas should be esoteric while impure and complicated ones are accessible to every dunce may seem curious, but that this is so has been recognized by thinkers from very ancient times.

Russell's formulation of the foundations of mathematics entails an analysis of mathematics as a formal system derived from purely deductive principles. There is, here, no concern with nor reference to the empirical side of mathematics, that is, to applied mathematics. However, it should be pointed out that which elements of mathematics are really the most purely deductive or simplest and most plausible remains to be decided.[37] Is the concept of number sequence, of the cardinality of numbers, less simple than the successor, the one-to-one coordination of elements? The answer may depend entirely upon the aesthetic feelings of individual mathematicians about these relationships.

Whether or not Russell's system can ever command universal acceptance is of no consequence in this context. The important thing is that the Logicists (as followers of the Russell school are called) no less than the Intuitionists and the Formalists explore the discipline of mathematics as an exclusively formal activity, just as Cubists explored painting in terms of its purely artistic side. Intuitionism, though it stands somewhat apart from the other schools in being more concerned with the relation of mathematics to experience, is occupied with structural problems, particularly those bearing upon the nature of mathematical proof. On the other hand, the Intuitionists (particularly Brouwer) accept absurdity as a basic notion in mathematics; in a way they may have some closer ties with the artists of the succeeding chapter than to the Cubists. I cannot

[37] Cf. Mises, p. 134.

forbear, in this connection, quoting from a marvelous little book by Mlle Lucienne Félix:

> Even a sketchy outline of any intellectual specialty in our century involves comparisons with bordering activities. It is as if, with the disappearance of the universal man (such as Leonardo da Vinci), more or less conscious influences have worked to establish in society as a whole the connection between specialties which formerly could exist within the mind of one man. These influences, so far as thought is concerned, almost always originate in the material contributed by mathematics or physics, and the terms of comparison follow in this order: mathematics, music, painting, poetry.[38]

[38] Lucienne Félix, *The Modern Aspect of Mathematics*, trans. Julius and Fancille Hlavaty (New York, 1960), p. 15. This is a fascinating work which deals mostly with the group of French mathematicians who publish under the pseudonym Nicolas Bourbaki. But even this rational Frenchwoman has been led to believe in the simultaneity myth. She writes on page 23: "The Cubist studied forms; any cross section could be useful. He even worked in time-space!"

I should also like to mention here an extremely useful work which I have had no occasion to cite but which has been of considerable assistance: Robert M. Exner and Myron F. Rosskopf, *Logic in Elementary Mathematics* (New York, 1959).

Conformity as Rebellion—
Expressionism, Dada, Surrealism

THE RECOGNITION that shapes, colors, textures, lines and space—the tractable elements of painting—had not only the ability to satisfy the more intellectual conditions of the formal impulse, but had as well the power to express feeling directly had been present in Seurat, was an impulse to form in van Gogh and Munch, and was a conditioning factor in the art of Henri Matisse. In Germany, during the time of the Cubist revolution, this assumption that a pictorial image conveys feelings through the peculiar provocativeness of shapes and colors became the sine qua non of artistic activity. *Die Brücke*, a movement founded in 1905 by Ernst Ludwig Kirchner, Erich Heckel, and Fritz Bleyl, initiated what is now called "German Expressionism." Superficially similar to Fauve paintings, the art of *Die Brücke* was far more pessimistic about the nature of man. Its fire was the flaming brand of a Zarathustra rather than the bright candle of Bergson, and it is no accident that several members of the group were ardent Nietzscheans.[1] The very name, *Die Brücke* (The Bridge), corresponds to the notion of the soul in crucial transition.

Thematically, the movement responded to van Gogh's idea of the external world infused with the feelings and values of the artist. In all of it there was a decided image character issuing from the inclinations of the artists. Nolde's woodcut of 1912, *The Prophet*, (Fig. 43) seems to have been ripped from a plank by the maddened fingers of a talented lunatic. Even the landscapes of this school seem prompted by an anguish proceeding from the mere "look" of things.

Formally, the paintings of this Dresden school did not differ in any

[1] Cf. Zigrosser, *The Expressionists*, p. 11.

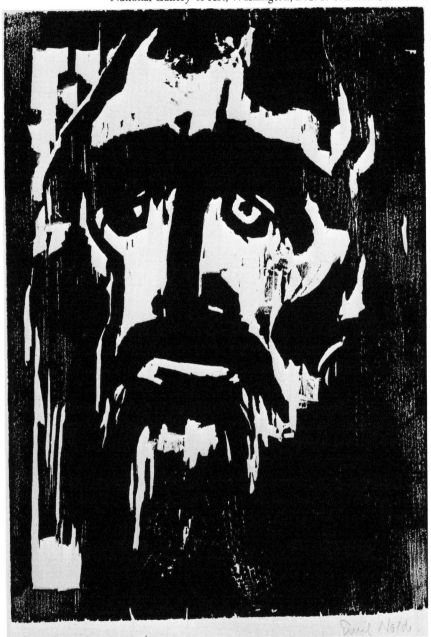

important way from van Gogh, Munch, and the Fauves who were their inspiration. But a bit later, in Munich, a much more advanced movement came into being. Called *Der Blaue Reiter* (The Blue Rider) its art was typified by Kandinsky, Franz Marc, Paul Klee, Macke, Jawlensky, and

129

the American, Feininger. Without the experience of Cubism the work of none of these men would have been possible. It too was abstract, that is, its aims were not primarily representational, but in other respects it could hardly have been more different.

Wassily Kandinsky's work (Fig. 44) was, by the beginning of 1911, completely divorced from the representational. But despite this—and in this respect he was far more extreme than Picasso or Braque—he was little concerned with a pure aestheticism. No, his intention was to express the emotion of an ardent spirit without recourse to any extrapersonal symbols whatsoever: "Whatever I might say about myself or my pictures can touch the pure artistic meaning only superficially. The observer must learn to look at the picture as a graphic representation of a mood and not as a representation of objects."[2]

This intention is quite different from the tradition of lyrical romantic painting which also tried to express mood, for the traditional painter always retained in his work the things—the gloomy forests, lonely beaches, sunny meadows, whatever—which provoked the mood. Kandinsky, instead "looks upon the mood as wholly a function of his personality or some special faculty of his spirit; and he selects colors and patterns which have for him the strongest correspondence to his state of mind, precisely because they are not tied sensibly to objects but emerge freely from his excited fantasy."[3]

Kandinsky's intention removed from the world of abstraction all of the elements of detached deliberateness inherent in Cubism. Unlike the color of most Cubists (except the "Section d'Or" splinter group headed by Delaunay), Kandinsky's color was bright. And this rich abundant color was associated with something that was still more radical: a thin, scrawling line made by the brush or pen. This line, as in Ensor, was the result of a lay, vernacular use of the instruments of art. It was, however, essential to the achievement of Kandinsky's artistic ends. Such a "doodled" line pertains to the self in the most pristine and basic kind of way, in the completely automatic outworking of the unconscious. It follows one's impulses in an utterly free and apparently random fashion, yet, as is the case with handwriting, is intimately bound up with the covert self. Furthermore, these pictures are full of conflict. Often a line will be scratched over as if to be gotten rid of. Kandinsky, by the simple ex-

[2] Quoted in Bernard S. Myers, *The German Expressionists* (New York, 1957), p. 214.
[3] Schapiro, "Nature of Abstract Art," p. 87.

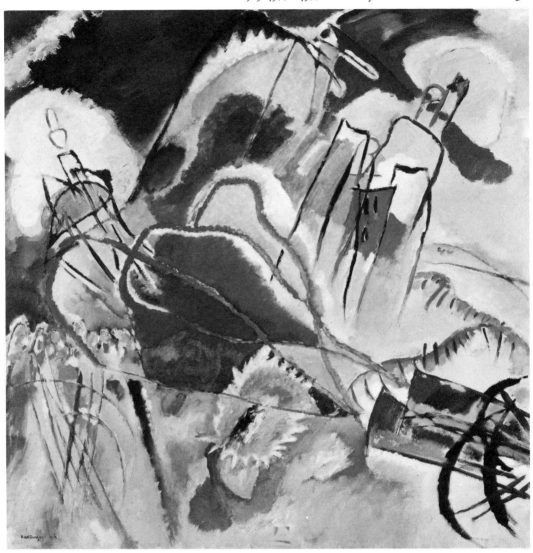

pedient of introducing into his work this kind of line, generally containing all the elements of automatic writing (with its themes of scribble, erasure, destruction), thereby involved his art with the unconscious and made his painting expressive in a peculiarly personal way. By this means the "secret handwriting" of the artist—traditionally disclosed in the microstructure of the brushwork and in the rendering of insignificant details of composition—was magnified and made the basis of communication.

Still, although an "untrained" way of making marks was utilized, the

pictures themselves radiate accomplishment. In a Kandinsky of the period preceding World War I no region is without its own special character and, still, each region is assimilated to all of the others. Through reflection and constant attention and alteration the painter ordered his random responses and reflexive actions into a composition. Hence, although no particular mood or emotion is acknowledged at the outset, and while the very impulsiveness of the creator is the starting point for the picture, eventually the painting is resolved into an objective symbol that is the visual equivalent of a mood. Like the moods evoked by a concerto they are the property only of the composer and kindred spirits who attend him. In fact Kandinsky, who had studied music as seriously as he had art, envied the position of the composer:

> A painter who finds no satisfaction in mere representation, however artistic, in his longing to express his internal life, cannot but envy the ease with which music, the least material of the arts, achieves this end. He naturally seeks to apply the means of music to his own art. And from this results that modern desire for rhythm in painting, for mathematical, abstract construction, for repeated notes of color, for setting color in motion, and so on.[4]

In many respects Kandinsky's paintings *are* similar to musical compositions. In some respects the process that culminated in the finished painting resembles the practices of the highly developed jazz musician who is the epitome of the impulsive but sensitive performer.

There is a further parallel between jazz and German Expressionism. Both arose in highly authoritarian atmospheres. Jazz was the black American's almost sole entertainment; like the artistry of the intelligentsia in Munich and Dresden prior to World War I it, too, was not subjected to scrutiny or direction of authority. In Germany at that time the world of the spirit was the single realm of being unharassed by Prussian rule. During the nineteenth century Heinrich Heine had already expressed this fact of German life in his *Germany: A Winter's Tale* when he wrote the famous lines: "The land belongs to the Russians and French; The sea belongs to the British; But we possess in the cloudland of dreams the uncontested dominion." Such an assertion depended upon the viewpoint of German intellectuals from at least that time until the end of World

[4] Wassily Kandinsky, *Concerning the Spiritual in Art*, trans. Francis Golffing, Michael Harrison, and Ferdinand Ostertag (New York, 1947), p. 40.

War I.[5] It was widely recognized that for Germany to make a place among modern nations many autonomous principalities had to be unified—by force if nothing else. That necessitated a centralized government with absolute power in things political and economic. But the world of pure thought was "uncontested," that is, the world's rulers were uninterested in controlling abstract thought because of its irrelevance to the hard logic of practical affairs. The vast differences between the paternalistic authoritarianism of that time and the totalitarian rule of Hitler's day could not be better exemplified.

In Germany at the turn of the century one had a curious situation in which intellectuals were free and active with respect to the spiritual sphere but passive and even apologetic about the political realm of human affairs. Indeed, many of them scorned such interests as being profane. To the extent that his art was a protest against the artistic status quo Kandinsky had an energy and the ability to put before the observer compulsions and tensions that other artists had not had the courage to face. So far as external reality is concerned, however, his paintings have nothing to say. They dealt with elements of psychic and aesthetic contest and in them we are made to feel the urgency and pure lyricism of the painter's emotion.

Since 1911 the idea of freedom as a condition of art and culture has become increasingly powerful in the modern world. It is reflected in the popularity of such devices as the phonograph which enables one to exercise freedom of choice in the privacy of one's chambers simply because one does not have to listen to a program of selections determined by some concert master. Painting, in particular, is seen as an opportunity for the uninhibited expression of strong, even antisocial feelings and a consequent experience of utter freedom, within the bounds of grace and generalized attractiveness. In some quarters the conviction persists that release through art can beneficially affect one's social behavior, that the particular discipline of the arts carries with it the seeds of humane propriety. Most explicitly enunciated by Sir Herbert Read[6] and John Dewey,[7] this dream of freedom and integrated behavior manifests itself in what seems to them the aesthetic base of all the rhythms and impulses of life. Whether or not they are right, it certainly is true that when Kandinsky

5 Cf. Myers, pp. 12–13.
6 See Herbert Read, *Education Through Art* (London, 1943), *passim*.
7 See John Dewey, *Art as Experience* (New York, 1934), *passim*.

speaks of liberty it is almost always in terms of artistry where, he said, there is "a great freedom which appears unlimited to some and which makes the *spirit* audible."[8] And it is perhaps to the point that in his *Reminiscences*, speaking of the student uprisings in Moscow in 1885, he remarked: "Luckily politics did not completely ensnare me. Different studies gave me practice in 'abstract' thinking, in learning to penetrate into fundamental questions."[9]

Clearly, Kandinsky's Expressionism represents a deep thrust of the theme of the self into serious art, for that theme became in his work the sole theme, without even an incidental subject. Kandinsky undertook a picture without knowing what the outcome would be. It emerged before his astonished gaze as it were, like an apparition of the alter ego, a manifestation of some unknown dimension of his own mind. Yet, once made concrete, it was comprehensible on an immediately grasped emotional plane. In this Kandinsky was by no means an isolated phenomenon; many artists working before and after World War I were fascinated by the hidden features of their own minds.

Of all those who probed the contents of the mind in search of imaginative forms Paul Klee was the most ingenious. A member of *Der Blaue Reiter* he is most commonly associated with the French Surrealist movement of the twenties, a rather doctrinaire offspring of a marriage between nihilistic Dadaism and Freudian psychology. An apparent connection lies in the observation that the art of Klee and that of the Surrealists had a mutual concern with the introspective and both depended upon eclecticism, secret meanings, and unique notions of communication. And, indeed, there is a considerable ground of similarity between Klee and at least one certified Surrealist, Max Ernst. But Klee was not Surrealistic in any strict sense. His images did not deliberately invoke the subconscious mind; they were products of conscious introspection. Where Ernst's images seem drawn from the matrices of a succession of nightmares Klee's are pure fantasies, born of esoteric daydreaming.

Confronted by a Klee one is at once aware that he is looking at an interior object, a product of purest reflection. That the painter intended to convey this impression is reinforced by his use of techniques which deny the visual conventions of everyday existence. For instance, when we

[8] Wassily Kandinsky, "On the Problem of Form," trans. Kenneth Lindsay in *Theories of Modern Art*, ed. Herschel B. Chipp (Berkeley, 1969), p. 159.
[9] Wassily Kandisky, *Reminiscences*, trans. Hilla Rebay and Robert L. Herbert in *Modern Artists on Art*, ed. Robert L. Herbert (Englewood Cliffs, N. J., 1964), pp. 24–25.

think of space in life we note first, among all things, the distinction be-
tween the figures and the background containing them. Were this not the
case one would never be able to differentiate among open spaces and solid
objects; one would go through life buffeted about, engaged in constant
collisions with free-standing objects. But Klee avoids this true-life dis-
tinction in various ways. Not that his work is merely flat. It contains an
illusion of space, but it is a space that represents the world of the imagina-
tion as a concrete reality. Apparently, Klee was convinced that the reality
of images depends upon entirely different qualities from the reality of the
outer world. His images are truly fantastic; they look like nothing of this
world nor do they resemble the things of some other unknown world.

Klee's use of the tools and techniques of art to attain a subjective
level of communication is evidenced in *The Twittering Machine* (Fig.
45). The machine itself is full of queer ambiguities instinct to Paul Klee's
method. What is the nature of the base of the device? Is it transparent,
having the form of an irregular rectangle seen from above, or is it a
trapezoid seen from below? Are the delicate lines within that pink zone
meant to represent extremities or are they supposed to be inscribed upon
the form? One can only guess. Or, as with all optical tricks of this type,
one can play at shifting from one assumption to the other. The weight of
the lines changes with their space and with the apparent properties of
the surface. The whole thing appears delicate, immaterial, but at the same
time extraordinarily rich in surface quality and invention. The figures
exist within a medium, but it is a speckled lavender medium that is unlike
the density of any atmosphere on earth. Such painting depends on the
example of Cubism, just as Kandinsky's did, but in this case the unit of
operation signalizes subjective intent rather than mere feeling.

Like so many of Klee's pictures this one is associated with a mistrust
of reason and science except in their most detached and mystical forms.[10]
The little birds are so drawn that we can nearly hear them chirping . . .
shrilly. Yes, hints Klee with some sadness, a bird's song could be dupli-
cated by the exact, precise, correct adjustment of mechanical parts. His
picture is of a machine for producing birdsong; one turns the crank
handle and the birds tweet grotesquely, jerking up and down on a sine
curve. The picture is an indictment of mundane, technical, laboratory
science.

[10] It is in these forms that Klee refers to them so often in his lectures and in his
speeches. For an example see Will Grohmann, *Paul Klee* (New York, n.d.), p. 372.

Klee's own precision was perfectly suited to the subject of his satire. And it is difficult to decide whether it is fitting or ironic that he was born in Switzerland, a country whose economy relies upon perfected mechanisms. Certainly, there is in his art none of the contemptuousness that familiarity is supposed to breed. But the same cannot be said of another satirist of modern technology who also made his home among the Swiss—the Rumanian poet Tristan Tzara, who, along with his colleagues, held everything he knew in the utmost contempt.

Although the seeds had been planted by Hugo Ball at his Cabaret Voltaire the year before,[11] Tzara is usually credited with "officially" founding the movement called Dada in Zürich on February 8, 1916 at precisely 6 P.M. No one agrees on who appropriated the word "dada" as a trademark for the group. Arp said Tzara invented it on the date above. Richard Huelsenbeck claimed that he and Ball discovered it by accident in a German-French dictionary,[12] and it is from Huelsenbeck that the usual definition—hobby horse—comes. But Ball pointed out that "in Rumanian *dada* means 'yes, yes,' in French a rocking-horse or hobby horse. To Germans it is an indication of idiot naivety and of an [*sic*] preoccupation with procreation and the baby-carriage."[13] But for the Dadaists it was "foolery extracted from the emptiness in which all the higher problems are wrapped, a gladiator's gesture, a game played with the shabby remains . . . a public execution of false morality."[14]

Tzara's one unquestionable contribution to this "foolery" was bringing his genius to the editorship of the principal organ of the movement, the periodical *Dada*. And it was his energies and inventiveness in that post, probably more than anything else, that brought disparate but parallel movements in New York and elsewhere into focus in Zürich, in the "peculiarly claustrophobic and tense atmosphere of neutral Switzerland in the middle of the Great War."[15]

One conceives of Dada in terms of a philosophy rather than in terms of individual artists and writers. If Cubism constitutes the ultimate revolution in the history of artistic innovation, then Dada remains at the

[11] See Hans Richter, *Dada: Art and Anti-Art* (New York, 1965), pp. 12–28
[12] See Richter, p. 32.
[13] Richter, p. 32.
[14] Hugo Ball in a letter to Richard Huelsenbeck, Nov. 28, 1916, cited by Richter, p. 32.
[15] Richter, p. 12.

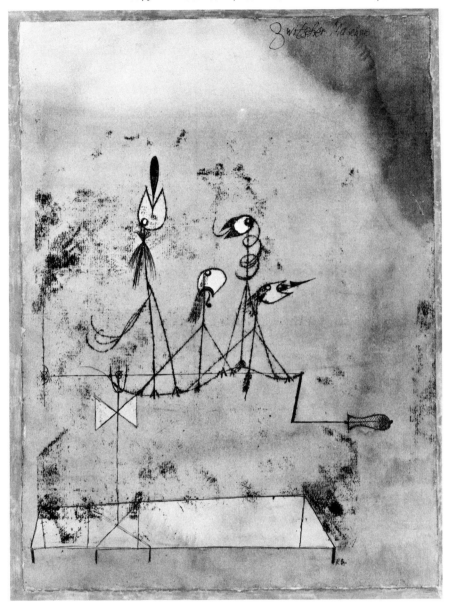

extremity of social protests. It is true, of course, that Dada opposed reform as strenuously as it rejected convention; the movement was as unprogressive as it was radical and as disdainful of liberalism as of reaction. Nonetheless, behind its japeries and riddled manifestoes lay a pitiless nihilism that brought every notion of stability into question and threat-

137

ened the very idea of intellectual respectability. Men like Marcel Duchamp and Louis Aragon had not only got to the point of believing that public morality should be abolished altogether; they at least pretended to despise the entire aesthetic tradition of their culture. Thus, Duchamp added a mustache to a reproduction of the Mona Lisa and captioned it with the letters L H O O Q which pronounced in French create the off-color pun: "Elle a chaud au cul!" (She has a hot ass.) Louis Aragon's poem "Suicide" consisted of the letters of the alphabet in their normal order. When Duchamp's most important painting, *The Bride Stripped Bare of Her Bachelors Even* (Fig. 46) was being shipped from his Manhattan studio to an exhibition in Brooklyn the glass on which it was painted shattered in transit. "He acknowledged the fracture as the work of chance and, with the network of cracks as a last refinement, declared the work 'completed' in 1923."[16] His attitude in this is especially striking because the painting was not produced in a carefree manner. His preparatory sketches are like engineering drawings, of an extreme precision. From 1915 to 1918 he worked on the painting. Then, for a year and a half, the sheet of glass lay on a rack in his studio, collecting the dust of New York City. After Man Ray had taken a famous photograph of it Duchamp cleaned away all of the filth except the cone shapes to which he adhered the dust by means of a spray fixitive. It is not expected that a Dadaist will devote such calculation to a work whose "absurdity" is acknowledged from the outset. Neither does one anticipate that so hard-working an artist will accept with a genial shrug the breaking of his work. But, of course, Duchamp's behavior is utterly consistent with Dada's presumption of the uselessness of all things and the futility of every action.

It is customary nowadays to explain the movement in terms of material impoverishment and spiritual exhaustion following the war of 1914. Malcolm Cowley has remarked a pattern in the periodic emergence of a predilection for individualistic and socially passive literature.[17] Such writing appeared after the revolutions of 1848 and 1871, following the disaster at Versailles, and after 1945. There can, in fact, be little question of the pertinence of such commentary. But it is a common defect of criticism of the twenties to exalt the loss of faith in social causes overmuch and give too little attention to the special character of World War I.

In terms of the history of ideas, that war was unique, for it was

[16] Richter, p. 95.
[17] See Malcolm Cowley, *Exile's Return*, 3rd ed. (New York, 1951), pp. 156–57.

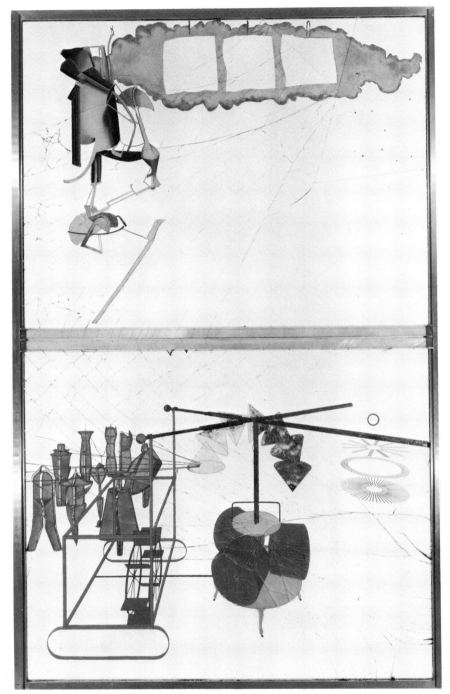

conducted as a systematic, rationalized slaughter in which the thousands of dead who participated in desperate acts of horror were merely carrying out routine transactions subordinate to the tremendous effluences of the warring economies. The stalemated nature of the conflict, the ghastliness of trench fighting, and the total absence of a decisive strategy on either

side emphasized the purely mechanical aspect of the hostilities. It was far easier to think of oneself as a cipher at Verdun than it would have been at Austerlitz, Shiloh, or Sebastopol—even easier than later in patrol actions on Guadalcanal or during the fitful firefights for the hedgerows of the Bulge. The reduction of men to mere instrumentalities was supposed to have ended with the hostilities, but for many the experience revealed the governing forces of modernity and thereby rendered the experience interminable and modern life intolerable.

Besides this business of treating men like machines there was something more that gave to Dada a special character. The features of the machines themselves were peculiarly stark. British historian Correlli Barnett has said of the men who began the war that "both individually and as a group they were as ill-equipped to lead this great machine as a seventeenth-century coachman would be to drive a Mercedes-Benz."[18] Nonetheless, the angularly upright surface vehicles and the new aerial weapons with their scaffoldlike silhouettes seem rather Edwardian somehow. Their internal combustion engines are like old perpetual motion machines, exposed rocker arms and cylinder heads being ranged around a central crankshaft; they remind one of the metaphysics of some nineteenth-century determinist. Vickers guns, Spandaus, Browning rifles, so completely dependent upon mechanical reciprocities, trip hammers, sear pins, gears, and cogs are highly intricate rather than complex. Compared to the dynamics of belligerency, they seem quaint and almost ludicrous, the toys of a corrupted tradition. Duchamp, a sort of proto-Dadaist even before the war, had sensed this irony from the very outset. He and his followers cast all engines into roles absurd or menacing.

The plethora of useless mechanisms and displaced appliances in Dada art exudes a kind of gallows humor. The elaborate and eerily pointless linkages of painted apparatus, the delusive "ready mades" (such as Duchamp's urinal, exhibited as "Fountain"), and, finally, the cunning self-denigration of the Dada exhibitors in Cologne who supplied viewers with axes to smash the works, all not only reflect the machinery and inanity of war but also challenge the most matter-of-fact notions of the bourgeoisie. Considering the nature of World War I it is not so terribly surprising that alongside the anarchic individualism of the movement there ran a feeble stream of pro-Marxist sentiment. For the most part,

[18] Correlli Barnett, *The Swordbearers: Supreme Command in the First World War* (New York, 1964), p. 5.

however, Dada had taken for an opponent the culture at large, and it opposed every convention with unreason. The Dadaists would have said the dose was homeopathic.

The chief achievements of Dada, apart from a very few first-rate works of art, were to be found in the liberating force of its example and in its revelation of the power and sensitivity of unreason. For it was from Dadaism that the most popular of all truly "modern" styles, Surrealism, grew.

Once Dada had achieved in fact what Paul Verlaine had only dreamt of—the liberation of poetry from *all* metric rules—it had destroyed "literature" for all but the reactionary. "The only way for Dada to continue," said poet Andre Breton, in a typical Dadaism, "is for it to cease to exist."[19] Therefore, in 1924, he himself founded Surrealism which he defined as "Pure psychic automatism, by which it is intended to express, verbally, in writing or by other means, the real process of thought. It is thought's dictation, all exercise of reason and every esthetic or moral preoccupation being absent."[20] Of the literary method Tindall wrote, "With the aid of surrealism the young explored Freud's underworld of dream and madness. Breaking the barriers between dream and reality, between the mad and the sane, surrealism is the climax of the romantic movement or its final decay. More specifically it is the climax of the symbolist tradition of Rimbaud, who, with Freud to help him became again an agreeable ancestor."[21]

In the beginning it was a literary movement; even Max Ernst, Jean Arp, and André Masson answered "Present" as poets at early meetings.[22] But since Surrealist poetry depended on the image more than on words, upon the symbol that could be visualized more than upon the music of sounds, it was inevitable that it should become eventually a movement more influential in the pictorial arts than in the literary ones.

Breton himself took Picasso to be the principal initiator of Surrealism in art,[23] but it was the Cologne Dadaist Max Ernst who developed the

[19] A famous and widely quoted statement which was invented not by Breton, apparently, but by J. E. Blosche in his manifesto *Dada Phrophetie* in 1919! (See Richter, p. 192.)

[20] Andre Breton, *Le Manifeste du Surréalisme* in Patrick Waldberg, *Surrealism* (New York, 1965), p. 72.

[21] William York Tindall, *Forces in Modern British Literature, 1885–1956* (New York, 1956), p. 235.

[22] See Waldberg, p. 34. [23] See Waldberg, p. 28.

mannerisms commonly identified with a Surrealist "style" in painting and sculpture.[24] As Jacques Lassaigne has said:

> It is certainly no exaggeration to claim that Max Ernst is *the* sur-
> realist painter and that without him there would have been no sur-
> realist painting, even though some painters might have attached
> themselves to the surrealism movement. Max Ernst was born with
> the spirit of surrealism inside him, and long before the movement
> came into being he was already nourishing these tendencies in him-
> self and encouraging their expression. Once the signal was given, it
> was Max Ernst who discovered and elaborated the techniques on
> which the movement was based.[25]

Of these techniques Ernst himself said that they "cast a spell over reason, over taste and the conscious will" which "made possible a vigorous ap-plication of Surrealist principles to drawing, to painting and, even, to an extent, to photography."[26]

Among the techniques he used to describe the irreducible contents of the unconscious was that of collage which he took far beyond the *papier collés* of Picasso and Braque to something quite different. In his collages he exploited "the fortuitous coming together of two remote realities on an incongruous plane" so as to convey some glimpse into a darkened corner of the mind.

In *Here Everything Is Still Floating* (Fig. 47) of 1919 Ernst had taken reproductions of a fish whose skeleton and viscera were displayed, a similar cutaway view of an insect, and some sort of tubular device and created a picture that is meaningless in the ordinary sense but is significant in extraordinary ways. The title, though in this case suggested by Arp, is a necessary part of the work. Everything is floating. The insect turned over on its back has become a vessel complete with a smokestack from which fumes waft upwards. Whether the things are floating immersed or whether they are hovering, floating in the sky is uncertain. But the very fact that one person encountering the articles so disposed will feel that they are in an atmospheric medium and another almost certainly hold that their surroundings are liquid means something—something about the viewer, who brings to the image his own apprehensions and fears, his

[24] For a very thorough treatment of Ernst see John Russell, *Max Ernst* (New York, 1967).

[25] Jacques Lassaigne, *The History of Modern Painting*, Vol. 3 (Geneva, 1950), p. 178.

[26] Quoted in Georges Hugnet, *Fantastic Art, Dada, Surrealism* (New York, 1946), p. 37.

47. Max Ernst, *Here Everything Is Still Floating*, 1920.
Collage, 4⅛ x 4⅞". Collection, The Museum of Modern Art, New York.

own joys and triumphs. The picture is rather like an elaborate projective test in which one sees oneself reflected. Only the most obtuse, or repressed, could find the coalition of these things inane. In Ernst the means that Cubism used to emphasize preoccupation with form has been turned into a symbolic device. The Cubistic has become incubistic. In certain respects this presumes Freud, who said of a typical patient:

> It takes him a long time to understand the proposal that phantasy and reality are to be treated alike and that it is to begin with of no account whether the childhood-experiences under consideration belong to the one class or to the other. And yet this is obviously the only correct attitude towards these products of his mind. They have indeed also a kind of reality; it is a fact that the patient has created these phantasies, and for the neurosis this fact is hardly less important than the other—if he had really experienced what they contain. In contrast to *material* reality these phantasies possess *psychical* reality, and we gradually come to understand that in the world of neurosis PSYCHICAL REALITY is the determining factor.[27]

[27] Freud, *A General Introduction to Psycho-Analysis*, pp. 377–78.

Tindall made clear the application of this principle to art:

> For Freud our most trivial acts—washing the hands, slips of the
> tongue, or falling downstairs—acquire significance. Dreams, too, may
> lead to the center of man's labyrinth; but dreams require interpreta-
> tion, for their manifest content has been distorted and condensed by
> the censorship of the ego. But symbols of dream are universal,
> constantly recurring in the night of every man and in the myths,
> literature, and popular sayings of his ancestors. This fortunate ar-
> rangement gave Freud a clue and artists a method.[28]

To ask what a collage like *Here Everything is Still Floating* "means"
is fatuous, rather like asking what a still life means. For, from the Freudian
perspective the selection of still-life objects, too, entails a series of de-
cisions that are not trivial but are related to the inmost yearnings of the
soul. The conventional still life, however, clothes those yearnings in a
respectable, rational mien. Surrealism presents the uninterpreted symbols
irrationally, as if by one's own sleeping mind. Their sense is in the mean-
ing the viewer's mind lays against them as it draws upon the ancient myths
and unrequited wants of childhood.

A second liberating experiment devised by Ernst was the use of
frottage, a technique that Leonardo Da Vinci was among the first to
express:

> I cannot forbear to mention among these precepts a new device for
> study which, although it may seem but trivial and almost ludicrous,
> is nevertheless extremely useful in arousing the mind to various in-
> ventions. And this is, when you look at a wall spotted with stains, or
> with a mixture of stones, if you have to devise some scene, you may
> discover a resemblance to various landscapes . . . or, again, you may
> see battles and figures in action; or strange faces and costumes and
> an endless variety of objects, which you could reduce to complete
> and well-drawn forms.[29]

Botticelli, too, had noted that one could secure an image of a landscape
by staining a wall with a wet sponge soaked in color. And in 1925 Max
Ernst perfected the method implied in the observations of these long-
dead creators. He published the results of graphite rubbings of wood
grain, leaves, textured stones, and so forth, in the book *Histoire Naturelle*.

[28] Tindall, p. 212.
[29] Leonardo Da Vinci, "The Practice of Painting" in *A Documentary History of
Art*, Vol. 1, ed. Elizabeth G. Holt (New York, 1957), p. 283.

Consider the provocatively titled oil painting *Man the Enemy of Woman or Man Woman's Best Friend* (Fig. 48). Quasi-human forms have been conjured up from background stains and color splotches. The power of the device to liberate the imagination from stricturing conscience is evident. In the work of Paul Klee, too, there was this taste for seeing into one thing all sorts of other things. His *Game on the Water* appears to be a relatively accurate rendering of wood grain or the rilling surface of a stream. Yet Klee has caught in the movement of the lines two eyes, a mouth, a nose.

The uses these modern artists made of *frottage* was entirely new. In Leonardo and Botticelli we never see anything but the product of the ratiocination prompted by accidental spottings. Their paintings contain, quite probably, figures suggested in this way but the stains themselves are absent. In Klee and Ernst, on the other hand, the stain or wood grain is preserved; you see the starting point or inspiration and also what has been read into it, and see both simultaneously. Moreover, the fortuitous

spottings and the created images become interchangeable. The effect is as if we had seen the image in the wood grain for ourselves, as if the resemblance occurred to us without any help from the artist. The artist draws the viewer's attention to the viewer's own sabotage of the natural world and its realities and thereby asserts the validity of his own mental condition. With the same technique he conscientiously preserves the marks of his activity as a painter by showing his inspiration, his use of it, and his product all at the same time. The last feature is, of course, what makes the work look modern.

Other Surrealists had invented techniques of painting that were purely accidental from start to finish. Oscar Dominguez spread gouache pigments on a sheet of paper, then placed another sheet of paper flat atop it and slipped off this second sheet, repeating the process until the paint dried up. The top sheets he called *décalcomanias* (transfers) and were, although the result of a recipe that could be practiced by a village idiot, not without their curious interest (Fig. 49).

Ernst, who was never passive with respect to such inventions, went on to make use of the texture peculiar to the décalcomania, an ooziness suggestive of molten earth, of terrible decay, of the mysteries of Angkor Wat. In the late thirties and during the forties strange landscapes dripped from Ernst's brush, landscapes such as *Day and Night* (Fig. 50) in which panels of light snare pieces of a frightening, excoriated vista. The meticulous detail which conveys the stereoscopic unreality of eroded earth confirms our belief in Ernst's world as a world that does exist within our memories if not within our worldly experience. This is not because appearances are itemized so sharply as, in the case of Salvador Dali,[30] to

[30] Dali has become *the* Surrealist in the public mind. His is the attempt to transcribe literally his dreams. His highly sophisticated, though retrograde technique, full of academic tricks straight out of Italian, Spanish, and Dutch Baroque painting, pleases even while portraying shocking content. It has become a kind of "applied Surrealism" subject to such definite procedures that it can be taught as readily as any other academic technique. The fellow is, nonetheless, something of a genius so far as the invention of thematic content is concerned and his paintings of the early 1930's are truly exquisite.

make them rival those which recorded by a camera are indubitably existent. It is due, instead, to the fact that the production of detailed images in Ernst's case is dependent on techniques that have little to do with rendering in its ordinary meaning. The excoriated walls of Ernst's nightcaves look naturalistic because they were produced by stresses and strains that duplicate on a microscopic level the forces that produce such flows matter in nature. The *décalcomania* technique, which Ernst applied to easel painting by mashing two wet canvases together, is such a mode of production. It pulls drying particles of pigment through viscous rivers of color and slides one level of fluid under another, just as lava presses boulders before and through it, just as a downpour of rain cuts a thousand reticulations through the least resistant parts of a slope. Once the textures he wishes appear, Ernst articulates them here and there and enhances and intensifies their effects. It is by no means a passive matter. His ability to control these things is awe-inspiring. He can recreate the structures of minerals and plants in a deceptively naturalistic way, and the effect of illusion that proceeds from the smallest conceivable unit of visual operation, the particle of pigment, through to the overall massing of monolithic shapes, is nothing short of uncanny.[31]

Surrealism, since it dealt with the symbolic subterfuges thrown up to consciousness by the unconscious mind, has a satirical element at its base, an element made quite obvious in the titles of Max Ernst's paintings. There is, however, also a tragic element that is less immediately apparent. It is the Surrealist's constant expression of loneliness. Surrealist art is, in a way, a deliberate attempt to deal with the inability of one person ever to communicate with another. It hoped, through the elimination of all but the most fundamental subterfuges, to achieve a universal language of emotion, to manage, as Sir Herbert Read put it in his English manifesto, to spontaneously generate "an international and fraternal *organism* in total contrast to the artificial manufacture of a collective *organization* such as the League of Nations."[32]

One would have to be incredibly obtuse to overlook the fact that the painters discussed in this chapter represent only further extensions of

[31] For a completely different opinion on the illusionistic techniques of Surrealism see Charles Biederman, *Art as the Evolution of Visual Knowledge* (Red Wing, Minn., 1948), pp. 497–515. This volume—privately, but expensively, printed by the author—contains many provocative notions and is remarkably thorough in view of the unorthodox premises upon which it is based.

[32] Herbert Read, *Surrealism* (London, 1939), p. 2.

the direction established by van Gogh, Ensor, and their contemporaries. The Blue Rider Expressionists represent an advance in sheer enthusiasm for feeling, perhaps; Dada celebrates disgust[33] with the objectivity that the nineties still in some measure sought, while Surrealists argue that they have synthesized intellect and feeling. But so far as any positive relationship to science is concerned the one thing that distinguishes the twentieth-century subjectivists from their predecessors is that all of them were familiar, at first or second hand, with psychoanalytic theory. Surrealism's embrace of Freud was, of course, doctrinaire. Apart from that everything said of van Gogh and projective psychology could simply be said with greater confidence of Kandinsky, Klee, or Ernst. And yet there is some little more to be added.

Although the principles of the newer painting are essentially the same as the old and while both states of development are affiliated with the same psychologic theories, there *is* a difference in the application of these principles. And the difference in painting has its analogy in the difference between general psychologic theory and "applied psychology," that is, the application of psychology to business, industry, and political affairs.

It may seem curious that artistic attitudes allied with an extreme antagonism to things material should at the same time conform to those supportive of a modern industrial state. But the matter becomes clearer when one realizes that advertising in capitalist countries (and communist ones too) is devoted to selling dreams and that products are *designed* to fill psychic needs more than material ones. This is not to say that genuine differences do not exist among competitively merchandised products. There are real differences, and to a modern consumer these may be of very real significance, especially where safety and durability are concerned. From a historical point of view, however, the differences between a Rolls Royce Silver Cloud and a stripped Chevrolet sedan are so slight as to be infinitesimal. During the Baroque age a baronial coach was very obviously grand, covered with convoluted floral patterns and embellished

[33] In this connection see Renato Poggioli, *The Theory of the Avant-Garde*, trans. Gerald Fitzgerald (Cambridge, 1968) wherein a "dialectic" of avant-garde movements and their developments is proposed. First, there is a movement generated out of sheer enthusiasm for the direction it, itself represents. That is termed *activism*. The second kind of movement agitates against someone or something; it is *antagonism*. Third, there is the kind of "transcendental antagonism" one connects with Dada, *nihilism*, more interested in demolition than in replacing one set of values with another. Finally, we have *agonism*, a movement going beyond nihilism to an acceptance of self-destruction as "an obscure or unknown sacrifice to the success of future movements."

with gilt, carrying coats of arms as well as footmen. All that it had in common with an ordinary coach or a freeman's wagon was the means of locomotion. By contrast, the Chevy compares favorably with the Rolls. The latter is but slightly more luxurious, a little more reliable, and modestly longer-lived. The seventeenth century could have barely told the cars apart. Mass-production's advantages are marked by uniformity all across the spectrum and there is no way to get around the fact. It can only be disguised.

As often as not, however, businesses do not make false claims for the distinctiveness of their products or services.[34] What they do do is transmute relatively insignificant objective variations into what consumer psychologists call "wants"—"wants" as distinguished from authentic material needs.[35] Consider this bit of information, taken from an unusually candid textbook on advertising design:

> Uncertainty of one's own taste makes car-purchasing habits highly predictable. Cadillac's advertising appeals to middle-brows who would like to be considered high-brows. Jaguar's, on the other hand, appeals to full-blooded high-brows who want to display their intellect. Potential Cadillac purchasers are not particularly attracted to the type of pictures Jaguar uses; neither are Jaguar owners unduly impressed by the splendor of Cadillac's photography. . . . They consider themselves a different breed altogether.[36]

All that this reflects, of course, is that in urban-industrial societies men are compelled to seek personal distinctiveness within the security of the group. When one adds to this compulsion—from which none of us is immune—the techniques of projective psychology he has two basic ingredients of what is called "motivational research." Its findings are not always so obvious as the discovery that distinct pretensions govern the purchasers of prestige-name automobiles. For example, an exceptionally extensive and well-controlled study of consumer personality discovered

[34] This may sound implausible but it is borne out by the relative success of various advertising slogans. Lucky Strike Cigarettes, for instance, used the slogan "It's toasted!" for years with tremendous success. All smoking tobacco is toasted and all cigarettes could have made the same claim; the American Tobacco Company just got there first with a suggestion of comforting nourishment.

[35] Cf. Edward L. Brink and William T. Kelley, *The Management of Promotion: Consumer Behavior and Demand Stimulation* (Englewood Cliffs, N. J., 1963), pp. 86–101.

[36] Stephen Baker, *Visual Persuasion: The Effect of Pictures on the Subconscious* (New York, 1961), p. 17, counting from the title page of Chapter I. (There is no pagination.)

that heavy cigarette smokers had strong needs for sexual activity, aggression outlets, and achievement, while nonsmokers scored higher in needs for order and compliance. Moreover, people who smoked filter cigarettes were more needful of achievement than nonfilter smokers whose corresponding desire was for independence. Actual sales campaigns verified the correctness of this analysis, which was based on a projective test called "The Edwards Personal Preference Schedule."[37]

Naturally, this kind of research frightens many people; they feel that the motivational psychologist will manipulate one's desires. In this connection it is important to stress that the researchers did not, after all, create the smokers' passion for achievement; they merely discovered a trait of the buying population which was already operating in the market but was not being made use of in an efficient manner. Similarly, psychologists recognize that, all the high-brow's protestations to the contrary, the sports car buff's interest in "cornering," "responsiveness," and braking is at the very bottom no less irrational than the limousine owner's fondness for comfort. The former would not drive a Cadillac even if it *were* safer. To blame the psychologist for one's own impulses is a neurotic symptom, albeit a symptom shared by many well-educated consumers. In any case, the hidden persuaders have proved unsuccessful as lures. In the study of cigarettes cited earlier other factors, such as price, product characteristics, and the nature of the sales offer turned out to be far more important than the EPPS scores. Still, the effectiveness of graphic presentations has been immeasurably increased by systematic research into the unconscious.

The design manual previously quoted in connection with the status notions of car buyers stresses the fact that sexuality pervades imagery and that even geometric shapes have definite sexual characteristics:

> This psychological principle has important commercial applications. A manufacturer must, during the early stages of merchandising, decide upon the "sex" of the package in which his product will be put. Should a man's hat be packed in a round box, for example? (A hexagonal shape is more acceptable.) Should a woman's toilet soap be oval or square? (Oval is more desirable.) Should detergents be packaged in square boxes? (Yes. Detergents have been found to move faster if they connote masculinity—power and action-mindedness— even though the buyers are mainly women.)[38]

[37] The study made reference to is cited and evaluated in Anne Anastasi, *Fields of Applied Psychology* (New York, 1964), pp. 301–3.

[38] Baker, p. 51.

Any attempt to conjoin this sort of recognition to Expressionist aims would seem farfetched indeed—were it not for the fact that Kandinsky and Klee were long associated with the foremost exponents of the application of psychological insights to the whole field of design. Both men, along with Feininger, were faculty members of the Bauhaus, the famous school of industrial design established in Germany in 1919 by architect Walter Gropius. The goal of the school was to reintigrate the creative artist into the reality of modern industrial society and, simultaneously, to humanize the exclusively material attitudes of the business community. More than any other single influence the Bauhaus brought together under one rubric the diverse strands we now call "modern art." Several men connected, directly or indirectly, with *Der Blaue Reiter* and with the Dada and Surrealist movements were on the staff. And its principle spokesman, Laszlo Moholy-Nagy (Fig. 51) was unremitting in his praise of the avant-garde antirationalists. Commenting on the rejection of Surrealism by the Soviets, he wrote: "Again and again artists must state that revolution is indivisible and that the intellectual and political strategy of the revolution must be accompanied by a long term emotional education. Only correlation and integration can bring a change in habits and attitudes of the people rooted in and grown out of previous conditions."[39] That Moholy-Nagy was not unaware of a connection between this prescription and the work of Freud is clear:

> Through the use of this psychological insight and the psychoanalysis of Sigmund Freud, space-time fundamentals may be understood also as the syntax and grammar of an emotional language which may re-create the path of the inner motion. This can express the problems of living (through the arts) more directly and synchronously in their totality than could be done by any mere descriptive version. And as people have to learn to read and relate the manifold signs of traffic control at metropolitan street intersections for physical safety, they must learn also to read and relate the emotional meaning of the expressive fundamentals used in the different arts in order to avoid the danger zones of psychological "intersections."[40]

It would be unfair to equate the explicit philosophy of any of the painters with Moholy-Nagy's view. He spoke for himself and not for those whose work he admires. But his rather touching faith in the priority

152 [39] Moholy-Nagy, p. 340. [40] Moholy-Nagy, p. 115.

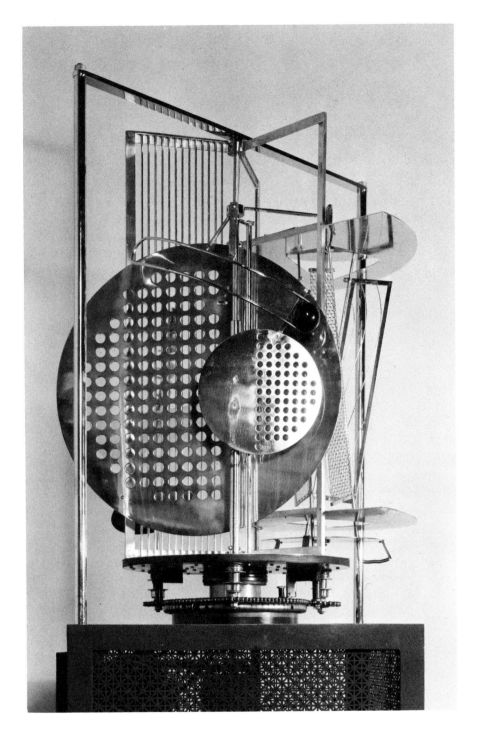

of artistic sensibility over political radicalism, his conviction that a particular mental set will sustain individual freedom within the highly organized technocracy he advocates is very close to the posture of the Expressionists prior to the war of 1914. Their freedom, like that of pro-

fessors, was altogether "academic." That's what they wanted, of course. What Expressionism and also Dada, Surrealism, and even the Bauhaus credo come down to is celebration of the subjective, the intimate, and the personal and the rejection as an illusion of the objective existence of a collective body termed "the masses." Socially, they hoped for a more active and individualistic conception of human relationships but their rebellions against middle-class ethical and aesthetic values had nothing whatever to do with opposition to the political realities of bourgeois life. Quite the opposite in fact.

The same sort of obsession with personal liberty that these artists sought sustains the middle classes. It does not really matter whether the "wants" that keep the system functioning are for bread, serious literature, personal services, orange juice, or marijuana. What is important is the preservation of private decision, particularly where those decisions relate to autonomous cultural activities—the arts, chess-playing, spontaneous socializing. That particular kind of freedom of the intimate is what Freud,[41] *Die Brücke, Der Blaue Reiter*, the Dadaists, and the Surrealists wished to attain, regardless of the costs. And it was for *this* reason that the Communists distrusted them. Hannah Arendt has put it sharply and, I think, correctly:

> If totalitarianism takes its own claim seriously, it must come to the point where it has "to finish once and for all with the neutrality of chess," that is, with the autonomous existence of any activity whatsoever. The lovers of "chess for the sake of chess," aptly compared by their liquidator with the lovers of "art for art's sake," are not yet absolutely atomized elements in a mass society whose completely heterogeneous uniformity is one of the primary conditions for totalitarianism. . . . Himmler quite aptly defined the SS member as the new type of man who under no circumstances will ever do "a thing for its own sake."[42]

Adolph Hitler, opening the "Great Exhibition of German Art 1937" in Munich declared that "the artist does not create for the artist, but just like everyone else he creates for the people."[43] From the other side, an official

[41] See Sigmund Freud, *Civilization and Its Discontents*, trans. Joan Riviere (London, 1939), *passim*.

[42] Hannah Arendt, *The Origins of Totalitarianism* (New York, 1951), p. 322.

[43] Speech inaugurating the "Great Exhibition of German Art 1937," trans. Ilse Falk and excerpted in Chipp, *Theories of Modern Art*, p. 482.

article in the *VOKS Bulletin* (Moscow) reads: "As opposed to decadent bourgeois art, . . . permeated with biological individualism and mysticism, reactionary and anti-popular, Soviet artists present an art created for the people. . . ."[44]

The fascist and communist aestheticians are perfectly correct when they assail modern art as "bourgeois." Not only is it true in etiological terms, it is so in its entire philosophy. It was inevitable that Expressionism, Dada, and Surrealism—the products of an elite underground intellectual group—should eventually be domesticated by the blithe sophisticates who populate the allied worlds of Fashion and High Society. Their appetites for novelty are so rapacious that they will consume the most pungent items as though these were delicacies created solely for their delectation. From digestion by the aristocrats of bourgeois taste it is but a single step to popularity.

Thus, in ridiculing the values of Western civilization the Dadaists and Surrealists added to the component strength of middle-class convention. By now such occurrences have become so familiar as to be routine. What is so interesting about the relationship between the anti-rationalist movements in art and the work of motivational psychologists is that it reveals just how closely contained is everything within a given social framework.

[44] Vladimir Kemenov, "Aspects of Two Cultures," excerpted from *VOKS Bulletin* (Moscow), U.S.S.R. Society for Cultural Relations with Foreign Countries, 1947 in *Theories of Modern Art*, p. 495.

The Moral Community of Technological Idealism

IT IS EASY to forsee that certain readers of the previous chapter will accuse the author of employing the most transparent kind of casuistry. One can easily imagine them being overcome with a sense of superior knowledge and closing the book in exasperation. For, after all, it is well known that Bauhaus philosophy opposed the meretricious uses to which advertisers put psychology. Despite the fact that many of the most skillful art directors in advertising agencies are products of Bauhaus curricula it is true that the intentions of the staff were quite noble. Gyorgy Kepes echoed Bauhaus convictions when he wrote, "If social conditions allow advertising to serve messages that are justified in the deepest and broadest social sense, advertising art could contribute effectively in preparing the way for a positive popular art, an art reaching everybody and understood by everyone."[1]

Besides, it can be shown that the aims of Bauhaus researches into perception were either aesthetic, directed towards creation of a new iconography, or were purely functional. An example of the first kind of interest has been provided by Hirschfeld-Mack, a member of the school throughout its existence:

> A very interesting seminar was held during those early years. It was under the leadership of Paul Klee and Wasily Kandinsky and others. They sought to discover the reactions of individuals to certain proportions, linear and colour compositions. . . . In order to find out whether there is a universal law of psychological relationship be-

[1] Gyorgy Kepes, *Language of Vision* (Chicago, 1947), p. 221.

tween form and color, we sent out about a thousand postcards to a cross section of the community asking them to fill in three elementary shapes, the triangle, square, and circle with three primary colors, red, yellow, and blue, using one colour only for each shape. The result was an overwhelming majority for yellow in the triangle, red in the square, and blue in the circle. This was only one of the many problems which was tackled in this seminar.[2]

That such discoveries can have commercial application was not the reason for seeking them, but it is not hard to see that application of them to practical ends was promoted by the orientation of the curriculum.

At the root of anything the Bauhaus did was "functionalism," the theory that aesthetic content will virtually take care of itself if a thing is designed to fulfill its purposes with maximum utility, ignoring all precedents and habits of construction. Students were given bizarre problems that challenged their imaginations and forced them to undertake empirical experiments with basic materials. They played with illusion as they did with stress, and with psychic effects as with die-casting, and all in the name of function. It was not until World War II that a discipline called "engineering psychology" rose into prominence, applying research into anatomy, perception, and time-motion to work methods, environments, and equipment design, but Bauhaus experiments concerning the effectiveness of different shapes, sizes, and materials anticipated almost all later research into tool and furniture design. So committed to functionalism did the school become (under a change of administration from Gropius to Hannes Meyer in 1929) that Klee "transferred his activities to the Düsseldorf Academy in 1931; Feininger . . . remained in a subordinate and uninfluential capacity. . . . Only Kandinsky was able to stand up to this new development."[3]

Kandinsky's survival is not surprising. Not only had he the most distinguished teaching and administrative background,[4] his work since

[2] Ludwig Hirschfeld-Mack, *The Bauhaus* (Croydon, Australia, 1963), p. 6.

[3] Myers, *The German Expressionists*, p. 200. Also see Hans M. Wingler, *Das Bauhaus* (Wiesbaden, 1962), p. 17.

[4] Between 1914 and 1922 Kandinsky was deeply involved in educational work in Russia. He had gone to Russia from Germany after the outbreak of the war. After the Russian Revolution he worked in the People's Commisarat of Public Education and also taught at the Moscow Academy of Fine Arts. By 1919 he was director of the Museum of Pictorial Culture (where he came under the influence of Constructivist sculptors Pevsner and Gabo and began working in the style that was so suited to Weimar tastes). By 1921 the Soviet government had begun to discourage abstract art and so he left Russia for the Bauhaus.

1919 had submitted more and more to the ideal of self-expression as a branch of technology. The paintings of the postwar period (Fig. 52) are far less interesting than the earlier works although they constitute a much prettier set of pictures. Because they are easy to comprehend they have an appeal, not unlike that of Matisse's Riviera pictures, for those whose sense of artistry is rather shallow. *Fish Form* operates at the level of taste attained by chic hostesses and interior decorators. It is possible to describe such works by simply noting the number of different kinds of elements. Someone has aptly called the style "an art of replaceable parts." It confronts no problems of psychological expression and stratifies, without refining, what the Cubists had begun. All too often the forms have been brought into the same ambit on a completely intellectual basis without real regard for their appositeness; that is, the shapes are all geometric but apart from a common regularity they have little to recommend marriage in a painting.

Naturally, it is possible to "rationalize" these failings. Kandinsky's best work had also been full of contest. And his taste for complex interlockings and collisions within a field of great variability remained unchanged. But he was unable to sustain the dramatic coherence of *Improvisation Number 30* (Fig. 44) when the elements themselves were ruled by a compass and the straight-edge.

This contrived-looking style, which Kandinsky shared with other Bauhaus artists (Fig. 51), mirrored German hopes between the two world wars. It reflected the idealism of the Weimar Republic, whose optimism in liberal reform and technological progress shows too in such doctrines as Karl Mannheim's Sociology of Knowledge. The Republic itself never had a chance, saddled as it was with all the sins of the defeated Empire. But that was by no means apparent in the twenties.

After the establishment of the Dawes Plan of reparations payments (which began by lending Germany 200 million dollars), and the conclusion of the Locarno Agreements stabilizing the frontiers, a new period of prosperity opened for the Germans. Municipalities and businesses obtained huge loans from the United States to renovate factories and reestablish the merchant marine. "Made in Germany" became again a familiar ensign in the world of commerce. Reparation payments were made on schedule from 1924 through 1930. The application of reason to political circumstances seemed promising indeed.

But German intellectuals were new at having anything to say about

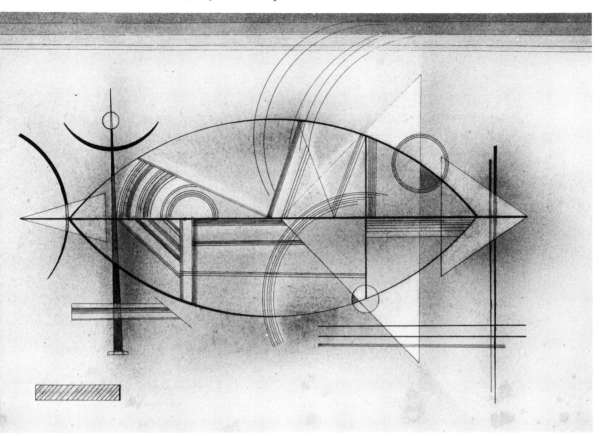

the operations of representative government. Conditioned by life in a land where everyone wants to be known as *Herr Docktor*, *Herr Professor*, *Herr Regierungsrat*, or what have you, rather than by such comparatively democratic titles as France's "Citizen," the "Mister" of the U.S., or the "Comrade" of Russia many of the non-Communists arrived at the conclusion that a technocracy—a government by experts—would be a fine solution to the major problems of society. Radiant faith in the ability of "designers" to run the world shines through everything Moholy-Nagy wrote. Heidelberg University's Professor Karl Mannheim was of a similar faith. But he had thought through many of the political problems of modernity.

In his most famous single work, *Ideologie und Utopie*, published in 1929, Mannheim began with the recognition that disinterested intelligence, represented by the intelligentsia, had been disengaged from practical af-

fairs for at least a century. Writes Charles Frankel, "To recapture that intelligence, and to give it an anchor in our institutions . . . is the problem with which Mannheim was concerned."[5] He wished to fulfill the liberal ideal of applying organized intelligence to human affairs. But he also recognized that human nature tended to fault dreams of social tranquility rather than support them. Before him Marx had argued that most men saw the world from a distorted angle because their world views were created by social institutions instead of the other way around. Marx called such distortions "ideologies," exempting only a few ideas—such as his own dialectical materialism—from the bane of this opprobrium. According to Mannheim, Marx had not gone far enough. Mannheim had read Hartmann and Freud as well as Marx and it shows clearly in the development of his own theory.

"Even in our personal life," he says, "we become masters of ourselves only when the unconscious motivations which formerly existed behind our backs suddenly came into our field of vision and thereby become accessible to conscious control."[6]

He writes:

> The study of ideologies has made it its task to unmask the more or less conscious deceptions and disguises of human interest groups. The sociology of knowledge is concerned not so much with distortions due to a deliberate effort to deceive as with the varying ways in which objects present themselves to the subject according to the differences in social settings. Thus, mental structures are inevitably differently formed in different social and historical settings.[7]

Mannheim was saying, then, that whole social classes of society, not just individuals, are controlled by the unconscious. All social thought, no matter how ostensibly "objective," represents a particular viewpoint because every man occupies a specific social habitat and his experience brings him into contact with only a limited range of experiences. In evitably, every opinion is partial and there is no such thing as an objective, unbiased truth.[8]

[5] Charles Frankel, *The Case for Modern Man* (New York, 1955), p. 122. Of all the many treatments of the Sociology of Knowledge by disciples and detractors in books and introductions to various texts, Frankel's twenty-nine page essay is the most penetrating. In this book he also deals impressively with Maritain, Niebuhr, and Toynbee.

[6] Karl Mannheim, *Ideology and Utopia*, trans. Louis Wirth and Edward A. Shils (New York, 1957), p. 47.

[7] Mannheim, p. 265.　　　　　　　[8] Cf. Frankel, pp. 122–26.

Up to this point the Sociology of Knowledge seems little more than discreetly stated iconoclasm, dedicated to shattering the intellectual foundations of government and replacing politics with anarchy. That is not the case, however. For, according to Mannheim, the absence of final truth is but one of two realities with which modern society must contend. The other is a need for social control. To demonstrate that this is a genuine need in industrial society the disciples of the Sociology of Knowledge—which has been tremendously influential in some fields[9]—use a recurring metaphor that contrasts the crossroads of a medieval village with the modern intersection.

We have already heard Moholy-Nagy make reference to the need for people to understand traffic signals and this is the point of the metaphor. On a medieval highway the number of passersby is small and the speed of travel pretty much determined by the slowest of them, the pedestrian. Given such low density and velocity, traffic can be left uncontrolled. A modern street intersection is an altogether different matter. Not only is the density far greater but chance collisions between vehicles are much more hazardous to life.

Medieval and modern societies in large exhibit characteristics similar to their highways. We are accustomed to thinking of the Middle Ages as having been ruled by authoritarianisms inimical to individual liberty. That is a justifiable view insofar as it applies to matters of doctrine and direct political power, but it would be incorrect to believe that the people of the time were uneasy about this. We modern men make a fetish of personal freedom precisely because it is in such very short supply. One of the reasons that feudal economies can tolerate such despotic and hierarchical governments is that overt control does not deeply penetrate the lives of people. In an industrialized urban culture the necessity for adherence to rules pervades one's entire existence. If it were not for traffic signs, highway dividers, litter laws, and police regulation, chaos would prevail. And human beings prefer anything to chaos; in modern times dictatorships are the usual response to social disorganization; they represent the

[9] It is important to understand that Mannheim is a sociologist in the German sense. American and British sociology has tended to be empirical whereas German sociology has often been more concerned with questions of ultimate social value than with terms of immediate relevance. Serious students of economics and sociology seldom bother with Mannheim; scholarship about him tends to be concentrated in the field of political science and his influence has been most strongly felt in community planning and education. In America his principal spokesmen have been educational theorist George Counts and the Social Reconstructionists.

coercive rationalization of society. Men threatened by anarchy will almost always accept the imposition of arbitrary "truths" simply for the sake of order.

What Mannheim wanted instead of either chaos or dictatorship was a planned but unregimented society, a marriage of social control and bourgeois freedom. To achieve this end he proposed a practical strategy of social reform.

Mannheim argues that, while all social classes are caste-marked by partly closed minds, there is one class in European society that has a special immunity to narrowness. Historically, it is a subclass, that part of the bourgeoisie to which Mannheim himself belonged. From the first the bourgeoisie had contained two different groups: the owners of capital on the one hand and, on the other, those whose only capital was knowledge. "It was common therefore to speak of the propertied and educated class, the educated element being, however, by no means ideologically in agreement with the property-owning element," Mannheim wrote.[10] He tells us that the chief characteristic of this group, the intelligentsia, is that it has been drawn increasingly from other than the middle classes and is, in any case, but loosely anchored in the outlook of any class, since, "Due to the absence of a social organization of their own, the intellectuals have allowed those ways of thinking and experiencing to get a hearing which openly competed with one another in the larger world of the other strata."[11] He was eager to get this class, whose members could break through the rigid ideologies that separate other men, into society's "loci of decision." This may sound very much like Jeffersonian Democracy's role for a "natural aristocracy," but there is instinct to every line in Mannheim a sort of moral dualism which distinguishes between a covert ethic for the elite and overt opinion and common morality for the general public.

Thus, since Mannheim had no desire to disenfranchise anyone, he came to the conclusion that it is "the task of the political leader deliberately to reinforce those forces the dynamics of which seem to move in the direction desired by him, and to turn in his own direction or at least render impotent those which seem to be to his disadvantage."[12] Every successful politician does in fact behave according to this precept, of course, but in

[10] Mannheim, p. 156.
[11] Mannheim, p. 12.
[12] Mannheim, *Man and Society in an Age of Reconstruction* (New York, 1940), p. 247.

Mannheim it becomes something more than a description of necessity. Speaking of consumer goods and merchandising, he writes:

> This method of stimulating demand is exactly what a planned but unregimented society should aim at; inducing conformity not by authority or inculcation, but by skillful guidance, which allows the individual every opportunity for making his own decisions. A planned society would direct investment, and by means of efficient advertisement, statistically controlled, would do everything in its power to guide the consumer's choice towards co-ordinated production.[13]

Because he held that it is only by remaking man himself that it is possible to reconstruct society along these benevolent patterns, it should not surprise us to discover that he agreed with John Dewey on the nature of education. The first and most significant goal of education in a planned, democratic society is the production of citizens capable of independent judgment and spontaneous cooperation. Once the intellectuals were in command Mannheim wished to produce whole crops of them and this goal he felt could be achieved only through a situation-oriented educational system: "The vital clue to the moulding of character and integration of personality lies in the mastery of the situation by the pupil. The situation is the simplest context in which the child can be taught to use his own judgment and thus to face the elementary conflicts of everyday life."[14]

The American reader is quite probably conditioned to think of this kind of education as *anti*-intellectual. That is because the popular meaning of "intellectual" here is synonymous with the descriptions scholarly, artistic, literary. But it is necessary to point out that Dewey's most prestigious supporters have been Karl Mannheim, the Bauhaus, and Bertrand Russell.[15] The learned of nations having a long classical tradition are less enthralled by their systems of public and private education than are Americans. For them the irrelevance of disengaged, cultivated intelligence to the domain of citizenship has been proven over and over and over again. Indeed, it is that very detachment Mannheim hoped to overcome with his

[13] Mannheim, *Man and Society in an Age of Reconstruction*, p. 315.

[14] Mannheim, *Man and Society in an Age of Reconstruction*, p. 305.

[15] Russell, in his *History of Western Philosophy* makes an interesting comment on Dewey: "I, in my lesser way, have tried to have an influence on education very similar to his. Perhaps he, like me, has not always been satisfied with the practice of those who professed to follow his teaching. . . ."

Sociology of Knowledge. What interested him about the intelligentsia was not the brilliance or erudition of its members but its encompassing social outlook.[16] In the planning of the historical process, after all, actions were not to be directed primarily to attaining "the best possible qualities or to following the more favourable path, but towards the means which are most likely to lead from the status quo to the desired goal and which gradually transform the person who uses them."[17] Consequently, the education of leaders would not be intellectually competitive so much as psychologically reinforcing and conducive to social awareness.

In like manner, the Bauhaus program (which extended from kindergarten through the university level) was what we today would call "Progressive Education": "Teaching focussed on learning for learning's sake will always bypass the ultimate objective which alone can give sense to the attempts of integration. Choices are easy if the goal is clear. Knowledge should not be suspended in a vacuum; it must be in relationship with socio-biological aims. This integration gives to human life content, direction, and a sense of security."[18] Moholy-Nagy uses Julian Huxley's *Evolution: The Modern Synthesis* to argue for recognizing that in human life as in the rest of nature the results of natural selection and the adaptations it promotes are by no means necessarily "good" from the point of view of either the species or of the progressive evolution of life. According to this line of argument, it would be both foolish and wicked for an economy or an educational system to copy the methods of so imperfect a system. Of course, the difficulties with this argument from analogy with modern

[16] It is not the purpose of this book to argue educational and social theory. Still perhaps it is not out of place to remark a few weaknesses in Mannheim's position. To begin with, the intelligentsia as Mannheim finds it is a wildflower, existing by virtue of a *post*-educational classlessness. It could very well be that the group is not subject to domestication. Certainly, it is odd for Mannheim to suppose that one can have an egalitarian system and still support a specialized elite whose purpose is the planning of history. If the dynamics of leadership are to be so institutionalized someone must at some time initiate the "chosen" into elitehood and it must be made perfectly clear to them that they constitute a distinctly separate order of person. More important, but less easy to develop briefly, is the objection that Mannheim misunderstands the role of objectivity in science and confuses the whole issue of the distinction between the study of human behavior and the study of nature. The Frankel book has a very good section on this (pp. 129–33). Finally, the most questionable part of the whole theory is the feasibility of planning history for a society that is not regimented. Friedrich A. Hayek in his *The Road To Serfdom* and Julian Benda in *La Trahison des Clercs* have brought the most devastating criticisms against the idea and the characters of those who promote it. (Neither book is as illiberal as many leftists pretend and many rightists hope.)

[17] Mannheim, *Man and Society in an Age of Reconstruction*, p. 223.
[18] Moholy-Nagy, p. 24.

theories of evolution are identical with those entailed in justifying *laissez-faire* economics with Spencerian or Darwinian principles,[19] but it will serve no useful purpose here to debate educational or social theory.

The point is that for these Weimar theorists the future of mankind lay in the development of individual capacities. Such an approach to education would, they felt, insure modern society of a necessary supply of specialists while simultaneously providing it with a benevolent and responsive leadership. Such confidence in the self presupposed, if not Expressionism, at least the general state of mind with which Expressionism was identified.

When Bauhaus spokesmen talked of design being an "attitude more than a profession" they were propounding a rationalized version of expressionist will. Moreover, these industrial designers and the Expressionists had more in common than merely an overlap of some members of the Bauhaus teaching staff. In *Die Brücke* and *Der Blaue Reiter* as in the Bauhaus and the Sociology of Knowledge the idea of some new communal existence for individuals was important. And all four put their faith in strong, radical methods; they shared a dynamic outlook on life and there was a common tendency to reject the past except where it served specific immediate purposes. Expressionism presumed a vast indefinite nature that enveloped and engulfed the individual; Moholy-Nagy spoke of "organic totality," and Mannheim of the "collective unconscious." Although the prewar Expressionists were emotional and ecstatic whereas the Weimar intellectuals appeared cool and calculating there was a peculiar affinity between the groups and sometimes, as in the cases of Kandinsky and Feininger, an actual overlap.

Against this view one might contend that, given the exaggerated statement of the parallels, one could bring even the Nazis under the same roof as the Bauhaus staff and Karl Mannheim. That is perfectly true. But grouping the Nazis with their despised enemies is not so preposterous as it may sound. The mere fact that Hitler drove the Bauhaus and Mannheim into exile along with every other cosmopolitan does not mean that he and they have no common ground.

It would, of course, be monstrous to contend that the likenesses that may obtain between the Nazis and the expressionist-technocrats are much

[19] What is most peculiar about the "survival of the fittest" notion as applied to human society is that Man did not rise by virtue of competitiveness among men but by reason of his ability to share information and cooperate in social units, thus enabling men to dominate animals more powerful than any individual man.

more than conjectural ones. Regimentation was a primary condition of the National Socialist community. Its methods were radical in the sense of being inhumane but they were not particularly innovative—unless one counts the creation of an entire technology for mass murder. The vast indefiniteness that engulfed the Nazi was racial, the blood consciousness of the German soil and the *Herrenvolk*. If the Bauhaus represents Expressionism rationalized then the Third Reich must represent it gone insane. In practice they have little in common but an interest in machine design and a taste for clean and regulated posters. Nazi oppressiveness is far from the unregimented society described in *Ideology and Utopia*. Still, if one rereads Mannheim's prescription for the planning of history on page 164 he will see that it would not have been out of place in the pages of *Mein Kampf*.

The resemblances between Nazism and Expressionism are sufficiently striking to have once inspired an attack upon the style by the famous Marxist philosopher and literary critic, Georg Lukács. In 1934 his article "Grandeur and Decay of Expressionism" appeared in the journal *International Literature*.[20] He attempted to prove that Expressionism was nothing more than a preparation for fascism and was intimately bound up with it. He contended that Expressionism, in dealing with the entire world as if it were no more than the product of individual psyches, helped promote the view that history is dependent upon a collective something called the "national psyche" which is a fundamental of fascist thought. Two years later Lukács was forced to retract this view because of complaints from Expressionists active in underground Communist activities in Germany. It is not easy to estimate the meaning of the retraction, however, because Lukács has always been a controversial figure in Communist circles and in 1933 he had already repudiated as "bourgeois idealism" everything he had written up to then, including his most influential work, *History and Class Consciousness*, which had had a considerable influence upon Mannheim. By the 1950's these "ins" and "outs" had taken on the character of a farce since by that time Lukács's attitudes on Expressionism at least had become an official Party line.

What Lukács had correctly estimated in Expressionism was its lack of any wholeness of vision. The movement was not just unorthodox and antitraditional, it was unrealistic in a verifiable way; that is, its partialisms

[20] See Georg Lukács, "Grösse und Verfall des Expressionismus," *Probleme des Realismus* (Berlin, 1955), pp. 146–83.

were *intentionally* partial. Ecstatic in its acceptance of individual separateness, it deified the autonomy of artistic expression. A committed leftist would not be deceived by the pretended antibourgeois spirit of the avant-garde and Lukács realized that Expressionism bore a direct relation to the structure of the society from which it sprang.

His error, or so it seems to me, lay in mistaking for a single limb the intertwined branches of an enormous tree. But standing as he was within the very shade of that tree it was not easy to see the details. He was even able to confirm his interpretation by citing a letter that the cunning propagandist, Paul Joseph Goebbels, had recently written to Edvard Munch complimenting him as a great Nordic artist.[21] Lukács could have bolstered his argument still more by reference to the convictions of *Die Brücke*'s Emile Nolde who had been an original member of the Nazi party in North Schleswig. Nolde's autobiography, *Jahre der Kämpfe* (1934) was intensely anti-Semitic and much of his art gives vent to the same prejudice. Therefore, when twenty-six of his works were included in the notorious Nazi exhibition of "Degenerate Art" in 1937, he wrote letters of protest to the Ministry of Culture and to Dr. Goebbels, attempting to convince them that his style was consistent with Aryan principles.[22] It was to no avail. In 1941 the government forbade him to paint at all, even as an avocation. Nolde's is one of history's oddest examples of unrequited political love. But, of course, it does not prove that the Expressionists are spiritual relations of fascism anymore than Andre Breton's political sympathies meant that Dada truly stood for the left. Nolde had made the same mistake as Lukács, taking separate branches for a limb.

Those branches, Expressionism and fascism, were in contact at certain points and they were sustained by the same root system, but they grew from different boughs. To extend, perhaps overextend, our metaphor we may compare Expressionism and Bauhaus pedagogy with branches which spring in different directions from one bough. Growing quite close by on the Bauhaus side is another offshoot, the Sociology of Knowledge. And, of course, there are subsidiary twigs and dead sticks woven into a maze of overlappings. All are sustained by that peculiarly modern hope of attaining truth by bringing disparate subjectivities into

21 For Goebbels to have done such a thing sounds incredible unless you know that Munch's late work is polarized to the early, more famous paintings. It is full of powerful men engaged in acts of destruction.

22 See Paul Ortwin Rave, *Kunstdiktatur im Dritten Reich* (Hamburg, 1949), p. 74.

some sort of collective whole. This hope has been one of the most conspicuous elements in the intellectual climate of the nineteenth and twentieth centuries.

As early as 1912 we find Kandinsky saying: "Just as each individual artist has to make his word known, so does each people, and consequently, also that people to which this artist belongs. This connection is mirrored in the *national element* in the work."[23] Even Mannheim's notion that intellectuals can give us an overall perspective "that takes account of all partial perspectives is a reflection of the popular notion that truth is discovered by listening tolerantly to all points of view."[24] The Bauhaus combined these conceptions: if a sense of community and openness does not arise spontaneously, it can be acquired through technical adjustments of the means of communication and production.

Intellectuals today are still struggling with the sense of homelessness that was revealed in the manifestos and documents of these earlier movements. The chief differences between highly mimetic French Impressionism, abstract German Expressionism, and our own contemporary "isms" are matters of degree. The relative intensity of the experience of anonymity and self-consciousness is greater in the mass societies of our age than it was in the class societies of nineteenth-century France or Imperial Germany and the dissociation of the artist from others has been similarly intensified. Consequently, artists have tended to emphasize more and more those attributes of the self that distinguish the individual from an anonymous mass. Such expressions seldom have anything to do with scientific thought except for the psychological theories with which their origins are associated.

Art since 1935 has not tended to correspond to scientific advances so much as it has responded to man's relationship to the *vie artifice* which science has created. But, then, there have been no fundamental changes in the philosophical foundations of either the physical or behavioral sciences. There have been modifications of the superstructure, produced by such things as the abridgement of the Principle of Conservation of Parity by Lee and Yang in 1957, but nothing anywhere near the magnitude of the theories of evolution and relativity. In much the same way the art of the early part of the century remains our art today; the variations are technical ones. That is to be expected, surely. Revolutions, by definition, are

[23] Kandinsky, "On the Problem of Form," p. 157.
[24] Frankel, p. 129.

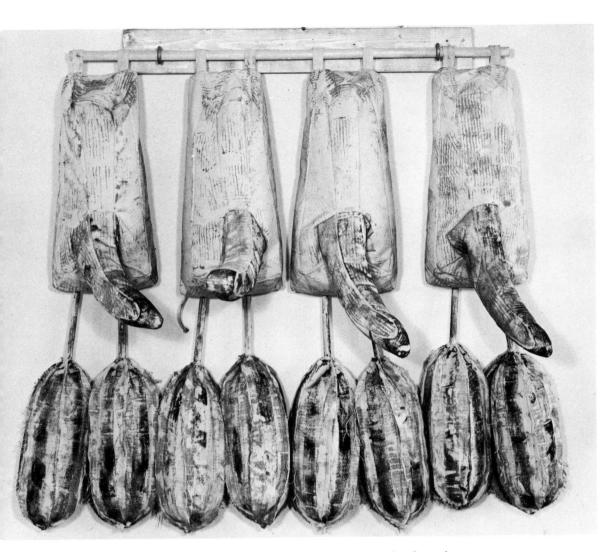

rarities. The avant-garde movements of recent decades have been comparatively conservative, little more than personal explorations of previously charted territory. The works of De Kooning, Johns, Dubuffet, Oldenburg, et al. are startling expressions of individual outlooks, certainly, and in that sense are highly original. But their precedents are clear. We are now delighted by their vigor or dismayed by what may seem a ferocious crudity or aimlessness. The best works of the most talented of them are really just summations of what has gone before.

One can observe exactly how recent art sums up the past by reflecting a while on the sculptures that Claes Oldenburg makes of modern appliances. His soft vinyl versions of things that are normally hard and firm have, unquestionably, definite sexual overtones related to an implied impotence of industrial society. In the case of his *Quadruple Dormeyer Mixers* (Fig. 53) the meaning is of a startling obviousness; they resemble

male genitals in a flacid state. But there are slyer insinuations as well. These mixers are inactive, "hung up." We can relate this to their softness since, after all, mixers are tools handled by women in the preparation of food. By means of these suggestive reformations of the appliance Oldenburg comments not only on the level of emasculation of inhabitants in the affluent society, he refers also to the role of the suppressed unconscious in the prosaic aspects of everyday life. Because this has been explicitly stated in the work it becomes allied with old-fashioned Realism's Revelation of the Obvious. In this case what is revealed is an open secret, the place of motivational psychology and an antiseptic sexuality in product design. The connection with Dada and Surrealism is, obviously, obvious. There is no reason to suppose that these connotations are inadvertant. Oldenburg is a very learned, witty, and deliberate man. He says, "The important thing about humor is that it opens people. They relax their guard, and you can get your serious intentions across. If I were as didactic in my work as I really am, I would bore people to death. But because I can put my message in a colorful engaging form, my message isn't heavy."[25]

Of the contemporary satirists Oldenburg has been the most inventive in identifying the overarching pattern of the increasing mechanization of human life. His shiny insubstantial appliances, his weirdly apt proposals for monuments and the sensitivity with which the former are fabricated and the latter rendered, give him exceptional standing among his peers. Probably, he will appear to the future much as John Singer Sargent looks to us, a brilliantly adroit individual whose work represents a distillation of what preceded it.

It does the living artist no disservice to recognize that his work is distinctly personal rather than unusually, revolutionarily, inventive. We value it, after all, primarily because of the extraordinary distinctness, tangibility, and force with which his personality and artistry command our attention.

[25] Quoted by *Time*, October 10, 1969, p. 68.

Epilogue

THE LATE RENATO POGGIOLI commented on the failure of modern artists to realize what Baudelaire and then the Surrealists had referred to as the *modern marvelous*, scientific in content and almost exclusively urban in ambiance. Poggioli believed that they failed partly because artists themselves had reduced the fabulousness of modern times to the level of extravaganza.

> Bontempelli sensed as much when he recognized that the myth of aviation had already been exhausted, some thousands of years before the airplane was invented, by the myth of Daedalus and Icarus. . . .
>
> From the *modern marvelous* . . . we have had nothing but the interpretations of fable or of rhetoric. Rather than being a wellspring of new myths its resources have been exploited as a call for new settings or a repertory of new themes; often, on the tracks of Poe, as an attempt to introduce scientific methods into the sphere of art.[1]

Poggioli saw things in terms of literary history and his grasp upon the meaning of scientific methodology was a bit infirm, but his point has cogency.

There was an authentic historical connection between the abstract formalism of the Cubists and the rationale behind David Hilbert's Formalism. Yet, so far as the principals were concerned, it was a purely coincidental one; the artists were not taking advantage of a *rationale modern marvelous*. All that can be said of the relationship is that the mental set it signified was a distinguishing feature not merely of a painting movement

[1] Poggioli, *The Theory of the Avant-Garde*, p. 219.

or a school of mathematics but of the times. That is of great interest but one ought not make too much of it.

A wise critic understands that everything, without exception, is symptomatic of certain aspects of the milieu in which it happened. One could, if one wished, produce a connection between salon art of the early twentieth century and contemporaneous diplomacy. And it is the mediocre work, particularly "kitsch," that reveals the spirit of the times in the sharpest and most direct way. Playbills, cartoons, calendar illustrations and the like have this property of authenticity exactly because they are documents. "But," as Poggioli said, "this type of revelation brings to light not the *modernity* of this or that epoch, but its *modernism*,"[2] that is, the desire of its purveyors to be up-to-date even when they deal in the nostalgic. Serious art is distinguished in other respects.

The single known work of Praxiteles holds an interest for us that is more than antiquarian. And the paintings of Poussin or Ingres, Picasso, Ernst, and Klee far exceed the ambits of the movements they used to signify. Clumsy Classicist art and mediocre Cubist works are now exempt from serious criticism. So are the monuments to banality produced by obscure Surrealists and by the less adept German Expressionists. In art as in life, one tends to recollect and relish the good while repressing the bad and neglecting the indifferent. Surely, a few artists now committed to Pop and Op art will be commemorated as individuals when the movements themselves have all gone by. For this reason, if for no other, the question we should ask becomes not what best represents a people but, instead, what represents their best.

The fascinating thing about the modern art that has retained its interest for us is that it was so often accompanied into existence by scientific-philosophical developments which are very nearly its counterparts in stature as well as disposition. Such similitude is of more than incidental interest because it points up so clearly the complex interactions between all intellectually conceived phenomena within the ongoing life of the culture. Thus, while there is a certain felicity to the idea that modern art has failed to extract from its wonderous age any new fantasies or legends,[3] the judgment tends to overlook the fact that modern art is

[2] Poggioli, p. 216.

[3] I am not certain, however, that one should so easily turn aside the credentials of such comic strips as *Krazy Kat* or of the cinema at its extremes of creativity and stereotype. It is easy enough to say that *Superman* is Olympus without grace, but neither Aesop

among the wonders of the age. This at least, I hope, is fairly evident from our review of its relevance to other kinds of inventions.

What is not evident at all is the way of the future.

Prophecy was ever an extremely hazardous occupation, and one is wise to suppress whatever gift of prescience he may suppose he has. That is especially the case in art history, where the success of the outrageous has made cowards of us all. None of us any longer has confidence in the safe perpetuity of his own opinions; that is one of the very few weaknesses to which art critics are no longer prone. For it is quite impossible to talk about art nowadays without having in our minds both the astonishing innovations of the last one hundred years and the drastic mortality of avant-garde movements. The transcience of modern styles is the most obvious thing about them. And our consciousness of that fact has given rise to the curious notion that creative art entails a perpetual revolution of form, and that the fine arts are always in a state of change. The notion accounts for the obsessive feeling that for a work of art to be good it must be original in the revolutionizing sense that Cubism was. But the currency of such feelings is unfortunate, for the notion is untrue as a fact. It misrepresents both the history of art prior to Cubism and, as well, the character of the movements succeeding it. In the first place, great paintings are distinguished by their scope and energies more than for their originality. One could not argue with any confidence that the highly inventive Masaccio was greater than Rembrandt anymore than it could be said that Shakespeare was less creative than a writer like Laurence Sterne. In the second place, confidence in the originality of post-Cubist art is misplaced. Cubism was already the most revolutionary of all modern movements simply because it separated the mode of representation from the things represented. Cubism is the peak moment in a voyage to the present that was begun by the Impressionists. It is simply not conceivable that there are yet higher peaks to come. This assertion sounds, I realize, dogmatic and conservative but it is really not.

Once the principle of complete autonomy for art has been established it does not much matter what else is done by painters and sculptors. Clearly, any kind of abstraction at all can be explained away as an offspring of Cubism. Nor would representationalism of some new, exotic type—no

nor anyone else has a precedent for the world of Krazy, Ignatz and Offissa Pupp. And the movies are a new realm of perceptions and effects.

matter how breathtaking its imagery—equal Cubism's shift of artistic in-
terest from depiction to construction. Trompe-l'oeil representationalism,
after all is said and done, is nothing more than a specialized instance of
construction. Its return would hold no challenge for the artist. In addition,
science is well on the way to making illusionism in art as obsolete as
photography is supposed to have done.

Nothing in the realm of pictorial illusion has ever been so completely
successful as the hologram, an image produced by the simultaneous inter-
section of three laser beams. A hologram contains all of the spatial qualities
of the visible third dimension; overlappings change as the viewer moves
his position relative to the projected image exactly as they would if they
were of solid objects on a stage. One of the most effective demonstrations
of the effect is a hologram of a chessboard on which, among the pieces,
stands an upright magnifying glass. The observer is able to see enlarged
any portion of the knight by changing his position with respect to the
glass. Moreover, the focal distance of the lens varies with the distance of
the viewer! The effect is that of looking through a small windowpane to
actuality beyond. Presently, due to the infant state of laser technology,
the appearance of the windowpane is dark red and the objects always
very small ones. But the technique accomplishes what the stereoscope
scarcely hints at. What makes the difference has been described in lay-
man's terms by Cochran and Buzzard:

> Since the invention of the camera, photographers have wished to
> capture windowpane realism on a sheet of film. But how? The
> physicist answers, "If we could stop time and 'freeze' the light wave
> striking the film window, by photographing not the scene, but the
> *light* from the scene, we would have stored all the information
> coming to the window. We could reconstruct the light exactly as it
> came from the scene. And we would again see the scene in three
> dimensions."[4]

In the simplest possible terms this is what holography does. Except that
the image need not necessarily exist beyond the window. My physicist
friends have shown me images projected out in front of the window and
I have even seen a demonstration using a cylindrical strip of film which

[4] Gary Cochran and Robert Buzzard, "The New Art of Holography," *Science Year*
(Chicago, 1967), pp. 201–208. The reprint of this nontechnical article for youngsters con-
tains a copy of the chessboard hologram and directions for projecting it with a conven-
tional slide projector. A necessary filter of ruby colored film was also provided.

projected an image one could walk completely around just as you could a free standing object. There are other curiosities arising from the character of holography: the slides used are blank so far as the human eye can tell, yet they are of such high resolution that the entire Bible could be recorded on only one square inch.[5] All of the visual information of the slide is contained in every portion of it; that is, if you cut a 2″ × 2″ hologram into ⅛″ squares you would then be able to project the entire image contained on the original from any one of the 256 resulting segments, although with considerable loss of resolution and definition. Not only that, presently it is possible to compress as many as 32 separate and distinct holograms on one slide by changing the angle of the vertical axis of the film for each exposure.

One can say with great confidence that as the science of holography is perfected and the images become more and more equivalents of the real world of vision the effects upon art and upon art criticism will be profound. And these effects will not pertain exclusively to its potential for mimetic naturalism. Because holography hinges on the regularization of interference patterns of light waves, it will someday become possible for any holographer who wishes to, to create three-dimensional abstractions, montages, and fantasies quite unlike reality. Probably the introduction of motion into the image by means of rotation of the film axis is inevitable. And, what is more, such fancies could be reproduced (in a far more exact sense than that presently connoted by the term) by direct copying with laser light for the delectation of thousands.

When one couples holography's potential with the vast capacities computers have for storing information in terms of electrical impulses, one can see that our views of imagery, genius, and creativity may be vastly changed. That might, in and of itself, produce convulsive cultural changes which would correspond to or outstrip those which occurred during the early part of this century. But if such changes do come they will have depended upon technical progress and aesthetic attitudes that would not exist except for the alterations in the meanings of "reality"[6] and "knowing" that took place on one side and the other of 1900.

What is true of the background for a future holography is also true of the other extreme that might be predicted for art. One can conceive of

5 Cochran and Buzzard, p. 207.
6 The novelist Vladimir Nabokov once remarked that the word "reality" was the only one that had no meaning at all without quotation marks around it.

a visual mode which has little or nothing to do with light, an utterly subjective form produced for the individual by his own internal system under the influence of various kinds of stimuli. The possibility of an art form existing somewhere in the penumbra between the visual phenomena of optical illusion and the nonvisual scenery of the dream is suggested by the experiences of those who use mescaline, lysergic acid, and related drugs. Prominent in their hallucinations are what appear to be intensified phosphene patterns. Checkered, whorled, attenuated configurations similar to those summoned by applying pressure to the eyeball appear in the ornament of many cultures and subcultures where the use of hallucinatory drugs is not uncommon. With each generation in the West becoming more inclined to use substances that help relieve the external pressures of organized society, it is by no means difficult to imagine a future in which a great deal of what now passes for aesthetic activity will be experienced in absolute privacy under the influence of chemical agents.

The prospect of widespread spiritual onanism appeals to me rather less than that of the electronic wonderland that all can share. Both extremes will probably come to pass. Neither is anything more than a logical extension of the linked traditions of modernity symbolized on the one side by Seurat's rationalism and on the other by van Gogh, on the one side by the "convenient fiction" of Ernst Mach and on the other by Hartmann's Unconscious. To van Gogh and Cézanne, already, the notion of transmitting a completely defined message was anathematic. They and the host of men who have followed their leads made the experiencing of a painting a part of its creation.

Unfortunately or fortunately, as the case may be, the future does not often work itself out with the kind of logic hindsight applies to the past. The unforeseen seems always to have been more important than the things one could have anticipated. Science-fiction has always underestimated the rate of technological advance and has frequently overestimated the moral excellence of future generations. To paraphrase Stephen Spender, we in 1970 are not as futuristic as the Futurists in 1909 thought we would be. It may be, after all, that easel painting will not go into immediate demise. Perhaps Andrew Wyeths of the future will be painting watercolors of the Martian landscape while scientists are making holograms of microorganisms there. Whatever happens will result from the confluence of innumerable developments no one can foresee.

It is the will of history that an epoch should owe to its past every-

thing transcending its momentary existence and yet should be susceptible of no other genius or perfection than that which it has created out of itself. In this brief history I have tried to reveal something of modernity's distinctiveness by comparing tendencies in the history of painting with concurrent ones in the physical and behavioural sciences. What has been clearest is the continuousness of the tendencies, particularly the subjectivistic ones.

Modern man's awareness of the self and of the limits of human knowledge appears at times to amount to a cultural abnormality. But that awareness is, perhaps, the personal tariff our civilization demands, as anxiety over death paid for Egypt's culture and fear of some terrible retribution for the Middle Ages. With the universe in which we live we are given an appropriate sense of purpose. And the purposes are always of the present and never those of past or future. The past has all gone by; posterity will have its own conceits and will make use of the past to justify them; the present has only its hopes and uses its arts and sciences as token fulfillments of them.

Bibliography

A. Books

d'Abro, A. *The Evolution of Scientific Thought from Newton to Einstein.* New York: Dover, 1950.

Abt, Lawrence Edwin and Leopold Bellak. *Projective Psychology.* New York: McGraw-Hill, 1964.

Anastasi, Anne. *Fields of Applied Psychology.* New York: McGraw-Hill, 1964.

Apollinaire, Guillaume. *Les Peintres Cubistes.* Paris: Eugene Figuire, 1913.

Arendt, Hannah. *The Origins of Totalitarianism.* New York: World, 1951.

Arnheim, Rudolph. *Art and Visual Perception.* Berkeley: University of California Press, 1954.

Baker, Stephen. *Visual Persuasion: The Effect of Pictures on the Subconscious.* New York: McGraw-Hill, 1961.

Barker, Stephen F. *Philosophy of Mathematics.* Englewood Cliffs, N.J.: Prentice-Hall, 1964.

Barnett, Correlli. *The Swordbearers: Supreme Command in the First World War.* New York: William Morrow, 1964.

Baudelaire, Charles. *Curiosités esthétiques, Œuvres.* Paris: Michel Lévy frères, 1868.

Bell, Clive. *Art.* London: Chatto and Windus, 1914.

Benda, Julien. *The Treason of the Intellectuals.* Trans. Richard Aldington. New York: William Morrow, 1928.

Berenson, Bernard. *Aesthetics and History.* Garden City, N.Y.: Doubleday, 1954.

Bergson, Henri. *Creative Evolution.* Trans. Arthur Mitchell. London: Macmillan, 1938.

178

Beth, Evert W. *The Foundations of Mathematics*. Amsterdam: North-Holland, 1959.

Biederman, Charles J. *Art as the Evolution of Visual Knowledge*. Red Wing, Minn.: Charles J. Biederman, 1948.

Boeck, Wilhelm, and Jaime Sabartés. *Picasso*. New York: Harry N. Abrams, 1957.

Bonola, Roberto. *Non-Euclidean Geometry*. New York: Dover, 1955.

Bouvier, Émile. *La Bataille réaliste, 1844–1857*. Paris: Fontemoning, 1913.

Boyer, Carl B. *A History of Mathematics*. New York: Wiley, 1968.

Brett, G. S. *History of Psychology*. Ed. R. S. Peters. London: Allen and Unwin, 1953.

Brink, Edward L., and William T. Kelley. *The Management of Promotion: Consumer Behavior and Demand Stimulation*. Englewood Cliffs, N.J.: Prentice-Hall, 1963.

Cassirer, Ernst. *Substance and Function*, bound with *Einstein's Theory of Relativity*. New York: Dover, 1953.

Cézanne, Paul. *Letters*. Ed. John Rewald. London: B. Cassirer, 1941.

Chipp, Herschel B. *Theories of Modern Art*. Berkeley: University of California Press, 1969.

Comte, Auguste. *Positive Philosophy*. Trans. and ed. Harriet Martineau. 2 vols. London: G. Bell and Sons, 1853.

Coquiot, Gustave. *Georges Seurat*. Paris: Ollendorf, 1924.

Cowley, Malcolm. *Exile's Return*. 3rd ed. New York: Viking, 1951.

Danielsson, Bengt. *Gauguin in the South Seas*. Trans. Reginald Spink. Garden City, N.Y.: Doubleday, 1966.

Einstein, Albert. *The Meaning of Relativity*. Princeton: Princeton University Press, 1953.

Eves, Howard. *An Introduction to the History of Mathematics*. New York: Rinehart, 1964.

Exner, Robert M., and Myron F. Rosskopf. *Logic in Elementary Mathematics*. New York: McGraw-Hill, 1959.

Faulkner, Ray, and Edwin Ziegfeld. *Art Today*. New York: Holt, Rinehart, Winston, 1969.

Félix, Lucienne. *The Modern Aspect of Mathematics*. Trans. Julius and Fancille Hlavaty. New York: Basic Books, 1960.

Flaubert, Gustave. *Madame Bovary*. Trans. Eleanor Marx-Aveling. New York: Pocket Books, 1952.

Francastle, P. *L'impressionism—Les origines de la peinture moderne, de Monet à Gauguin*. Paris: Elsevier, 1937.

Frankel, Charles. *The Case for Modern Man*. New York: Harper, 1955.

Freud, Sigmund. *Basic Writings of Sigmund Freud*. Ed. A. A. Brill. New York: Modern Library, 1938.

―――. *Civilization and Its Discontents*. Trans. Joan Riviere. London: Hogarth Press, 1939.

―――. *Collected Papers*. London: Hogarth Press, 1940.

―――. *A General Introduction to Psycho-Analysis*. Trans. Joan Riviere. Garden City, N.Y.: Doubleday, 1953.

―――. *Neuropsychoses*. London: Hogarth Press, 1940.

―――. *On Creativity and the Unconscious*. Ed. Benjamin Nelson. New York: Harper, 1958.

Fry, Edward. *Cubism*. New York: McGraw-Hill, 1966.

Fry, Roger. *Cézanne, A Study of His Development*. London: Hogarth Press, 1927.

Gaunt, William. *The Aesthetic Adventure*. New York: Harcourt Brace, 1945.

Gibbon, Edward. *The Autobiographies of Edward Gibbon*. Ed. John M. Murray. London: John M. Murray, 1896.

Giedion, Siegfried. *Space, Time and Architecture*. Cambridge: Harvard University Press, 1941.

Gleizes, Albert, and Jean Metzinger. *Du Cubisme*. Paris: Eugene Figuire, 1912.

van Gogh, Vincent. *Dear Theo*. Ed. Irving Stone. Boston: Houghton Mifflin, 1937.

Gombrich, E. H. *Art and Illusion*. New York: Bollingen Foundation, 1961.

Grohmann, Will. *Paul Klee*. New York: Harry N. Abrams, n.d.

Grosser, Maurice. *The Painter's Eye*. New York: Rinehart, 1951.

Halasz, Nicholas. *Captain Dreyfus, The Story of a Mass Hysteria*. New York: Grove, 1955.

von Hartmann, Eduard. *The Philosophy of the Unconscious*. Trans. William Chatterton Coupland. London: K. Paul, Trench, Trübner, 1893.

Hauser, Arnold. *The Social History of Art*. 2 vols. New York: Knopf, 1951.

Hayek, Friedrich. *The Road to Serfdom*. Chicago: University of Chicago Press, 1944.

von Helmholtz, Herman. *Popular Lectures on Scientific Subjects*. London: Longmans, Green, 1893.

―――. *Treatise on Physiological Optics*. Ed. James Southall. 3 vols. New York: Dover, 1962.

Herbert, Robert. *Modern Artists on Art*. Englewood Cliffs, N.J.: Prentice-Hall, 1964.

Hirschfeld-Mack, Ludwig. *The Bauhaus*. Croydon, Australia: Longmans, 1963.

Holt, Elizabeth G. *A Documentary History of Art*. 3 vols. Garden City, N.Y.: Doubleday, 1957.

Hugnet, Georges. *Fantastic Art, Dada, Surrealism*. New York: Museum of Modern Art, 1946.

Hultén, K. G. Pontus. *The Machine*. New York: Museum of Modern Art, 1968.

Hunter, Sam. *Modern French Painting*. New York: Dell, 1956.

Ivins, William M. *Art and Geometry, A Study in Space Intuitions*. Cambridge: Harvard University Press, 1946.

James, William. *Pragmatism, A New Name for Old Ways of Thinking*. New York: Longmans, 1907.

Jammer, Max. *Concepts of Space: The History of Theories of Space in Physics*. Cambridge: Harvard University Press, 1954.

Kahnweiler, Daniel Henry. *Juan Gris, His Life and Work*. Trans. Douglas Cooper. London: Faber and Faber, 1947.

———. *Der Weg zum Kubismus*. Munich, 1920. Trans. Henry Aronson as *The Rise of Cubism*. New York: Wittenborn, Schultz, 1949.

Kant, Immanuel. *The Philosophy of Kant*. Ed. Carl J. Friedrich. New York: Modern Library, 1949.

Kepes, Gyorgy. *Language of Vision*. Chicago: Paul Theobold, 1947.

———. *The New Landscape*. Chicago: Paul Theobold, 1956.

Klein, Felix. *Elementary Mathematics from an Advanced Standpoint*. 2 vols. Trans. Charles A. Noble. New York: Macmillan, 1953.

Kline, Morris. *Mathematics in Western Culture*. New York: Oxford University Press, 1953.

Kramer, Edna E. *The Mainstream of Mathematics*. New York: Oxford University Press, 1952.

Langer, Susanne K. *Feeling and Form*. New York: Charles Scribner's, 1953.

Lenin, Vladimir Ilich. *Materialism and Empirico-Criticism*. Trans. A. Fineberg. Moscow: Cooperative Publishing Society of Foreign Workers in the U.S.S.R., 1937.

Mach, Ernst. *The Analysis of Sensation*. Trans. C. M. Williams. Chicago: Open Court Press, 1914.

———. *Space and Geometry*. Chicago: Open Court Press, 1906.

Mannheim, Karl. *Ideology and Utopia*. Trans. Louis Wirth and Edward Shils. New York: Harcourt, Brace, 1957.

———. *Man and Society in an Age of Reconstruction*. New York: Harcourt, Brace, 1940.

Martet, Jean. *Georges Clemenceau*. Trans. Milton Waldman. London: Longmans, Green, 1930.

Maxwell, J. C. *Matter and Motion*. Notes and Appendices by Sir Joseph Larmer. New York: Dover, n.d.

Meschkowski, Herbert. *Evolution of Mathematical Thought.* Trans. Jane H. Gayl. San Francisco: Holden-Day, 1965.

von Mises, Richard. *Positivism, A Study in Human Understanding.* Cambridge: Harvard University Press, 1951.

Moholy-Nagy, Laszlo. *Vision in Motion.* Chicago: Paul Theobold, 1947.

Moore, George. *Modern Painting.* London: Walter Scott, 1906.

Morelli, Giovanni. *Italian Painters: Critical Studies of Their Works.* Trans. C. J. Ffoulkes. London: John M. Murray, 1892.

Myers, Bernard S. *The German Expressionists.* New York: Frederick A. Praeger, 1957.

Newman, James R. *The World of Mathematics.* 4 vols. New York: Simon and Shuster, 1956.

Nietzsche, Friedrich. *Thus Spake Zarathustra.* Trans. Thomas Common. New York: Modern Library, n.d.

Pissarro, Camille. *Camille Pissarro, Letters to His Son Lucien.* Ed. John Rewald. Trans. Lionel Abel. New York: Pantheon, 1943.

Plato. *The Dialogues of Plato.* Trans. Benjamin Jowett. Chicago: Encyclopaedia Britannica, Inc., 1951.

Poggioli, Renato. *The Theory of the Avant-Garde.* Trans. Gerald Fitzgerald. Cambridge: Harvard University Press, 1968.

Rave, Paul Ortwin. *Kunstdiktatur im Dritten Reich.* Hamburg: Gebrüder Mann, 1949.

Raynal, Maurice; Jacques Lassaigne, and others. *The History of Modern Painting.* 3 vols. Geneva: Albert Skira, 1950.

Read, Herbert. *Surrealism.* London: Faber and Faber, 1939.

Rewald, John. *Georges Seurat.* New York: Wittenborn, 1946.

———. *The History of Impressionism.* New York: Museum of Modern Art, 1946.

———. *Post-Impressionism from Van Gogh to Gauguin.* New York: Museum of Modern Art, 1956.

Rich, Daniel Catton. *Seurat and the Evolution of "La Grande Jatte."* Chicago: University of Chicago Press, 1935.

Richter, Hans. *Dada: Art and Anti-Art.* New York: McGraw-Hill, 1965.

Russell, Bertrand. *A History of Western Philosophy.* New York: Simon and Schuster, 1945.

——— and Alfred N. Whitehead. *Principia Mathematica.* Cambridge: Cambridge University Press, 1910. A popular treatment can be found in Russell's *Introduction to Mathematical Philosophy*, London: Allen and Unwin, 1924.

Russell, John. *Max Ernst.* New York: Harry N. Abrams, 1965.

Schapiro, Meyer. *Cézanne.* New York: Harry N. Abrams, 1952.

———. *Van Gogh*. New York: Harry N. Abrams, 1950.

Schilder, Paul. *The Image and Appearance of the Human Body*. New York: International University Press, 1951.

Sewall, John Ives. *A History of Western Art*. New York: Holt, Rinehart, Winston, 1961.

Steegmuller, Francis. *Flaubert and Madame Bovary: A Double Portrait*. New York: Viking, 1939.

Tindall, William York. *Forces in Modern British Literature, 1885–1956*. New York: Vintage, 1956.

de Tocqueville, Alexis. *Democracy in America*. 2 vols. Trans. Henry Reeve. New York: Alfred A. Knopf, 1945.

Vaihinger, Hans. *The Philosophy of "As If."* Trans. C. K. Ogden. London: Kegan Paul, 1954.

Venturi, Lionello. *Four Steps toward Modern Art*. New York: Columbia University Press, 1955.

Vollard, Ambroise. *Renoir, an Intimate Portrait*. Trans. H. L. Van Doren and R. T. Weaver. New York: Alfred A. Knopf, 1934.

Waldberg, Patrick. *Surrealism*. New York: McGraw-Hill, 1965.

Weller, Allen S. *The Joys and Sorrows of Recent American Art*. Urbana: University of Illinois Press, 1968.

Wells, H. G. *The Time Machine*. New York: Random House, 1932.

White, Morton. *The Age of Analysis*. New York: New American Library, 1955.

Wien, W. *Die Relativitätstheorie*. Leipzig, 1921.

Zigrosser, Carl. *The Expressionists*. New York: George Braziller, 1957.

Zimmerman, Robert. *Henry More und die vierte Dimension des Raumes*, Vienna, 1881.

B. ESSAYS AND ARTICLES

Bernard, Émile. "Une conversation avec Cézanne," *Mercure de France* 148, no. 551 (June 1, 1925): 372–97.

Boime, Albert. "Thomas Couture and the Evolution of Painting in Nineteenth-Century France," *The Art Bulletin* 51, no. 1 (March, 1969): 48–56.

Brittain, H. L. "A Study in Imagination," *Pedagogical Seminary* 14 (1907): 137–207.

Cochran, Gary, and Robert Buzzard. "The New Art of Holography," *Science Year*. Chicago: Field Enterprises, 1967, pp. 201–8.

Laporte, Paul M. "Cubism and Relativity," *Art Journal* 25, no. 3 (Spring, 1966): 246–48.

Levin, Harry. "—But Unhappy Emma Still Exists," *The New York Times Book Review*, April 14, 1957, p. 4.

Lukacs, Georg. "Grösse und Verfall des Expressionismus," *Probleme des Realismus*. Berlin: Aufbau-Verlag, 1955, pp. 146–83.

Matisse, Henri. "Notes of a Painter," *Henri Matisse Retrospective Exhibition*. Text and catalogue by Alfred H. Barr, Jr. New York: Museum of Modern Art, 1931.

Ortega y Gasset, José. "On Point of View in the Arts," *The Dehumanization of Art, and Other Writings on Art and Culture*. Garden City, N.Y.: Doubleday, 1950.

Perry, Lilla Cabot. "An Interview with Monet," *American Magazine of Art* 18, no. 5 (March, 1927): 120.

Picasso, Pablo. "Picasso Speaks," trans. Marius de Zayas. *The Arts*. New York: 1923, pp. 315–29.

Richardson, John Adkins, and John I. Ades. "D. H. Lawrence on Cézanne: A Study in the Psychology of Critical Intuition," *Journal of Aesthetics and Art Criticism* 18, no. 4 (Summer, 1970): 441–54.

Schapiro, Meyer. "The Apples of Cézanne: An Essay on the Meaning of Still-Life," *The Avant-Garde*. Ed. Thomas B. Hess and John Ashbery. New York: Art News, 1969, pp. 34–53.

———. "Leonardo and Freud, An Art-Historical Study," *Journal of the History of Ideas* 17, no. 2 (April, 1956): 147–87.

———. "The Liberating Quality of Avant-Garde Art," *Art News* 56, no. 4 (Summer, 1957): 36–42.

———. "The Nature of Abstract Art," *Marxist Quarterly* 1, no. 1 (January–March, 1937): 77–98.

———. "Seurat and 'La Grande Jatte,'" *Columbia Review* 17 (1935): 9–16.

———. "Style," *Anthropology Today*. Ed. Sol Tax. Chicago: University of Chicago Press, 1953, pp. 287–312.

Schneider, Pierre. "The Many-Sided M. Nadar," *Art News Annual*, No. 25 (1956): 57–72.

Steegmuller, Francis. "The Translator Too Must Search for le Mot Juste," *The New York Times Book Review*, April 14, 1957, pp. 4–5.

Teriade, E. "Matisse Speaks" (Quoted views as of 1951), *Art News Annual*, no. 21 (1952): 42–43.

Wind, Edgar. "Critique of Connoisseurship," *The Listener* 64, no. 1653 (Dec. 1, 1960): 973–79. This article was part of a series by Wind. They have appeared in book form as *Art and Anarchy*. New York: Alfred A. Knopf, 1964.

Index

189

Sterne, Lawrence, 173
Stravinsky, Igor, 120n
Strikes: Russian workers', 82
Strindberg, August: *The Inferno*, 83; *Miss Julie*, 83
Style: meaning for twentieth-century artists, 105
Sub-conscious, 94. *See also* Unconscious
Successive contrast, 12
Superman: comic strip, 172n
Suprematism, 10, 56
Surrealism: in art, 10, 56, 134, 141-148, 149, 154, 155, 170, 171, 172; in literature, 141, 142
Survival of the fittest: application to human society, 165n
Sutter, David, 65, 67
Synthetic statements: in logic, 26

Taine, Hippolyte, xvii
Technology: history of, xiv; and art, xiv-xv
Thematic Apperception Test, 98
Theology, 27
Third Reich, 166. *See also* Fascism; Hitler; Nazis
Time: in physics, 107–108, 110–111
Tindall, William York, 141, 144
Titian: *Venus of Urbino*, 6, 7, 8
de Tocqueville, Alexis, 82
Toynbee, Arnold, 160
Trac signs and signals, 152, 161
Trompe-l'oeil art, 174
Toulouse-Lautrec, Henri de, 92, 105
Tzara, Tristan, 136

Uccello, Paolo, 63
Unconscious: in psychology, xviii, 94–96, 102, 103, 176; and ideology, 160
Urban environment, 20, 22, 77–78, 99, 150

Vaihinger, Hans: *The Philosophy of "As If,"* 62–63n, 64
Vauxcelles, Louis, 99n
Velasquez, 7, 12
Verlaine, Paul, 47, 141
Vermeer, Jan: *Head of a Young Girl*, 40, 41, 42
Vienna Circle, 120
Villon, Jacques, 104
Vlaminck, Maurice, 99
Vuillard, Edouard, 83

Wagner, Richard, 83
Weapons: World War I, 140
Weimar Republic, 158; intellectuals of, 165
Whistler, James M., 116
Whitehead, Alfred North: *Principia Mathematica*, 125
Wittgenstein, Ludwig, 120
World War I, 138–140
World War II, xvi
Wyeth, Andrew, 176

Zeitgeist, 3, 48
Zeno, 47, 109
Zola, Emile, 25, 27, 28, 31, 47; *Nana*, 31; *Le Roman expérimental*, 31
Zöllner, Johann, 106–107, 108